TAKING
AIM!

TAKING AIM!

THE BUSINESS OF BEING AN ARTIST TODAY

Edited by Marysol Nieves

FORDHAM UNIVERSITY PRESS & THE BRONX MUSEUM OF THE ARTS / NEW YORK 2011

Fordham University Press has no responsibility for the persistence or accuracy of URLs for external or third-party Internet websites referred to in this publication and does not guarantee that any content on such websites is, or will remain, accurate or appropriate.

Fordham University Press also publishes its books in a variety of electronic formats. Some content that appears in print may not be available in electronic books.

Library of Congress Cataloging-in-Publication Data is available from the publisher.

Printed in the United States of America
13 12 11 5 4 3 2 1
First edition

CONTENTS

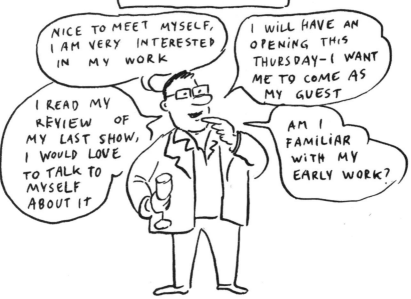

AIM FOREWORD

ANTONIO SERGIO BESSA

Three decades old and going strong, Artist in the Marketplace is a program so closely intertwined with the history and mission of The Bronx Museum of the Arts that like the institution itself it has endured the comings and goings of many cultural trends, several administration changes, and a number of strategic plans, budget cuts, and downsizings. More to the point, despite the fact that its model has been replicated many times over by peer institutions and colleges across the country, Artist in the Marketplace's sheer longevity alone makes it hard for one to find in the art world a program that is its equal.

Inarguably, AIM is the Bronx Museum's main brand, and like that of every good brand, its success is predicated on good design: a simple structure of basic elements that has proved over the years pliable enough to adapt to the circumstances of the moment. Like the much-fabled "little black dress," AIM has been able to adapt over the years to changes in the cultural landscape by adding to or discarding accessories from its clear-cut structure. Now, on the occasion of its thirtieth anniversary, the program positions itself for a major realignment with the goal of making its core values relevant to newer generations of artists to whom the most basic tenets of the art practice have been challenged by, among other things, the emergence of digital media.

Why change, one might ask, a formula that has proved so lasting? The truth is that, in programmatic terms, longevity alone is no measure of success. And as if to corroborate the dictum, over the past few years the program has sporadically received mixed feedback from participants, visitors to the exhibitions, and even funders. The complicated thing about longevity, it seems, is the danger that elements which originally felt so fresh might calcify. ("Are you guys still doing the 'elevator pitch' thing?" a candidate to the program recently asked me.) Another possible snag over the many years has been the perception that the program is on autopilot. ("Is this a Bronx Museum program? Who's in charge?" asked

a grants manager from a supporting foundation.) Well, we are in charge, and we realize that it is about time we did some housekeeping.

To that end, the first step has been to improve the program's evaluation process, which traditionally had been conducted through written forms. In 2007 we introduced roundtable discussions at the end of each term and assigned a staff member from the curatorial department to accompany and document each session. The immediate feedback from all participants together with the notes about each session provided invaluable information and allowed us to identify areas that needed improvement—specifically those related to accessibility and participation. It became evident, for instance, that if AIM is really about demystifying the art world, the Bronx Museum needs to become more accessible to its participants. In addition, because another stated goal of the program is to encourage artists to create their own networks, we realized that the group dynamics in each session needed to change.

As for the changes, subject matter has been kept intact for the most part and the emphasis has been placed on the program's methodology, which has now shifted away from the loose lecture format it had in the past toward a dialogical model. While acknowledging our culture's current stress on interactivity, this shift in approach is also a humbling admission that the *business* of being an artist cannot be taught. Taking inspiration from the philosopher Paulo Freire's critique of traditional education as "suffering from narration sickness," and of the teacher as a narrator whose "task is to 'fill' the students with contents of his narration,"[1] we propose to open up AIM to the many narrations of its participants. In this new model, AIM becomes a forum for the exchange of experiences and ideas, asking participants to be actively present and to be the agents of change in their own processes.

To ensure the continuous flow of these diverse narratives, the program is now led by a faculty of five instructors covering issues ranging from career management, fundraising, and copyright to grant writing and the use of social media. In structuring the program around a faculty, our intention has been to reflect the decentralization of the art market of the 2000s with its multiple art fairs, biennials, and mega-galleries popping up all over the globe. The program has also been enriched by the addition of visiting artists from our International Residency Program, who bring to the discussion alternative perspectives related to the art market. As Melissa Rachleff, one of the faculty members, points out, the most effective means to learn is by "doing," and each session now incorporates as subject matter real situations brought in by the participants.

In the same spirit, we have integrated the main components of the program's final exhibition into the curriculum, thus allowing the artists a bigger stake in its final organization. The exhibition, which has now become biannual, is in the care of two guest-curators who work closely with the Bronx Museum staff as well as with the group of selected artists. The guest-curators also lead the initial sessions each term and follow up throughout two years with individual studio visits and regular updates on the exhibition's process. Another important change to the program has been the creation of the Art Critic–in–Residence, a two-year fellowship in which a noted art critic is selected to present four lectures and contribute an original essay on a topic related to the art market for inclusion in the biennial catalogue.

Around the time the AIM program was created in the early 1980s, New York was seen around the world as the center of the art market. That situation has changed considerably since as cities like Los Angeles, London, Berlin, and Beijing, to name a few, have succeeded in creating alternative models for local artists and eventually becoming themselves the focus of global attention. Amidst such complex configuration the most pressing challenge for emerging artists everywhere is perhaps building a sense of purpose. By stretching the AIM program into a two-year cycle (with all that entails), our goal has been to draw attention to the increasing complexity of a career in the arts nowadays while also allowing participants enough time to reflect on what paths to embrace and what strategies to apply. By expanding the scope of the exhibition and making it a wider Bronx affair, the Bronx Museum reiterates its commitment to make contemporary art a vital force in the local community.

Note

1. Paulo Freire, *Pedagogy of the Oppressed*, trans. Myra Bergman Ramos (New York: Herder and Herder, 1972), 57.

"You are light years away from getting into the Whitney Biennial."

ACKNOWLEDGMENTS

HOLLY BLOCK

At age thirty in the art world one can be many things—one could be an emerging or an established artist; one might be preparing for one's first museum exhibition or a commission to create one's first public art project; or, better yet, one might find one's first commercial gallery exhibition sold out. All of this is possible, but most important is the fact that one can actually be identified as a professional visual artist at the age of thirty. In real life, age thirty can potentially mean one-third of one's life cycle; and common sense says that at thirty you are at a halfway point in your career—not quite fully developed, but halfway there. All these possibilities inform our decisions and ultimately affect our careers in a meaningful way.

As in the business world, starting with a bang in the art world is not necessarily a guarantee that an artist will end up with a great career. Strong navigational skills are necessary, and the business of providing pathways to help emerging artists become established is a process that often goes undocumented and unrecognized. For thirty years the Bronx Museum of the Arts has offered the Artist in the Marketplace (AIM) program, and we are still firm in our belief that emerging artists continue to need multiple modes of exposure. Not quite a training program (no "boot camp"), AIM is an opportunity for the exchange of information in an informal atmosphere—information that is often omitted from more traditional college or university curricula, where the expectation is that one will learn these things on one's own. The AIM program has evolved over the years based on the participants' needs and the changes in the art world, and clearly it has not only assisted in launching careers in the fine arts but has also served to demystify the art world, exposing artists to the workings, the mechanics, and the strategies that are often internal and not necessarily spoken or shared. Today's art world is still the only business referred to as a "personal exchange," often compared to that of

the "diamond business"—similar in practice, but with its own very distinct set of idiosyncrasies and protocols.

Over the past thirty years, AIM has benefited from the vision and leadership of numerous professionals, most notably former Executive Director Luis R. Cancel, under whose tenure the program was founded, as well as the stewardship of great Program Managers like Joan Snitzer and Jackie Battenfield. We thank them for their insight in helping to make the program the model it has become. We also thank all the curators, art critics, art dealers, lawyers, income tax experts, and artists who annually collaborate with us and share their knowledge with AIM participants.

The Bronx Museum is proud to collaborate with Fordham University Press in the production of this volume, and we thank its Director, Fredric Nachbaur, for his support, as well as that of his staff: Loomis Mayer, Eric Newman, and Kate O'Brien-Nicholson. Guest editor Marysol Nieves has brought to this project her many years of experience at the Bronx Museum—starting as a graduate intern and Assistant Curator, later as the Museum's Senior Curator and for a brief period as interim Director. Her deep understanding of the Bronx Museum's mission and of its commitment to the emerging art scene has been instrumental in reuniting the many accomplished professionals whose insights are presented here. We thank her for the amazing output of energy in coordinating this project; we also thank Mónica Espinel, Sally & Milton Avery Arts Foundation Curatorial Fellow; and Scott Sheu, our summer 2010 intern from the Arts & Business Council, for their research in support of this volume. I also thank the staff of the Bronx Museum for their efforts. Special thanks to Antonio Sergio Bessa, Director of Curatorial and Education Programs; Yvonne García, Director of Development; Lynn Pono, Programs Manager; and Alan Highet, Director of Finance. Last but not least, I want to thank the many contributors to this book: Rocío Aranda-Alvarado, Regine Basha, Ian Cofré, Kianga Ellis, Pablo Helguera, Cary Leibowitz, Omar Lopez-Chahoud, Melissa Rachleff, Rodney Reid, Sara Reisman, Raphael Rubinstein, Brian Sholis, Axel Stein, Carla Stellweg, Barbara Toll, Anton Vidokle, and Lydia Yee, as well as the numerous arts professionals who graciously agreed to be interviewed.

Many people have supported AIM over the years. Among the most important I thank the artists who have participated in this program that to date numbers more than 1,000 from all over the globe; the Bronx Museum's Trustees and staff for their commitment to this program from its inception; and all the arts professionals who have provided their insight, time, and advice. I extend our appreciation to the funders for

their forward thinking and generosity over the years; they include the DeWitt Wallace Fund; Mobil Foundation, Inc.; the National Endowment for the Arts; AT&T; Philip Morris Companies, Inc.; the New York State Regional Education Center for Economic Development–Bronx Community College; the Lila Wallace–Reader's Digest Fund; the Jerome Foundation; the Greenwall Foundation; the Alice Baber Fund for Art; the Elizabeth Foundation for the Arts; Consolidated Edison of New York; Joyce Mertz-Gilmore Foundation; NYNEX; the New York Times Foundation; the Scherman Foundation; Bankers Trust Company; the Chase Manhattan Bank; National Westminster Bank; R. H. Macy & Company; Merrill Lynch Company Foundation; the Jacques and Natasha Gelman Trust; the Emily Hall Tremaine Foundation; the Helena Rubinstein Foundation; the Peter Jay Sharp Foundation; the Dedalus Foundation; and numerous individual patrons. The thirtieth anniversary of AIM is made possible by the generous support of the MetLife Foundation Museum and Community Connections grant, UBS, the Sally & Milton Avery Arts Foundation, the Helena Rubinstein Foundation, and the Greenwall Foundation.

TAKING AIM!

*"In this art school you will learn the path to success by
learning from the utter failures of our faculty."*

Taking AIM

An Introduction

MARYSOL NIEVES

Most investment advisors would probably agree that aside from understanding the complexities of the financial markets, one of the key elements for success in the business world is the ability to forecast emerging trends—to identify recent developments and the potential opportunities implicit in these and, in the process, blaze new trails. The Bronx Museum of the Arts' perspicacity and leadership in founding the Artist in the Marketplace (AIM) program thirty years ago to address the particular career management needs of artists demonstrates such heightened discernment and vision. Indeed, the founders of AIM seem to have had a prescient understanding of this critical juncture and of the myriad economic and cultural factors that would soon transform and expand the art market while multiplying and conflating the gamut of possibilities available to artists, thus necessitating a level of instruction and skills beyond those harnessed in the confines of the studio or classroom. Thirty years later and with a growing alumni base that boasts more than 1,000 artists, AIM's core values—centered on fostering creative entrepreneurship, encouraging professional networking, and demystifying the often opaque practices of the art world, all of which are essential to the program's success—remain equally significant today as the contemporary art field has become increasingly more complex, decentralized, and global. Indeed, AIM's strength resides not so much on a reliance on the vagaries of the art market or on defining "success" strictly in commercial terms or based on some monolithic conception of the art world but on grasping the art world's complexities and the plethora of opportunities that are available in order to take aim and strategically determine one's own course of action. This is one of the program's hallmarks and a true marker of its longevity and effectiveness, as any former AIM artist will attest. In many ways, this book, *Taking AIM! The Business of Being an Artist Today*, represents a culmination of the Museum's unwavering support of visual artists while extending the invaluable information

1

beyond the program's annual 36 participants and literally "taking AIM" to a much wider audience and community of art practitioners. And, although this book is intended principally as a professional development guide for emerging artists, it is worthwhile to survey aspects of this remarkable program's history as well as the environment that led to its creation because they provide useful insights into the state of the contemporary art field during that time and its ongoing evolution vis-à-vis the broader cultural landscape.

Ignited, in part, by the cultural activism that defined that era, AIM emerged in 1980 against the backdrop of a much smaller and more centralized art world. And, while a program like AIM may appear incongruous with the objectives of a community-centered museum situated in the South Bronx, seemingly far removed from the locus of the art world or the so-called marketplace, many of the wider cultural circumstances that led to the creation of AIM are intrinsically connected to the overall political and grassroots activism that sparked the Museum's inception and that likewise transformed the art world during the 1970s and 1980s vis-à-vis the emergence of the alternative art movement. Moreover, as former AIM Project Director Joan Snitzer points out,

> When the AIM program began, [New York City] was still in the midst of a deep economic recession. SoHo, an abandoned warehouse district, was the [place] where artists were able to convert raw factory spaces. The rents were low, and the large, open spaces could be creatively configured to accommodate each artist's living and working needs. During that time the image of a New York artist was also different. Being a successful artist meant simply being able to support yourself through your art and receiving positive recognition from peers. A few sales and a federal NEA or state CAPS grant ranging from $3,000 to $15,000 would provide enough income for an artist to live for a year or two. For these reasons, SoHo and its surrounding areas attracted creative people from many parts of the United States. [But] by the mid-1980s—the "Wall Street" era—the city's economic prosperity altered the way an artist needed to think about and conduct a career. The rewards were very high, but establishing a career as an artist in New York City became much more complex. Through all that change, the Bronx Museum was growing and evolving, learning how to best serve its audiences. Since it was experiencing so many of the same issues that emerging artists were, it could uniquely empathize with and anticipate their needs.[1]

Indeed, a relatively new arts organization at the time, the Bronx Museum was founded in 1971 as part of a citywide effort to decentralize the arts.[2] A decade later and under the dynamic leadership of activist, arts administrator, and cultural entrepreneur Luis R. Cancel (Executive Director from 1978 to 1991), himself a Bronx native and professional visual artist, the Museum set an ambitious agenda aimed toward striking a greater balance between the need to simultaneously "be responsive to [its] local constituents and its aspirations to be [like] a 'downtown' contemporary arts center."[3] As Cancel asserts, "The cornerstone of my success as Executive Director rested on maintaining that balanced approach to exhibitions and programs."[4] Critical to this vision was Cancel's development of an education program, which the former director describes as "one of the institution's key priorities. The Bronx Museum of the Arts already had the Satellite Gallery program in place when I arrived so [the focus] was reaching Bronx artists and highlighting their work throughout the borough. AIM became one of our first and most successful adult education programs."[5] AIM dovetailed perfectly with the Museum's programmatic mission while Cancel's first-hand experience as an art student at Pratt Institute in the 1970s (where he earned a BFA in painting and printmaking) was no doubt one of the main sparks that ignited the program's inception. Cancel describes the period immediately following his own graduation from Pratt as being, "released into the real world with no clue how to earn a living as an artist [so] when I had the opportunity to do something about it, I designed the Artist in the Marketplace program."[6] Cancel's statement speaks to the proactive stance and spirit of advocacy and action that defined this cultural moment. Moreover, AIM's emphasis on transparency (exposing the inner workings and practices of the art world) and building communities (networking and sharing resources) embodies many of the ideals and pursuits of the alternative arts community, and these are certainly values that helped shape and continue to inform the Bronx Museum today.

And while Cancel's leadership and vision may have provided the catalyst for the AIM program, its overall design and structure—which remain largely the same today—were jointly developed by Cancel, former Assistant Director in the 1980s Carmen Vega-Rivera, and the aforementioned Joan Snitzer, who from 1980 to 1991 served as AIM's first Project Director. Snitzer, herself a visual artist, was approached by Vega-Rivera about facilitating a portfolio development grant for Bronx artists.[7] As Snitzer recounts, "I quickly discovered that the artists had very developed aesthetics in their creative artworks. What was intensely needed was guidance on how to survive as an artist. I proposed a series of weekly

informational seminars for working artists, culminating in a group show at the Museum."[8]

Snitzer's knowledge and access to the downtown arts scene largely concentrated in SoHo was particularly instrumental in securing the caliber of speakers who would ensure the program's success and depth, particularly as AIM quickly transitioned from serving Bronx artists to serving a citywide art community. The speakers, as she recalls, "came from all areas of the art world: dealers, critics, curators, artists, collectors, lawyers and accountants. Some of the city's top influencers came to speak, including the *New York Times* art critic Roberta Smith; curators from the Whitney, the Guggenheim, and the New Museum; nonprofits like White Columns and Exit Art; collector Sam Wagstaff; and Vincent Fremont, Vice President of Andy Warhol Enterprises."[9] Moreover, Snitzer's keen instincts and understanding of the skills necessary for artists to compete in this new environment were critical to AIM:

> What was needed—and what we delivered—was practical information ranging from how reviews are selected for *The New York Times* to organizing and filing taxes as an artist. Many sessions were scheduled at the offices of museums or the backrooms of prominent galleries. All of the sessions provided the artists with the opportunity to ask questions and suggest valuable topics for discussion. The small group size and intimate settings gave the artists a unique opportunity to gain "insider" knowledge on how the art world functioned.[10]

Thirty years later, as the Bronx Museum commemorates this milestone anniversary and the impact of one of its cornerstone programs, this book asserts AIM's enduring vision and objectives. And, like the program itself, it is intended to provide artists with unfiltered access to and information about the business practices and idiosyncrasies of the art world for those still new to or not yet versed in its inner workings. Mirroring the structure and topics featured in the AIM program's weekly workshops and discussions, each chapter—structured through a series of informal interviews, conversations, testimonials, and/or commentary—focuses on the specific perspective of a representative of the art world, ranging from the artist, curator, critic, dealer, and collector to those who focus on the field's ongoing diversification and growth: a range of arts professionals who oversee public art, artist residencies, and commissioning programs as well as funding initiatives and other support opportunities. Likewise, the impact of the prior decade's economic boom on the art market is represented by the views of such professionals as art advisors, corporate curators, and art fair directors. The expansion and seemingly

inexhaustible potential of the Internet are examined through the dynamic development of networking and social media, blogging, and other digital media and tools that are paving the way for new modes of interface, communication, and creative entrepreneurship for artists and arts professionals alike. And, of course, a publication intended largely for artists would not be complete without some samples of the creative energy that defines this vital community. AIM alumna Amy Pryor graciously allowed us to use one of her topographical collages for the cover design. Akin to archeological excavations or geological cross-sections, Pryor's work incorporates a dizzying array of sources, from junk mail and ad circulars to bills and consumer packaging materials that reflect aspects of contemporary life and the ways in which information is often processed and codified. An artist's commission by AIM alumnus Pablo Helguera is interspersed throughout the book, injecting an element of humor via a special edition of his well-known *Artoons*, a series of witty cartoons that deftly satirize the coterie of characters who have—for better or for worse—come to typify certain aspects of the art world. The multifaceted artist and provocateur Cary Leibowitz contributes his version of the ever pervasive "best of" survey using the past three decades in the contemporary art field to elicit the completely biased and subjective opinions of a divergent group of "tastemakers" and "opinion shapers" who embody our current pluralistic reality and the many "art worlds" that coexist, overlap, and diverge at any given time. Finally, in keeping with the retrospective tone set by AIM's thirtieth anniversary, a selected chronology of key events that have defined the contemporary art milieu during this period is presented, including those that have framed the broader culture and our collective histories.

Much as the Artist in the Marketplace program does, *Taking AIM!* acknowledges the reality that the demands of today's marketplace require a reassessment of what it means to be an artist and what is needed to compete and succeed in this field. And, while for some being an artist is a lifestyle or "vocation" that should remain unencumbered by the mundane exigencies of a traditional profession or career, this book asserts a more balanced view—one that embraces the significance of nurturing a solid and rigorous artistic practice coupled with a practical understanding of the professional skills and business acumen that will enable artists to navigate the world beyond the studio. Indeed, this book enthusiastically embraces and asserts the myriad opportunities and expanded field of options confronted by today's artists in the marketplace. And, far from proclaiming a single route or shortcut to "success," it aims to empower artists and arm them with the information and tools

they need to make their own choices, develop their own strategies, and discover the multiplicity of art circuits or constellations that make up the art "universe" so that they may map their own paths and thus build and sustain careers that will withstand and even thrive amidst the contemporary art field's often obsessive pursuit of the "new" and the fickle conditions of the commercial art market.

Notes

1. Joan Snitzer, interview by the author, October 13, 2010.

2. The Bronx Museum of the Arts came into existence as part of a series of serendipitous circumstances that temporarily linked its fate with one of the city's most venerable and powerful cultural organizations—the Metropolitan Museum of Art, which at the time was waging a campaign to expand into Central Park. Opposed by community leaders and residents at the outset, the plan was ultimately *approved* as part of complex negotiations that included the creation of several "satellite" museums, including the Bronx Museum. It was under these less than auspicious conditions that a fledgling museum in the South Bronx was born, initially housed at the rotunda of the Bronx Borough Courthouse on the corner of 161st Street and the Grand Concourse. A decade later the Museum moved to its current home, the former Young Israel of the Concourse Synagogue, four blocks north on the corner of 165th Street and the Grand Concourse. I am grateful to Luis Cancel for his elucidating insights into certain aspects of the Museum's early history. Luis Cancel, interview by the author, September 11, 2010.

3. Cancel, interview.

4. Ibid.

5. Ibid.

6. Ibid.

7. Snitzer, interview.

8. Ibid.

9. Ibid.

10. Ibid.

"That's nothing. Try herding artists."

Talking AIM

A Conversation with Holly Block and Jackie Battenfield

MARYSOL NIEVES

Although the intention of this book is not to document the history of the Artist in the Marketplace program but rather to capture its vital spirit and share its accumulative professional wisdom with a broader audience of artists and cultural producers, it's useful to explore aspects of the program's evolution over the course of the last three decades. To this end, I interviewed two individuals—Holly Block and Jackie Battenfield—whose years of service to AIM and guiding leadership represent (along with the contributions and vision of the program's early instigators) a stalwart commitment and understanding of the program's core values and its key constituents—emerging artists.

After a highly successful eighteen-year run as Director of the downtown alternative art space Art in General, in 2006 Holly Block (who had previously worked at the Museum as a curator from 1982 to 1988 in addition to facilitating the AIM Program and leading its seminars on numerous occasions) was appointed Executive Director of the Bronx Museum of the Arts. She has since led a number of significant initiatives that have greatly enhanced the community of artists served by AIM as well as its audiences. Likewise, Jackie Battenfield's dual experience as an artist and arts administrator coupled with her creative approach, boundless energy, and passionate support for artists made an indelible mark on the program during her remarkable tenure from 1993 to 2007 as AIM Program Facilitator. The conversation that follows focuses on aspects of the program's development while honing in on the creative and entrepreneurial leadership that has enabled it to remain current and always responsive to the changing needs of artists vis-à-vis the conditions of the "marketplace."

MARYSOL NIEVES: *Holly, you've had quite an extensive involvement with the AIM program as a curator and arts administrator over its thirty-year history. From your perspective, how would you describe the program's development during the last three decades?*

HOLLY BLOCK: The idea behind AIM was that you could take a group of artists, put them together, and they would create their own resources. They would empower themselves and organize themselves through exhibitions and open studios. This generated a sense of community that is still one of the program's greatest assets. Now we call it networking; back then it was called community organizing. And remember [that] in the late 1980s and early 1990s, artists were driven to organize their own exhibitions because so few artists were showing in galleries at the time.

Initially it was just one semester instead of two and we only selected eighteen artists a year. The catalogue was black and white and that format has really changed over the years. It's become much more substantial. I also think the distribution of the catalogue has increased over the years. That's made a huge impact, getting that material out, as well as sending it to commercial galleries. The AIM program has gone through many changes, but what was great in the early days, and is still true today, is that it evolved and changed depending on the type of artists who were participating. It could be much more responsive, unlike a school curriculum where things are structured for many years and it takes a long time to make changes.

NIEVES: *How would you say that the program continues to reinvent itself and remain relevant and vital to the emerging artists' community?*

BLOCK: I think the computer has probably been the biggest change for artists working today, and you see that in AIM as well because many artists no longer have workspaces. I remember one of my studio visits being at a coffee shop, sitting over a laptop discussing all these ideas and then based on this meeting two months later the project was realized. The other thing is that artists have expanded their technology vocabulary in a big way. A lot of them are very focused on social media and on event-based performance. All of that has [affected] the program. I think certain aspects of the seminars have become much more important, like the writing component. It's so clear that artists have to know how to write because they're constantly preparing grant applications. Many of us serve on panels all the time and review [the artists'] images and are always giving feedback on the quality of their images. Not to say you have to be a [professional] photographer, but you certainly need to photograph your work well enough so that it's properly documented.

I think the expansion of the Critic-in-Residence program is also a huge change for the AIM program. We've started inviting a critic to

cover a series of seminars about writing and also to write the catalogue essay for the show. We've also started working with an independent curator who makes the studio visits and participates in the selection process. I think it's nice to have new information and new people involved with the program on a regular basis. We have the flexibility to evolve the program based on what the artists are looking for. We start the program each year by asking the artists, "What are some of the things that you're really interested in hearing?" So, I think it changes based on the group of artists and their needs. You never pick the same group. They're never at the same level in terms of experience and access to resources.

NIEVES: *It's great that the artists have an opportunity to develop relationships over time with some of the arts professionals, such as the critic and curator. In the past that access was much more limited.*

BLOCK: I think the real idea was to make it more like a workshop. And, sometimes workshops are multiple sessions because some material is much more involved and needs several sessions. I think the networking or the social component has been redefined. A lot of the exploration that Jackie provided for the program, where [the artists] exchanged studio visits with each other and had assignments, that's been expanded on over the years.

NIEVES: *Well, that's probably a great segue to bring Jackie into the conversation. Jackie served as Program Facilitator throughout much of the 1990s and 2000s, and I really think she brought a unique perspective to the program. Jackie, how did you first get involved with AIM? And, what was your role as Program Facilitator?*

JACKIE BATTENFIELD: It was very exciting to be Program Facilitator during the 1990s because so much changed in the art world during that decade. I had just left the Rotunda Gallery, to take the insights I had learned about the art world and apply them to managing my own career as an artist. I was a full-time artist living off my studio practice. I had all the same questions as the AIM artists. I was doing all the things that they were doing. I'd say, "I'm in the trenches *with* you. So let's climb out, together." That's the perspective I brought to the program. And as Holly pointed out, the 1990s was a time when there were very few resources for artists. There were lots of spaces to do your art and there was a fabulous community of people around you. But there wasn't any place to show it. Alternative spaces were just being developed. Certainly the commercial galleries weren't that

involved with emerging artists. So it was an exciting time to be here. It's so different from today. And I think it's really interesting that Holly addressed technology. Nowadays, there are lots of opportunities to exhibit your work, but it's hard to find a space to make it. So the 1990s was a transition from that.

Every year I started organizing the seminars by asking myself, "What's out there? What do artists need to know about? And how are things being done these days?" I would tell the artists, "What your teachers told you may be the art world of ten or fifteen years ago. You have to be aware of how things are done today if you want to participate in it." The other thing I noticed was that the AIM artists needed opportunities to talk with each other and not just have one seminar presenter after another. So I instituted homework assignments and sessions that dealt with the issues and questions the artists had about organizing a package of information of their work, writing about their work, conducting studio visits, and putting together grant applications. I found it very important to get the artists to start interacting with each other in a meaningful way. My assignments were based on how I learned to do these things. It was through my curatorial experience running a nonprofit gallery that I learned what worked in an artist statement, how to organize a portfolio, conduct a studio visit, or write a grant proposal. I wanted the AIM artists to get this same kind of experience. How does a curatorial perspective change a studio visit? For example, one of the assignments was they had to do studio visits with five artists in the program who followed them alphabetically on the list and write up a proposal for a two-person exhibition. Of course, they could also visit other AIM artists and I actually did have *some* who diligently visited everybody in the program. But from this one exercise, they began to understand how you think you know an artist's work from seeing it as an image, but experiencing it in the studio is so different. They also had to choose two of the artists for an "exhibition" and describe why the work fits together. They also watched how other artists did or didn't organize their work for a studio visit and they learned from that.

NIEVES: *That's interesting because I recall that during that time several AIM artists began organizing exhibitions with not just their fellow artists from the program but with others as well. So I think to some extent your assignments were the seed that led to those projects. And also the message that as an artist you don't have to wait to be invited to participate in an exhibition; you can curate your own projects and create your own opportunities.*

BATTENFIELD: Actually, there were several exhibitions that did take place during that time. One of them was "Take This Job and Shove It"—an exhibition at the downtown space HERE where they exhibited their artwork next to an example of what they did as a day job. It was a great show. These exercises also showed them how to be helpful to one another. For example, when you're in an organization you never send out a grant proposal or something written without having another pair of eyes look at it. A colleague will correct your mistakes and tell you if something doesn't quite describe what you thought it did. One of the assignments was to respond to a "hypothetical" opportunity—a commercial gallery opening a new space that was looking for artists. They had been recommended by a friend to send their materials to this space. What would they put into an envelope and mail out in response? Each of the artists had to mail their package to another AIM artist. I then gave the artist recipient a list of questions they had to answer about the package they received from their fellow artist so they could focus their critique. And then they would bring everything to the AIM session and we would talk about what worked or didn't in the packages. What they quickly realized was how helpful feedback from another artist could be. The other thing I instituted was "News You Can Use." That was how we opened up every AIM session . . . they had to bring in tips: What are the shows that they should be looking at? What opportunities did they hear about? What deadlines were approaching? So they had to become responsible for sharing information with the group.

NIEVES: *You spoke previously about the art world in the 1990s, and I think one of the legacies of that decade aside from the rise of the non-profit art spaces and the expansion of the art market was the development of a number of programs (including graduate-level courses) designed to make information such as that provided by AIM accessible to more artists. So, I was wondering if you might speak about the AIM program in the context of other artists' career development programs.*

BATTENFIELD: I think the thing that's really crucial about the AIM program is that other organizations have copied and utilized the format in their own programming. And, I'm glad they have because it's been a successful program. But first I'd like to address graduate school because I teach a Professional Practices class in the MFA program at Columbia University, and a student's experience of this information is different from [that of an AIM participant]. When you're in school, students have regular studio visits from professors, well-known artists,

critics, and curators. There is a community of other graduate students who may work part-time, but they're not working full-time jobs. So you have easy accessibility. And you assume that's the way it's going to be forever. What is different with the AIM artists is they know it's pretty lonely to have a studio practice. There may be twenty-four other studios in your building, but everyone's working different jobs and nobody's there at the same time. And what the AIM artists listen to and what they respond to about the AIM program seminars is based on the fact that they are out trying to get support for their work and have to figure things out on their own. Also, AIM includes a wide range of artists [at different] ages from those who have been out of school for a decade or more to those with a recently minted BFA or MFA. There are also artists who were in another profession, did not go through art school, and are primarily self-taught.

Very few programs have the resources of New York City to draw upon. AIM has always been such a competitive program that the Bronx Museum has the luxury of a rich [pool] of artists to work with. Many organizations offer a professional development workshop or seminar, but they are not based on a curriculum. AIM is based on a curriculum so that one subject logically follows another. When professional development is a series of workshops and participants are not required to attend all of the sessions, the information acquired is hit or miss. And I think that's really significant and perhaps the one thing that makes AIM a little bit like a graduate program—the fact that there is certain continuity week after week in the way the program is structured. I certainly thought about that very carefully every time I put together the twelve weeks of seminars.

NIEVES: *Jackie points out, and rightly so, that one of the best resources the program has is its access to the New York City art world. However, I think the information that is disseminated through the AIM seminars is relevant outside of this local context, which is why I think one of the most exciting developments in the program's recent history has been expanding its reach to serve a wider population of artists. Holly, can you tell us about the International Artist-in-Residency program?*

BLOCK: I felt very strongly that since our immediate population in the Bronx is from all over the world—we have the largest population of recent immigrants in New York City living right here in the Bronx— why not have a first-hand approach? So for the last two years we've been able to select eight artists from all over the world to come here.

The two most recent participants are from Senegal. We've hosted artists from Venezuela, Brazil, South Africa, and Egypt. And they've been here for two months at a time, usually two artists at a time. They live in the neighborhood and we provide studio spaces where they're able to make new work. But the most important aspect was to design this program so they could participate in the AIM seminars. This brings them into direct contact with an amazing group of fellow artists, plus they're plugged in to the weekly seminars. They're able to share information about their own countries and cities. For example, the artist from Egypt was one of the founders of the Center for Contemporary Art in Alexandria. So really interesting international programs and the AIM artists are able to benefit from hearing about those experiences and the types of residencies other artists have participated in and sharing that exchange.

NIEVES: *What's the selection process for the artists? Is it similar to the AIM selection process?*

BLOCK: We follow the same format, but we've decided to do a nomination process and identify individuals who've worked in those particular regions or cities, or who have done cultural exchange programs and have traveled to those countries extensively. What's great for me is that some of these places I've visited before, and it's great to go to a place like Dakar and work at the Bronx Museum where we have this huge West African community from Senegal, Ivory Coast, and Ghana. And to visit Dakar and see great work especially since so much of it never comes here to New York even though we have this international community. So there's enormous potential to make an impact. And, also for artists who really have not had the opportunity to be in New York. It introduces them to New York, to the art world, and to a much broader public. Plus several of them have already written to me about how they've incorporated aspects of AIM into hosting seminars and workshops in their own countries.

NIEVES: *That's so amazing—it really demonstrates the incredible relevance of AIM across different cultures and communities. I know Jackie is frequently invited to lecture throughout the United States about career management issues for artists, and I would like her to talk about some of the frequent questions, concerns, or misconceptions that she hears from artists.*

BATTENFIELD: They just want information and they want it from a trusted source. One can find information on the Internet, but you

don't know if it's a valid source. I find that as a practicing artist, other artists see me as a more trusted source of information. One of the most common questions I get is, "How do I get a New York gallery?" I think that's sad because that just shows the biggest misconception that artists have—they think there's one art world and it's all happening out of their reach. I try to emphasize that there are many layers, many ways that one [may] participate within the art world and I like to think of it more as an arts community. So, the first question shouldn't be "How do I get a gallery" but "What are the best opportunities for the work that I want to do and how do I want to participate in this art community?" The other question I get, which kind of follows the "how to get the gallery" question, is "How can I promote my work without seeming too pushy?" I remind them that it is part of their job to promote their work and there are ways to go about it with [one's] integrity intact. It's funny how artists worry about being too pushy. Generally the people who are asking me if they're too pushy are the people who aren't pushy enough.

So, I really try to demystify the idea of this monolithic art world and have them think more about how to participate in the business of art. If you want a career within the art world, well, you have to learn something about the art world and not just work in your studio. Everything I've learned is from my experiences, which have given me insight that I wouldn't have had otherwise. If you want to be part of this world, you gotta know something besides how to make the art. Artists need to explore all the avenues, from those things they can do for themselves—having an open studio, organizing an exhibition, collaborating with other artists, to putting together a collective as well as looking at all the nonprofits in their community. Today's art world is huge. There are all sorts of ways that one's work can be in front of an audience. That's another thing that artists are often mystified about: "Who is my audience?" They don't really think about "Who would be the person most receptive to my work and why?" The goal is to make the kind of art you want to make and get your work into the most appropriate venue for it. Not every place is right for you.

BLOCK: And it's usually not one place. . . .

BATTENFIELD: It's never one place. Many artists are looking for this one person out there who is going to take care of them and their work forever. And I say, "You need to take care of yourself and you need to learn how to become a good partner with whatever venue you are working with." The AIM artists are in partnership with the Bronx

Museum, first by participating in the seminars [and] then with the exhibition. When you're working with an exhibition curator or with your dealer, the two of you may have different points of view. You may have different goals, but you're working in partnership. Some partnerships last for one exhibition or one studio visit, and others can last for many years. So I encourage [the artists] to think about proactive ways they can participate within the art world instead of seeing it as an "us versus them" proposition.

NIEVES: *We've talked at length about the AIM program, and, of course, the program was designed for emerging artists, but we haven't really discussed what constitutes an "emerging" artist. And with a program that's lasted thirty years and managed to stay relevant to artists, how has that very concept evolved during this period? How has the Museum's definition of an "emerging artist" changed over the years?*

BLOCK: I think we had these very steadfast rules about what an emerging artist had to be in order to be in this program. And I think over the last several years we've taken the scissors to them. I mean, I no longer feel [that] one of the guidelines should be that you can't be represented by a gallery as if being represented by a gallery means that you have a piece of paper, a contract, when the reality is so few artists even have that. When we started this program, we were the mediator between the commercial gallery world, the museum world, and the artists' space world. So basically a program like this would introduce [participants] to artists' spaces. They would show at nonprofit galleries. From the nonprofit galleries they would get selected or hand-picked into commercial galleries and then museums. So, one of the biggest changes in thirty years is that people are showing everywhere, all the time, simultaneously. I think that's probably one of the reasons why "emerging" is much more open-ended. In the early days I think it was age-driven because for many people who didn't go to graduate school it was sort of an in-between before the gallery system. I think you can be emerging, just as we know, up until the day you die.

BATTENFIELD: Actually, I do think there is a definition for "emerging," and I don't know that it has anything to do with gallery representation. I define "emerging" as [artists who have] not really ventured out into the art world very much. They haven't had multiple experiences with curators, commercial galleries, nonprofits, or public art. I think of it as the first decade of building a practice, seeking an audience, looking to see where their work fits into the multiple layers of the art

world. And that can happen at any time. If you're not out there seeking an audience for your work, then you can be emerging for the rest of your life.

BLOCK: Also, there might be just one aspect of the art world that you know in depth, but you really don't know how to cross over to other areas.

BATTENFIELD: Right. I see that all the time, artists who have had long exhibition histories and suddenly their practice has shifted media, morphed into performance, or their work has become project-based or moved from project-based into painting and sculpture. Suddenly they've got to reinvent themselves and look for new avenues of support. But that's what's so wonderful about today's art world—it's multilayered, it's multidimensional. If you have an Internet connection, your work can be seen by anyone. There's no longer a stranglehold by one faction of the arts community. Curators don't have it. Commercial gallerists don't have it. Nobody has it. It's an open field. And that's very exciting, but it's also much more puzzling for artists to navigate their own path through what seems like a big minefield. I encourage artists to turn this into an opportunity. For example, staying connected with their peers because some of them may end up changing hats, such as when they discover they are better suited [to] running a gallery than making art. Collectors become curators. Curators become directors. People move from nonprofit organizations to galleries and back again. No one has a static role anymore. And that's kind of exciting. So, holding on to the people you know, building really good relationships within the art world, which doesn't mean that you need a zillion of them, but you need a few good ones.

NIEVES: *It's interesting because I think in this current economy and the impact it's had on the commercial and nonprofit art sectors, when you're able to look at your career as the possibility of wearing these multiple hats you can embrace this moment as offering a wider field of opportunities.*

BATTENFIELD: The fact is that all artists' careers, even [those of] well-known artists . . . it's a rollercoaster! There are ups and downs.

BLOCK: Well, I say ebb and flow . . .

BATTENFIELD: You can say ebb and flow, but I'm saying it's a rollercoaster, man! And this is the biggest Cyclone, rollercoaster . . . there

can be real downs and really big highs. How do you manage the in-betweens . . . multiple partnerships. Having good relationships with people that really support what you're doing gives you a better platform from which to have a lifelong career and not one for three to five years.

NIEVES: *Holly, could you address some recent changes the Museum has implemented with regard to the AIM exhibition? The annual AIM exhibition has really become quite anticipated within the contemporary arts community, so it would be good to learn more about the Museum's recent decision to shift from an annual to a biennial exhibition series and what that means for the program and the artists you serve.*

BLOCK: I think these changes are the result of thinking about how we can really make a difference for our audience. The biennial concept came about from when we used to do the "Bronx Show" every year or so, where we collaborated with other local spaces to highlight Bronx artists. But also, it's great to see two years' worth of artists. We wanted to share these artists with other art spaces in the Bronx so that people would travel to other neighborhoods besides the [Museum's]. In the early days, I was the curator of the Museum's satellite gallery program. We used to have satellite galleries in different parts of the Bronx and it would really encourage people to visit different neighborhoods. And I think that was our intention so that the AIM artists [would] have the opportunity to exhibit in other locations, both traditional art locations and non–art locations. This year [2011], our partner is Wave Hill. The idea is to provide the artists with more space so we can better highlight their work. Also, to expose these artists to other spaces, to a broader public, and to increase audiences and get more people involved with the AIM program.

BATTENFIELD: What you're acknowledging is what we've been saying all along. The art world is a very multifaceted place, and artists aren't just making their work strictly for within museum walls. And what's exciting is how much more artists are working within varied communities. They want their work to have an impact beyond the white box.

*"My work is an ongoing conceptual
exploration of notions of cuteness."*

THE ARTIST

"So my proposal is this: I try to bomb the museum, you try
to stop me, and I go down in art history as the visionary
artist and you as the retrograde curators."

Three Decades, Three Artists

Rina Banerjee, Kate Gilmore, and Whitfield Lovell

ROCÍO ARANDA-ALVARADO

This discussion about the development of a career in art features three artists who took part in the AIM program during three different decades. Whitfield Lovell graduated from the program in 1984. Rina Banerjee is from the class of 1996. And, most recently, Kate Gilmore participated in 2003. The works of all three artists are related in the ways they approach connections between objects, spaces, memory, and meaning. Individually, they represent the breadth of methodologies, aesthetic persuasions, media, and interests of the artists who participate in the Bronx Museum of the Arts' AIM program.

What is immediately apparent from this interview is that no path is the same, though there may be similar experiences. Materials often reveal new paths or can be the source of new inspirations, as can spaces where the work will be displayed. All of the artists discuss a variety of issues related to careers, school, and forming significant relationships with peers and others. Lack of diversity and gender imparities are problems still encountered in the art world. These are all addressed in the thoughtful responses of the three participants recorded here. These discussions took place in October 2010.

ROCÍO ARANDA-ALVARADO: *First talk a little about the development of your career, your early life as an artist through to the present.*

KATE GILMORE: I was not born with a pencil in my hand; I was not one of those kids who doodled all day in class; I didn't know I was an artist until later in life.

When I left home and went to college, that's when things became clear. Like my sister, I always thought I would be a writer since this was the thing that I did the most and was pretty good at. As I started taking classes in college, I began to realize that, while I loved to read, I didn't love to write. It wasn't a natural way for me to express myself. After some minor [setbacks] I discovered art. I started working pretty

traditionally—clay, wood, plaster (still materials I am drawn to and use often in my work)—and realized that I was an artist. It was the best way for me to express myself and the only thing I did that made me somewhat content. I felt that, for the first time in my life, I could communicate the way that I wanted to—to express my ideas fully.

RINA BANERJEE: My work, after [I attended] graduate school in painting at Yale (1995), shifted from abstract painting to sculpture and it did so by way of my engagement of materials, textiles, objects as signifiers. My work was very much aware of the tactile in its entry into abstract art, gesture, symbols, and language. It was easy to be drawn by the historical location of the objects I used, as they revealed themselves tightly hinged on time, culture, and geographical locations. The aesthetic leaning of a particular style of furniture has more to say than we sometimes acknowledge. There is also a beauty of contradiction that plays on this: how class and culture evolve, part ways, mix and get mixed up. I wanted work with a range of scale that really spoke to our body. Figurative sculpture, architectural sculpture, animal and vegetable, plastic, natural, etc. This really was driven by site-specific work which was possible outside the white cube. The location and audience of an exhibition often directed the sculpture I made at different times.

WHITFIELD LOVELL: I grew up in the Bronx, where I began studying art seriously at age thirteen. My art teacher in junior high school, Margaret Nussbaum, was very devoted and she spent her lunch hours helping me to develop a portfolio for the specialized art high schools. I was accepted at the La Guardia High School of Music and Art. During high school, I also attended the Whitney Museum Art Resources Center, the New York State Summer School for the Arts, the Cooper Union Saturday Program, and the Metropolitan Museum of Art High School Program.

At the Metropolitan, I met Lowery Sims, who is currently the chief curator at the Museum of Arts and Design. She introduced me to Randy Williams, a teacher in the high school programs. They both became mentors and role models, at times providing advice that would help make the path ahead seem a bit less daunting.

ARANDA-ALVARADO: *What role did art school play (or not) in your career?*

GILMORE: Once I had decided to become an artist, it was full steam ahead. I knew what I wanted to do and I just had to figure out a way

to get there. I took a couple of years off to really work and figure out materials, discover my voice, what I wanted to say, and then I applied to graduate school. I went to [the School of Visual Arts], which for me was a great experience. After having a liberal arts education at Bates College, I really needed to focus on just art-making: studio, studio, studio. Tons of people came by (most of whom tore me apart—thank goodness!) and I learned.

I came in doing sculpture and left doing a version of what I do now. I really figured a lot out in graduate school, thanks to a tough faculty and lots of work. After graduate school, I applied to everything—shows, residencies, grants, etc. My first show was at Exit Art, where they allowed me to make an absurdly large installation, video, and performance project that almost killed a couple of small children but, besides that, was an amazing experience. I showed at most every alternative art space in the city and then started showing in institutions and commercial galleries. Now, I am lucky enough to be able to show my work in many different places and create ambitious projects that I could never do on my own. I continue to grow and change, which, like my experience in college and graduate school, is scary, but essential.

BANERJEE: Art school was an environment that nurtured an intellectual grounding for the work where the art market was unabashedly commercial.

LOVELL: I found art school very difficult. I went to Maryland Institute and Parsons School of Design, and I graduated from Cooper Union. My difficulties stemmed from the fact there was so little diversity in art schools in the 1970s. Talking about art is subjective enough to begin with, but when no one around you, faculty or classmates, has ever been in the company of someone of your background, really awkward things can occur. You can easily feel like a Martian making art from outer space. Thankfully, there are many more minorities attending art schools nowadays.

I enjoyed being in the art world much more after graduation. In fact, I began making friends at gallery openings while I was still in college. I found there was so much more acceptance in the alternative gallery world than in the microcosm that art schools become.

ARANDA-ALVARADO: *What about the transition from art school to your professional practice?*

LOVELL: The transition from art school to professional practice was huge. There is no time more tumultuous in life than finishing college and

trying to establish yourself in the world. Finding food, shelter, employment, companionship, etc. are all such consuming preoccupations that most people have to put major studio productivity on hold. When I was graduating from Cooper Union, I went to visit Lowery Sims at the Met, and she informed me that now what I had to do was "Get a job and support yourself! If you don't, the art and everything else will suffer." I taught freelance for seven years until I got hired full time as a professor at the School of Visual Arts. I stayed at SVA for fifteen years until I felt I was able to survive on my art sales.

ARANDA-ALVARADO: *Were there particular successes or setbacks that marked your path as an artist? How did these affect you or your work?*

GILMORE: As I mentioned, my first show was with Exit Art. They picked me for this exhibition called "The Reconstruction Biennial" that was pretty perfect for my work. I had never shown anywhere and they took a huge chance with me since I didn't have that much work. Jeanette [Ingberman] from Exit Art always talks about how I had sent in a video that made her laugh so hard that she had to put me into the show. This was a very important experience for me. They gave me the opportunity to make something really ambitious and to try something new. Luckily, it ended up well and a large photo of the piece was published in *The New York Times* accompanying a review by Roberta Smith. This really gave me a ton of confidence and helped me to realize that I really could do this art thing. I continued to apply everywhere and eventually landed some exciting shows. I was in MoMA PS.1's "Greater New York 2005" and that opened a lot of possibilities for me as well. I am [an artist who] has really worked my way up through all the different artistic channels. I think, because of what I do, it was important for me to move through nonprofits, alternative art spaces, and institutions before I moved into commercial galleries. It allowed me to not have to think about money in relation to my work and to make sure that the work was expressing the ideas that I was interested in and communicating to a public—not solely informed by commercial interests.

BANERJEE: Well, there is almost no commercial interest in my work, really. The work is complicated to install at times and [the] content and its many intertwining references to cultural politics can make it a slow read.

LOVELL: Life has many lessons and challenges that can affect your work along the way. Hopefully, as you grow, you can learn from your experiences, and that wisdom will be reflected in your work. There were many rejection letters, and a good amount of acceptance letters as well. Early cash grants such as [from] the New York Foundation for the Arts and the New York State Council on the Arts provided a great deal of support. Being picked up by DC Moore Gallery provided enormous help in terms of visibility and increased income.

ARANDA-ALVARADO: *Were there key people (other artists, curators, critics, dealers, etc.) who helped nurture you and/or your practice? These relationships seem to be important in one's career development. Can you talk about forming these relationships?*

LOVELL: My art teachers and mentors were very important because they kept track of me during my college years and continued to encourage me in my early adult years.

Since I did not fit in at art school, it was important for me to feel a part of something. I began to attend openings at the Just Above Midtown Downtown Gallery, then on Franklin Street; the New Museum; the Studio Museum in Harlem; and Creative Time. I worked for some of these organizations as well. These involvements led to my developing quite a social network. Many of the people I met in those early times are still friends or acquaintances today.

GILMORE: In my "art life," I have been very lucky to have many people support me and to believe in my work. Teachers, curators, colleagues—these connections and relationships helped me to grow artistically and to learn the ins and outs of the art world in which we function. It is important to know that these relationships were formed by genuine experience. While these relationships, I'm sure, started in a very hierarchical structure (teacher–student, curator–artists, not known–well known), they have developed into real friendships. Everything is a two-way street—there is a giving and taking in every personal interaction.

BANERJEE: People who were very helpful to me include Jane Farver, from the MIT List Visual Art Center, formerly curator at the Queens Museum. She included my work in the "Out of India: Contemporary Art of the South Asian Diaspora" exhibition at the Queens Museum in 1997.

ARANDA-ALVARADO: *Were there specific key moments or events that helped with significant transitions or helped to solidify your career or lead to other opportunities?*

LOVELL: The most significant moments in my career happened when I left New York. Ironically, everyone says you have to live in New York to make it as an artist, but for me leaving to spend a year in Houston, Texas, brought opportunities that I would never have gotten at home in New York. In Houston, at Project Row Houses in 1995, and at the University of North Texas in Denton in 1999, I was able to explore and create full-scale installations incorporating site-specific wall drawings and found objects. Not only did these two venues allow me to expand my artistic voice, but they also led to my gaining national exposure.

GILMORE: My show with Exit Art opened a lot of possibilities for me. I was lucky enough to get some press for the exhibition, and some new opportunities came about. I also applied to nearly everything, and eventually the rejections turned to the occasional acceptance. I kept inviting people to my studio, showing wherever and whenever I could, and meeting lots and lots of people. The word "no" was not (and really still isn't) a part of my vocabulary—you do things until you can't. Eventually, people became aware of what I did, and the shows became more plentiful. As a part of the "Greater New York 2005" exhibition, I was allowed an even broader audience to see my work, and this opened up even more opportunities. I did residencies (AIM was part of this!), group exhibitions, screenings, whatever! I wanted to be a part of the conversation.

BANERJEE: A key moment for me was when Laura Steward, former director of SITE Santa Fe and former curator at Mass MoCA, really enabled me to move into large-scale sculpture by including my work at Mass MoCA in 2003.

ARANDA-ALVARADO: *What role did your family play in your identity as an artist or in the path of your career?*

GILMORE: I am very inspired by my family. They are a unique bunch. They all have strong personalities (to say the least) with a very "special" way of communicating and functioning in the world. Luckily, they have been very supportive of me, even when they didn't totally get what I was doing. I [was] brought up with the understanding that [people] can do whatever they want to in the world as long as they do

it 110 percent. I think I have taken this information both metaphori-
cally and literally. Working hard has clearly been a consistent concept
in my work!

BANERJEE: [As with] anybody else, the lack of visibility and support for
Indian artists makes it hard to accept my choices as legitimate.

LOVELL: My family was always very supportive of my being an artist. My
father is a self-taught photographer. He has an artistic streak that was
not nurtured except through his activities with his camera and in his
darkroom. So, he saw the artist in me before I even knew about it and,
apparently, he told everyone that he was going to send me to art
school even when I was still a small child.

My father's photography also influenced my work, in that I draw
from photographs. I started working from his photos in the 1980s,
working with family themes, and then eventually I began collecting
vintage photos of anonymous African-Americans that I work from
today.

ARANDA-ALVARADO: *Do you have any views on the art market that you
would like to share?*

GILMORE: The art market is an afterthought. Money is good! Nothing
wrong with it. That said, it is important that artists be artists because
they are artists. The "market" is one thing, art is another. If they can
come together for you, God bless [you]!

BANERJEE: I think it's really important to explore and take risks early
and never let that go or you may find yourself dissatisfied and taken
for granted.

LOVELL: The market is a very fickle and trendy machine. One should
never gauge [one's] artistic merit based on success in the art market.
It is a luxury to be able to live on your art sales, because that will allow
you to work full time on your art without having to take teaching jobs,
or some other form of employment. But art sales don't always indicate
that the work is particularly strong, or that it will have a lasting place
in the world. No one knows why a certain thing might sell well at any
given time in history and not sell at all five years later. On the other
hand, what about the work that begins to sell fifty years after it was
made, or a hundred years later? You have to be willing to make your
art regardless of whether it sells or not. Art is a life, not a job. If you
are not committed enough to what you do to keep on through thick
and thin, then you might as well do something else.

ARANDA-ALVARADO: *This idea of the possibility of dissatisfaction (relative to one's activity in the art market) is important, no?*

BANERJEE: It's a unique responsibility to speak to everyone and still have intimacy available in the work, to forge the commercial with the intellectual (a humanist project). I think about this more now after making work for exhibition for over twenty years. [I think about] what motivates me and keeps others engaged with my work now. The landscape does shift, but I find that satisfaction in the work is not a dull sensation that is ever-present; rather, it is more a pin prick that slowly reveals itself . . . builds to become an envelope of signals that hold you, embrace you. There is so much noise out there, even in your own work, that you have to sustain critically, around that, the self-critical moment that twenty years ago was a pin. Now it is music that was once noisy play.

ARANDA-ALVARADO: *Finally, do you have advice for younger or emerging artists?*

GILMORE: Make good work! Make lots of it. Don't get wrapped up in the surface stuff because that will eventually tear you down. It is important to be strong, have a full voice, and be confident in what you do. That said, it is essential that you be humble. You may be on top today, but tomorrow could be a different story. You want to have a community that supports you and that you support as well. It is always a two-way street. And . . . work very, very, very hard!

ARANDA-ALVARADO: *What, for you, is the "surface stuff"?*

GILMORE: I think the "surface stuff" can be very daunting. When I say "surface," I think I mean the pomp and circumstance that can exist in the art world (and that probably exists in every world at different levels). It is important to be level-headed and to know that you are doing what you are doing because of art. I think when there is this understanding, you can actually have some fun with the "pomp and circumstance" and realize it is not what necessarily defines an entire community.

BANERJEE: Yes. Be idealistic. It's a dangerous but generous path. Conservatism is the new boogey man.

LOVELL: My best advice for younger/emerging artists is to take your time and focus on the strength of the work. Many young artists get on the fast track too early, meaning they want a shortcut to success and they

might not take the time to step back and figure out what the work needs in order to be solid and grow. If one achieves any degree of commercial success too early, [this] can alter the natural evolution of the work.

I also recommend that, as you network with other artists and arts professionals, be sure to develop relationships with people you can really talk to about the work. You have to have people in your life whose opinions you trust and respect. Conversations about what is going on in the art world, or who is getting what, are fine, but you need to bond with some colleagues who will challenge you to develop artistically.

Engaging in meaningful conversations about art, having the courage to make even difficult works, maintaining a level of visual and intellectual stimulation—these are all among the most important characteristics of a career that is fulfilling. In addition, a serious commitment to the work is significant—not only the time to make the work but also applying as broadly as possible to as many opportunities as are available to make and show works of art. And this should be constant, in spite of rejections.

A glimmer of hope is represented through small and alternative non-profit spaces that often have allowed artists their first opportunities to create large-scale work. Continually applying to programs offered by these kinds of smaller spaces is essential as it often provides a unique opportunity to create and show new work. I would add that looking for these kinds of spaces and opportunities outside of New York City is also very fruitful and should be pursued by all artists interested in developing a strong career.

With their words, these artists offer seeds of wisdom to artists at various stages of their careers, perhaps the most significant being the admonition to continue to make work, even in the face of challenges of time, space, and money.

"We just feel more comfortable working with dead artists."

Small Worlds

An Interview with Polly Apfelbaum and Amy Cutler

LYDIA YEE

Polly Apfelbaum and Amy Cutler began working in New York at very different times—the early 1980s and the late 1990s, respectively. Whereas Apfelbaum's experience in the freewheeling East Village was one of showing in different galleries and "growing up in public," Cutler made her mark in a group exhibition at the Drawing Center and joined Leslie Tonkonow just a couple of years after graduating from Cooper Union. Although their work emerges from different traditions—Apfelbaum blends elements of painting and sculpture, while Cutler's practice is rooted in drawing—they share a number of mutual concerns: an interest in narrative, "feminine" subjects, and an evocative use of color.

Apfelbaum and Cutler make their work by hand, and printmaking has provided both with an escape from the isolation of the studio as well as an opportunity to expand their practice through collaboration with master printers. Each has been exhibiting in museums and galleries in Europe in recent years, and showing abroad affords them the freedom to experiment without the pressure and scrutiny of the hometown audience.

LYDIA YEE: *I would like to start by asking you both what sort of work you were doing when you first started garnering attention and at what point where you at in your career.*

POLLY APFELBAUM: That is a bit complicated to answer. I moved to New York City in 1978. My first one-person show was in 1986 in the East Village. I was showing fabricated wood pieces; later I added found objects. The work that is probably recognizable with what I am doing today—using the dyed fabric—was first shown in SoHo in 1992 in an exhibition called "the blot on my bonnet" at the Amy Lipton Gallery.

YEE: *Did you first have opportunities to exhibit your work in East Village galleries?*

APFELBAUM: The first show of the wood work was in a small gallery on 10th Street called Paulo Salvador, run by a lovely Brazilian man; he later died of AIDS. He mostly showed sculpture. Then I moved to Loughelton Gallery, which was an interesting gallery, also in the East Village, run by two women who had both gone to CalArts. At the time I didn't even know what CalArts was and they were showing mostly people who had gone to CalArts, Sue Williams, Kate Ericson, and Mel Ziegler. They had John Baldessari curate a show there that included Meg Cranston and John Miller. It was a little different from some of the other East Village galleries. I was learning and showing at the same time, growing up in public. My work at the time sometimes looked like a one-person group show. I was mixing things up, trying a lot of different things out. But the East Village was open to that; and Loughelton in particular, because of the CalArts connection, was very idea-driven. I had spent a year in Spain in 1985 and was also influenced by a large exhibition of Arte Povera I had seen in Madrid.

YEE: *Maybe you could show a heterogeneous group of works together because the East Village was a kind of experimental cauldron anyway.*

APFELBAUM: Totally. But you know, I started showing in the East Village at the same time I was in group shows at White Columns and at Artists Space. Valerie Smith included my work in one of the "Selections" shows there, which was very important for me. It was great to have one foot in the so-called commercial world and also to be showing at nonprofit alternative spaces. Before I went to Spain in 1984, I really didn't have work to show or many opportunities, but when I came back in 1985, the East Village was really active. You have to remember too that many of the early East Village galleries were run by artists. They really opened things up.

YEE: *Did you make a distinction in what you would show in a commercial gallery versus an alternative space?*

APFELBAUM: No, I didn't. There was not so much pressure to sell, or to make saleable work in those days. And at that point, so many different things were going on in my work; I could just put it out there and suffer the consequences. That's what I mean by growing up in public, taking risks. I think the work kept changing a lot because of the dialogue around the work with critics and other artists—there was a strong sense of community. It was an exciting time for me. When I moved to New York right out of art school, it took time to build a

community. That's one of the reasons I did the Artist in the Marketplace program. I remember Stanley Whitney, a teacher of mine, saying that after school your support structure disappears, especially if you didn't go to school in New York. I was looking for programs where I could meet other artists.

YEE: *Amy, you started working about fifteen years after Polly got her start. Did you find that your experience had some parallels with hers, or was it a completely different situation in the 1990s?*

AMY CUTLER: After I graduated from Cooper Union in 1997 I moved to Williamsburg, Brooklyn. My first show was at a small gallery called Eyewash. I sent my slides to every nonprofit space that had a registry. In 1999 the Drawing Center included my work in a Selections show. This was really exciting because the Drawing Center had always been one of my favorite exhibition spaces.

YEE: *What work did you have in the Drawing Center show? Was it your first body of work out of school, or had you been working for a while?*

CUTLER: It was a combination of the two. I had been working with gouache on paper since 1995, so the show included some older paintings along with some made specifically for the show. They were all fairly small in scale . . . I'd say around 20 × 14 inches.

YEE: *Figurative work?*

CUTLER: Yes, figurative work. It was a group of paintings in which I had made the conscious decision to remove all the information from the background of the painting. The white of the paper became a major part of the composition.

YEE: *I think there's some commonality in your practice in addition to some of the things like narrative and color. Both of you have quite a cohesive body of work. Is that something that's important for you both as artists? Did it develop naturally, and have you ever tried to break away and do something radically different?*

APFELBAUM: In the early work I was trying different things and mixing it up—found objects, fabricated work, and then the dyed fabric work. At a certain point I really did want to clean house and tighten ship, and the fabric work was more consistent from a material point of view. But I really hate the idea of consistency or style and I was more interested in consistency of thought rather than material consistency.

I wanted to clarify my thoughts and materials. I like things very simple, and so sometimes I have to get things clear for myself, so that it makes sense to me.

One of the strange places I landed was on the floor and it's a fascinating place to be. I really thought it's a hard place for people to focus on, so I tried to focus on that space. I still like that space.

CUTLER: I work very slowly, producing only about ten to twelve paintings a year. In some ways consistency is just born out of necessity. The ideas come and they are not complete until I've fleshed them out with all the minute details. I wish there was another way around it sometimes. I envy those who are spontaneous and fast.

YEE: *And, Amy, what do you think of the concept of the signature style that Polly mentioned? Is this something you try to work against or do you not have a problem with it?*

CUTLER: I'm at that point where people do expect certain things from me. It can be very frustrating at times, but ultimately you have to go with your gut. Experimentation and change are the only way [one] can grow as an artist. I always want to try new things. Sometimes my attempts are underwhelming . . . something as simple as changing the type of paper I use is a big step.

YEE: *What do you do when a dealer or curator asks you for more of this?*

CUTLER: I had a show at the Walker Art Center in 2002. It was my first museum show. When the curator came to my studio to discuss what would be included in the show, he specifically asked for more large works on paper. At the time I was also painting with flash and casein on wood panels. It didn't seem like an absurd demand. I understood and agreed that [including more large works on paper] would make a more cohesive show. In the end it really was a wise decision. I've experienced dealers and curators who pick and choose what they feel is more representative of my work. I understand their reasoning, but I don't always agree with their opinions.

YEE: *But that was quite early on in your career, and maybe now you would think twice about going along with what a curator or dealer wants.*

CUTLER: Sure, I understand their motives and have a bit more experience. I think I've learned a lot along the way.

YEE: *When each of you first joined a gallery, how developed do you think your work was, and did you feel that joining a gallery inhibited you or gave you more opportunities to grow and develop?*

APFELBAUM: I was lucky because most of the dealers I have worked with have given me a lot of space. I can only work that way. Especially early on, the dealers never knew what I was going to show. The best dealers trust their artists. And in the East Village days, things were pretty loose.

CUTLER: My work has been fairly consistent over the past ten years. Joining a gallery seems like a very practical decision. It has definitely provided me with more exposure, which in turn has led to more opportunities. I'm not a very business-minded person; I'd rather be in the studio making the work. I really don't enjoy certain social aspects of the art world so I am happy to pass that on to someone else.

APFELBAUM: I have never had a contract with a gallery. It's a very strange world, the art world. I don't think there's anything else like it. I always say it's not "government regulated," but then would we want it to be?

CUTLER: Right, nothing moves forward without my approval. Nothing is set. It's always a negotiation. I've worked with the same gallery for years and things are always in flux. There are so many variables to consider. Right now I'm working toward a show in Sweden, which is something I am looking forward to. In New York I am known for a specific type of work. Stockholm seems like a good place to experiment. I feel like I will be able to challenge myself in a different way.

YEE: *In the current economic moment, it is quite difficult to sell work. Does this situation provide an opportunity to go ahead and experiment because who knows if your show is going to be a financial success?*

APFELBAUM: My work has always been a challenge to sell. It's big, it's on the floor, it moves around. . . . The recent work is even more difficult because it is situational—each piece is made for a specific site. So when it is acquired, it's almost always by museums. It's funny because a friend of mine said he was coming to town and said he hoped something from my show would be left for his collector's group. I said you don't have to worry, this work doesn't even have a price on it. He said In this day and age is there anything that you can't sell? And I said Well if there is I just made it.

YEE: *Is it a worrying time or an interesting time for you, Amy?*

CUTLER: I think this is a great time to play and revisit ideas that I couldn't entertain when the pressure to sell was in the air. I've started to work a bit more with printmaking. Right now I am working on some etchings. My approach this time is different from in the past. I am now learning to enjoy the process, which can be full of surprises. I'm also enjoying the collaborative aspect of working on a print. It also gets me out of my hermit-style studio and in touch with some very creative people.

APFELBAUM: It's really wonderful to work with other people sometimes. It gets you out of yourself when you are someone like me who works alone on the work. I've never had a support system of assistants; I just find that distracting.

On the other hand, printmaking is a collaborative art and I really love it. For about ten years now I have been working with Durham Press in Pennsylvania. They are incredible printers and we have a great working relationship. It's all very immediate and intuitive when we are working. We never thought the prints would be such a success. We mostly make monoprints—they are more like works on paper.

CUTLER: Printmaking has taught me a lot about letting go of control. Unexpected things happen in printmaking all the time. I am learning to embrace chance. It has certainly brought me out of my comfort zone. Printmaking has changed the way I work in the studio as well. In 2004, I made a ten-color lithograph, which meant ten separate plates. It felt like a never-ending coloring book because of all the color separations. But after working on that lithograph I never thought about color the same way again.

YEE: *What was a milestone in your career, and what do you take away from that kind of moment?*

APFELBAUM: My midcareer survey at the Institute of Contemporary Art in Philadelphia was a milestone. When you've been working for more than twenty years and have to do a show with only fourteen pieces, because four were very large, what story do you tell? It's like putting yourself on a diet. It was very difficult for me. I think the show was an installation about installation. And then it went to three places so I had to reinstall the show three different ways three different times. It was really hard work, mentally and physically. It took up a lot of space in my world. You have to revisit your life again and again and

that's over two to three years, because these shows travel. I sort of went into overdrive as I was worried I would not make new work again but it also pushed me to really examine my work and see what I had not done and what I wanted to do.

YEE: *After an experience like that you have to kind of build in a period where you don't accept more invitations or you're going to do only the things you really want to do.*

APFELBAUM: Well, then I pulled back. I really did. I wanted to take my time with the work and focus less on showing, more time to explore in the studio. It wasn't about the showing. It was more about me reconnecting to things. I feel very lucky that I could step back and then go forward. Like the signs in the subway, sometimes you have to go back to go forward—it was important to do the survey show, but not an easy thing.

YEE: *Amy, have you had any comparable experiences with a big project or something that made you reconsider the direction in your work?*

CUTLER: In 2006, I had a large solo exhibition at the Indianapolis Museum of Art. There were around sixty paintings and drawings in that show. It was really interesting to see six years of work in one exhibition. It felt like a big reunion. I never had that kind of experience before. I was able to stand back and actually see where all that time had gone. Each piece is so strongly linked to a certain point in time. That same year I was invited by the Museo Reina Sofía in Madrid to take part in a program called "Producciones." It was an invitation to have a solo show with the stipulation to create something site-specific and different from what I normally do. Basically, my framed gouache paintings were not welcomed. When I visited the site I was over-whelmed by the beautiful architecture. Enormous vaulted ceilings with amazing marble floors. This was not a New York–style white box. The building was steeped in history. Before it was a museum it was a hospital, the first hospital in Spain with a psychiatric ward. This was revolutionary at the time. Before that hospitals would just combine all their patients. There was so much to respond to. I knew at that moment I would have to make a sculpture. So the next year was dedicated to producing this sculpture installation called "Alterations."

YEE: *And you exhibited your sculpture at the Reina Sofía?*

CUTLER: Yes, in 2007 there was an exhibition at the Reina Sofía and then a smaller version in New York. It then traveled in a group exhibition to two museums in Denmark in 2009 and 2010.

YEE: *Did you paint the sculptures?*

CUTLER: Yes, I hand-painted 120 figures with gouache and applied a clear coat of acrylic over that. I had sculpted six prototypes in clay and then had molds made. The final figures were cast in Hydrocal. The scale of this project took over my painting studio and basically shut down my painting practice for a year.

YEE: *Do you think you might continue in this vein?*

CUTLER: I think there will be more three-dimensional work in my future.

YEE: *When you have these kinds of opportunities to exhibit outside the United States, do you find that your work is received differently in different contexts?*

APFELBAUM: It's always good to get out of your comfort zone, but sometimes you just can't really know or understand the context perfectly. You are there for a short period of time installing and then you leave. . . . Leaving things behind is sometimes a little strange, and there's a distance. But there is also a kind of freedom; you can try new things away from your home base and work with new contexts. Sometimes that distance is just what you need to see things in a different way. People don't know that much about you. The spaces a lot of times can really be more interesting. I think in New York it's more the white box. I have worked in amazing architectural settings in Europe and the UK. And even in New York, there are many different contexts.

YEE: *Is that also the case with you, Amy?*

CUTLER: Showing abroad has been very exciting. It's a very wonderful experience to be a guest artist in other countries. I think maybe sometimes I get so wrapped up in that part that I don't even realize I'm there to work. I am always interested in learning about other cultures. I especially like taking in the minutiae of everyday experiences. I understand Polly's point. I end up feeling a bit disjointed. I usually leave the day after the opening, which usually doesn't allow me to spend much time with the exhibition once it is installed. I think the feedback I have received has been sincere. Somehow when you are dealing with language barriers, people become more direct and their reactions seem very honest. This is very important to me. If I am able to communicate without verbal explanations then something is working.

APFELBAUM: I agree that showing in Europe is very exciting. Often in Europe they are much more willing to go the distance for art. I think in certain places in the United States people are really closed off to contemporary art in some of my more recent experiences. When I showed recently in the inaugural show in Carlow, Ireland, it was such a matter of pride. It took them ten years to get this new contemporary art center off the ground. I had also been in an inaugural show at Kiasma in Helsinki and something like 300,000 people went to the opening show, practically everybody in Finland. It was a matter of pride to have a national contemporary art center. Here, sometimes we seem like we're still in the culture wars. I had this crazy experience in Montana this year. Did I tell you about that?

YEE: *No.*

APFELBAUM: I did a show at the Yellowstone Art Museum in Billings, Montana, and one of the board of directors decided she didn't like the show so the director tried to close the show down and the curator was fired when he stood up for the work. I was excited about the show; it related to the landscape, to the West. They had brought me out there and then the shit hit the fan. I had already shown in a small town in Ireland, very similar work, and they were just so happy to have me, no questions asked, just made me feel comfortable. Then I had this ridiculous situation. This is abstract work and somebody in Montana who was paying the bills decided that this might not be art. It was that primitive. I'm trying to forget the situation.

YEE: *When you've had opportunities to exhibit outside the States, how have the curators been introduced to your work? Have they come to shows here or seen your work in other exhibitions or publications?*

APFELBAUM: I have galleries in London and Vienna, and they have been very good at setting things up. And [exhibiting outside of the United States] gives your work wider exposure. The Milton Keynes exhibition was from showing in London. I had a show at the Frith Street Gallery and the curator saw it. The show in Switzerland at the Helmhaus, I think the curator had known my work from Galerie Nächt St. Stephan in Vienna.

CUTLER: The curator from the Reina Sofía came across my work online. She was researching narrative art and then contacted my gallery. The Danish curator saw my show at the Reina Sofía. I think many foreign

galleries/curators visit the New York and Miami art fairs. I've had some invitations and inquiries related to having work at the fairs.

YEE: *I wonder if in your experiences outside the United States, where there's more public funding, if this also has been a factor. Polly, you compared the situation in Ireland versus Montana and I wonder if because it's a public institution funded by public money there's more of a civic pride rather than an attitude of "I'm an individual who put money into this institution so I can call the shots."*

APFELBAUM: Absolutely, I think for me it was really interesting because people complain about the government funding for the arts. The people in Billings had voted against giving their tax money to art institutions. People who are clueless about art are the ones who are often sitting on boards, who are writing the checks. I think it's a big problem.

CUTLER: So what happened with the show?

APFELBAUM: When I came back, I had an e-mail forwarded to me from the director saying we're closing the show early. I had even gotten a good review in the local paper. To make a long story short I made a few calls to some people involved in the Montana art world who have some power. They did not close the show, but they fired the curator.

YEE: *Well, maybe she got out of Montana.*

APFELBAUM: Well, it's a he. This is a role reversal.

YEE: *Oh, sorry, that's a gender assumption.*

APFELBAUM: You know what, it was a role reversal. Women usually love my work. This was a female donor, female director, male curator. So go figure. It's an interesting art world. A friend said, it's the power of abstraction to still shock people.

YEE: *Do you feel there's any kind of gender politics in the museum or art world that shapes a favorable or negative reception to your work? Is this ever an issue for you, Amy?*

CUTLER: Not to my knowledge. They either like my work or they don't. I always think there are more women who like my work, but it's not always the case.

YEE: *I guess there are more women curators, at least at certain levels in the art world. You often assume the director is a man and the curators are often women.*

APFELBAUM: Back to Montana. I think there was a misreading of the work. I think one of the issues they had with the work in the show is they thought there was no craft. They want to see the sweat.

YEE: *So they expected to come see a show where it's apparent that she's put hundreds of hours into it.*

APFELBAUM: Right—isn't there a quote about it taking twenty years to get there and a few minutes to execute? If you have an issue with work, it's an opportunity to open it up to discussion. Some people right now are really scared to have a dialogue. Art makes them nervous.

YEE: *Well, that's good. It should make them a little nervous.*

APFELBAUM: It was fine with me as long as they don't close a show down.

YEE: *Thank you both very much—that's all the questions I have. It turned out to be a nice coincidence that Amy visited your studio ten years ago when she was in the Artist in the Marketplace program.*

APFELBAUM: It was so nice to hear her memories about that studio visit when she first walked in. She remembered certain works that were in the studio and that I showed slides of Carnaval I had gotten in Brazil. Did you also know that she was at Skowehegan the same summer I was a faculty member there? Small world.

"I got to go—my painting is talking to me."

Art without Market

ANTON VIDOKLE

These days it's becoming more and more difficult to imagine the production of significant art without an art market. However, it is very important to keep in mind that much of important modern and contemporary art was produced without the artists' ever entering the marketplace, either because it was just not there—as in the former Soviet states, for example—or because artistic culture was militantly opposed to the art market, as was the case with the artist-run and alternative spaces movement.

While some people mistake e-flux for an enterprise or a business, it was started precisely in opposition to the kind of narrowness and professionalization that characterized an art world shaped by the art market created in New York in the late 1990s. It began with a project called "The Best Surprise Is No Surprise" at the Holiday Inn in Chinatown, self-organized with a group of friends, including Regine Basha and Christoph Gerozissis. We had absolutely no money for this venture, just an interest in inserting ourselves into the Holiday Inn culture . . . Without yet knowing the effects of e-mail, we sent one announcement around for the event, and 500 people showed up. Shortly thereafter I thought it would be useful to develop this mode of communication into a resource that others could use, and together with a group of artists friends started e-flux.

At the center of e-flux as a project is a concern with circulation and distribution. The dramatic image of the production of art is often embodied in such cinematic clichés as the agony and ecstasy of a genius creating in his studio, or the spectacle of consumption that instantly brings to mind lives of the rich and the powerful, auctions, fairs, high prices, deals, bargains, fortunes, crimes, and so forth. Most of the time these two parts of the classical economic equation displace and hide the third crucial element that brings art and its discourse in contact with people: circulation. While circulation is nearly invisible (in the way that street cleaning sometimes is), we can argue that the ethics and aesthetic of circulation

largely determine what is produced, how it is consumed, and who consumes it.

In this sense, most of the projects and activities enabled by e-flux have to do with thinking of different and, we hope, less unfair and alienated ways to circulate and distribute art and the ideas it generates. One of the peculiar things about e-flux is that after working on it for more than a decade, we (e-flux is currently developed jointly with artist Julieta Aranda and writer Brian Kuan Wood) still do not have a clear definition of what it is. It's not an art space, a publisher, or a Web site, because e-flux as an art project has many different dimensions and evolving interests: artistic, organizational, educational, critical, collective, and so forth.

This kind of an open, undefined quality is something very difficult to develop and maintain these days, both in art and other areas of life, because there is so much pressure in the market-driven economy to divide labor, to professionalize. As artists, curators, and writers we are more and more forced to market ourselves by developing a consistent product, a concise presentation, a statement that one can communicate in thirty seconds or less, and oftentimes this alone passes for professionalism. For emerging artists and curators there is an ever-increasing number of well-intentioned graduate programs that essentially indoctrinate them into becoming content providers for the art system and whose values and welfare are then completely defined by that system's supply and demand, while at the same time putting would-be artists in debt because of the astronomical tuition fees.

It seems to me that this division of labor is more or less what produces the market in the first place: If I know only how to paint and have no idea how to repair things, cook, mend clothes, and so forth, this specialization results in a lot of urgent needs for goods and services necessary just to keep myself alive—all of which I have to get elsewhere, and immediately a market is created through my own alienation. The more narrowly professionalized and specialized life becomes, the more dependent we become on the market, and the more naturalized the market becomes as the ultimate arbiter of values. I suspect that this may be one of the ways in which market system, as an institution, perpetuates itself.

In my opinion one viable way to resist this tendency in art is through developing a more sustainable economy. The original meaning of the word "economy" had to do with managing a household, as well as with a certain sense of thrift or conservation necessary for a long-term well-being. For me, the key notion here is long term: The field of art urgently needs an economy capable of creating conditions enabling one to reclaim

one's time from the demands of the market, from narrow professionalization and the kind of alienation it brings. I think it is possible to develop such an economy and share it with others, as we have tried to do with e-flux through focusing on redistribution. There are probably many other ways to do this: through collective approaches, through looking at other historical and social models, and so forth. What is of utmost importance is not to just take the current state of things for granted and assume that one can produce new or different culture while trying to fit into a market economy rooted in inequity and alienation.

*"As curator, my job is to let the artist design and install the
show and to let the work speak on its own."*

THE CURATOR

Climate Change

East Coast to West Coast Curators
Articulate the Evolving Curatorial Role

REGINE BASHA

As of late, the role of the curator has been a much-debated topic in contemporary art circles. Once a specialized field deriving from art historical studies or museum studies, the post-academic career of a curator mostly concerned the discreet caretaking of a collection, educating, writing on art, and the logistics of exhibition development. For the most part, much of this activity remained behind the scenes, though there have always been the few industry "stars," so to speak. The Latin root for "curator," *curare*, which means to heal, also brings to mind the public service responsibility the curator has to both the artist and to the audience. Are curators healers? If we were to take the definition seriously and in the extreme sense, we would enter a Beuysian realm where the cult of personality reigns and the production of meaning becomes a complex, staged effect. In the hands of "the healer," the viewer/listener/participant falls under the spell of art as a salve. But where is the artist in this picture? If the curator heals, then does the artist agitate? Who is ultimately in power, and what are the terms of negotiations? What are the criteria for collaboration? With the rise of the "independent curator" in the 1990s and the parallel emergence of "relational aesthetics" as the new site-specificity, the codes of collaboration, engagement with audience, directing, and producing became blurry between the artist and the curator. As we saw more and more artists curating shows, we also witnessed more and more curators operating as free agents in creatively designing exhibitions as concepts. Given that there have been both successful and disastrous examples of "the curator as artist," the debates on power, ethics, and representation of the artist's intention continue. Some may conclude that the role of the curator is not only elusive but untenable as such and in need of an overhaul.

More and more, curators (and directors who are also curators) today must finesse their highly slippery position as mediator between institution and artist, between collector and institution, between artist and the public and between institution and the public. When they are working on an

international level or even on a smaller, regional level, add to this list government officials, cultural diplomats, parks and recreations departments, the mayoral office, and so on. Because of this amalgam of relationships a curator must build, the job is often likened to that of a film producer.

But instead of being concerned with what are the roles of the curator (because clearly they are many), one should consider what the responsibility of the curator is to art. Whether in an institution or not, a curator may have a highly personal sense of responsibility to artists and to art that is often the singular and individual driving force behind all the work and effort.

The aim of the series of interviews that follows is to locate that sense of responsibility to art and track how it was shaped and where it might vary in each of the contributors. The seven participants were asked to respond to the same set of questions. The questions have to do mainly with how they entered the field of curating, where it has taken them, and what concerns about art and visions for the future they may be grappling with. Their candid and insightful commentary reveals how each has arrived at what he or she does from very different trajectories, generations, and backgrounds professionally and how each is engaged with specific practices.

Tairone Bastien is a graduate of Bard College's Center for Curatorial Studies. After graduation he worked as an Assistant Director and then Director of a small startup gallery in Manhattan that focused on emerging artists. Early on in his career, Bastien was drawn to performance, largely because, as he states, "there seemed to be so much of it taking place in studios and experimental art spaces and yet it was underrecognized and unsupported by galleries and major institutions." In 2005 he joined the curatorial team of Performa part-time, then full-time in 2006; he continues to work at Performa today with founder RoseLee Goldberg.

REGINE BASHA: *Tairone, what is your particular scope at Performa, and how does it frame your curatorial vision specifically?*

TAIRONE BASTIEN: My focus at Performa is, of course, on performance. As a curator I am deeply concerned with both the history and contemporary trajectories of the form. Before I came to Performa, however, I saw my job as a curator in more abstract terms, with regard to framing and supporting an artist's work. But now I find myself being able to help an artist in much more practical ways, whether that means helping an artist conceptualize and coordinate a film shoot or overseeing the build-out of a stage and set for a performance. I've enjoyed being able to work more closely with an artist and be involved in the process of creating the work.

BASHA: *So, from this perspective, and the closer relationship you have with creating the work, how would you define the primary role of a curator today?*

BASTIEN: Artists are constantly finding new ways to upset traditional standards by which art is made, shown, and disseminated. There seems to be more and more artists whose work does not operate or sit easily within a typical gallery or museum structure—whether it's Tino Seghal, who creates performances that cannot be transcribed or documented; or Dexter Sinister, who operates a bookstore and disseminates texts and other printed material. Considering that a growing number of artists are working in nontraditional ways, I would say that the role of the curator today is to engage with and respond to these and other new modes of working and generate opportunities for them to show their work. This means [that] curators now, more than ever, have to learn to operate outside the traditional gallery and museum frame.

BASHA: *True. In this expanded context, then, what is it that you most care about when presenting emerging art to the public?*

BASTIEN: With regard to performance, one of my main concerns is the scrutability of the performance. When artists first attempt or experiment with performance they often have a "just do it" attitude, presenting fresh work without necessarily thinking about how an audience might apprehend or interpret it. As performance proliferates and more and more of it is showing up in museums and galleries, artists need to think about performance in a much more critical way. My role as a curator is to think about and help guide the audience into the work. Sometimes that means selecting a location that will draw out certain intentions and references in the piece, and most times it means designing and writing a program that is loaded with information and hints to what is at stake in the work.

BASHA: *What kind of advice would you give to an artist who might be in the first stages of identifying her/his own particular goals and career path?*

BASTIEN: If you are just starting out, my advice would be to familiarize yourself with the large art eco-system, but identify and stay close to your peers and find like-minded individuals to insulate yourself and help nurture what it is you do. Get to know other artists, but also seek out writers, curators, and gallerists. Start a conversation about the work you admire, are troubled by, and think about, and form your own community. Also, give it time. The art world is ever-expanding

and finding new artists and ideas to apprehend and think about; eventually the higher-ups will take notice and or cycle around to what it is you and your friends are doing, but by that time you and your friends will be a self-sufficient machine and you won't necessarily need or desire the establishment's approval. Now that's a great place to be!

BASHA: *How do you think the current economic crisis might have changed the way we work as curators? Also, if you could change, improve, or revisit anything about the art world today (besides better funding), what would it be?*

BASTIEN: The market may be down, but rather than sit idle, a lot of artists and curators are generating their own opportunities, everything from forming loose associations and collectives (for example, Bruce High Quality Foundation University) to hosting exhibitions and performances in their apartments and studios (Kara Walker's 6 to 8 Months), to starting nonprofits of their own (Third Ward and Recess Space). The proliferation of alternative spaces and models of working is what most excites me about the art world today.

Although we are seeing more performance in museums and galleries compared to five years ago, there is, in general, still very little support for this kind of work compared to the funding, space, and institutional infrastructure in place for the plastic arts. Museums, with their emphasis on exhibitions, are still very much object-centric. But, as new scholarship emerges and museums begin to fill the gaps in their collections with performance and conceptual works of the 1960s and 1970s—all the way through until today—new scholarship emerges on the influence of performance on avant-garde movements throughout the twentieth century. I'm thrilled that the Tate Modern and MoMA have led the way by establishing performance departments that appear to be on par with the other curatorial departments, but, considering how rich, varied, and untapped this history is, there needs to be a more widespread effort involving more institutions both big and small.

Anne Ellegood joined the Hammer Museum in April 2009. Previously she was Curator of Contemporary Art at the Hirshhorn Museum and Sculpture Garden from 2005 to 2009 and worked as the New York–based curator for Peter Norton's collection from 2003 to 2005. From 1998 to 2003, she was Associate Curator at the New Museum of Contemporary Art.

REGINE BASHA: *What is your particular scope and how does it frame your curatorial vision specifically?*

ANNE ELLEGOOD: My focus is contemporary art, in all media by artists from around the globe. Through the Hammer's series of single gallery project-based exhibitions, I have the opportunity to work with a lot of artists from Los Angeles, which has an amazingly dynamic and large community of artists. Nonetheless, the Hammer Projects series is intended to be international in scope, and I try hard to make sure there is a good balance between local and international artists throughout the year. I am committed to bringing artists from other parts of the country and the world to the Hammer to, in many cases, exhibit their work in Los Angeles for the first time. I am also part of a curatorial team that will organize the Hammer's first Los Angeles Biennial. The exhibition is a collaboration with the nonprofit space LA><ART, and it will focus exclusively on artists based in Los Angeles. Generally at the Hammer we prioritize organizing exhibitions of the work of artists we consider to be underrecognized and deserving of more attention. The Hammer's overall commitment to emerging artists and underrecognized midcareer artists fits with my curatorial vision perfectly.

BASHA: *From your perspective and position, what is the primary role of the curator today?*

ELLEGOOD: I believe curators' roles change depending on their position and the type of institution they work for. Some positions may be more focused on building a collection and caring for that collection, while others may be more focused on producing site-specific public art works, for example. But in a general sense, a contemporary curator's role is to advocate and support living artists' work through exhibition, production, scholarship (writing), and acquisition and to bring their work to the public's view. Fundamentally, I see myself as an advocate for artists, as someone who mediates between an artist and my institution and between an artist and audiences. I see my role as an enthusiast who wants to share my passion for an artist's work with a public.

BASHA: *What is it that you most care about when presenting (emerging contemporary) art to the public?*

ELLEGOOD: My primary goal is to make the best possible exhibition with an artist with the resources available so that the public can experience an artist's work as it is intended. I care about providing the support and resources of the institution to the [artists] so that they are able to realize an exhibition (in many cases their first in a museum) that they feel will allow audiences a full and meaningful introduction to their work.

BASHA: *An ever more diffused art world presents new challenges to emerging artists. How would you recommend an artist identify her/ his own particular goals and career path?*

ELLEGOOD: With the increased visibility of the international contemporary art world and the many messages out there about what it means to be a successful artist, I believe it is critical that artists stay focused on their work and stay true to themselves. There is really no single path for "success," and it is important to identify what it is about making art that brings you the most satisfaction or pleasure or sense of challenge and try to make decisions that will help support this. This may mean, for some, that teaching brings them a sense of community, support, and structure that they find productive, while for others, teaching is an unwanted distraction from time in the studio. Some artists may find that seeking support through studio programs, research fellowships, and commissions is appropriate for their work, while others desire the support of the commercial gallery system in order to sell their work and enable their production to continue. Having a network of peers—other artists, curators, writers—to go to for advice and to bounce ideas off of is very meaningful. Creating your own community in what can feel like a vast and unwieldy contemporary art world is vital.

BASHA: *Besides funding, if you could change, improve, or revisit anything about the art world today, what would it be?*

ELLEGOOD: I would like us all to be able to have more time and focused attention to truly look at and experience art. I would like us to find more opportunities for contemplation, for confusion, and for pleasure in our engagements with art and artists. There is so much to see and so much happening in the contemporary art world, I think we all feel a great deal of pressure to see more, even if it means not seeing well. I would like us to see slower, see better, and see more than once, whenever possible.

Kate Fowle arrived in New York in 2009 to take on the position of Executive Director of Independent Curators International, where she has reinvented the program and level of engagement with independent curators. Prior to her work at ICI, Fowle was curator at the Ullens Center for Contemporary Art in Beijing and previously was Chair of the Masters Program in Curatorial Practice at California College of the Arts in San Francisco. Fowle also curates independently, while her purview at ICI allows her to register the issues and visions arising out of the next generation of curators around the world.

REGINE BASHA: *What is your particular scope at ICI? How has it framed your curatorial vision?*

KATE FOWLE: I would say that I am interested in both regional and international practice and certainly not genre-specific. I wouldn't say that my position at ICI frames my curatorial vision per se, but it certainly helps people to understand the way that I understand the curatorial role. Recognizing that exhibitions aren't the only way to discover what's going on around the world, we've developed a new series of programs that provide a platform for curators to share their research and experiences. Through online forums and the formation of partnerships with art organizations worldwide, we've instigated talks, conferences, publications, curatorial training, and professional networking opportunities that enable people to gain access to current thinking from places that are not always on your radar, such as Lagos, Quito, Ho Chi Minh City, or Vilnius for instance. We've also instigated short-course training programs, which bring emerging curators together to learn from some of the leading professionals in the field today.

BASHA: *And what would you say the curator's primary role is today?*

FOWLE: To provide a platform for artists' ideas and interests; to be responsive to situations and ideas; to creatively address timely artistic, social, cultural, or political issues; and to sustain dialogues with practitioners and continuously update research.

BASHA: *What is it that you most care about when presenting art or ICI programs to the public?*

FOWLE: That the [artists are] supported in thinking through how their work and ideas are presented, so that they think through the relationship of the work with the space in which it is shown and the kind of audience that will see it. Another concern is to present the work in a way that does not overly define or contextualize it.

BASHA: *For the purposes of this book, how would you recommend an emerging artist think about or consider a career path in this ever more diffused art world?*

FOWLE: The starting point is to understand your passion in relation to your strengths and weaknesses, and to really think specifically about what you want.

Miki Garcia has been at the Contemporary Art Forum (CAF) in Santa Barbara for more than six years as Executive Director. Before that, she worked as a Project Coordinator at the Public Art Fund in New York,

which functions much like a museum without walls. Previously she worked at the Museum of Contemporary Art in San Diego, where she began as a Curatorial Intern and was then hired as a Curatorial Associate.

REGINE BASHA: *What would you say is the focus of your curatorial work at CAF specifically?*

MIKI GARCIA: I have an MA that specializes in contemporary Latin American and Latino art and have continued this interest throughout my career, while broadening my scope to work in a more generalized contemporary art field. In addition, my years at the Public Art Fund gave me a unique skill set for working with projects outside the scope of the museum or gallery. In addition, I think that my area of expertise after all these years has been the practice of working with emerging and midcareer artists, encouraging them to create newly commissioned work and/or take risks in the installation or production of new works. Although I do not specifically work in these areas, I believe that my background in Latino/Latin American art and work with commissioning projects frames the way I think about curatorial and exhibition programming. My tendencies are to work with artists who represent or offer ideas of hybridity, complexity, and multivalence—whose work is not easily categorized and who resist didacticism or direct answers to questions.

BASHA: *Given this trajectory, what would you say might be the curator's (your) primary role?*

GARCIA: Because I work specifically with contemporary art, I am engaged in developing and providing resources that make it possible for artists of our time to produce the most compelling works possible. This necessitates an ongoing and in-depth knowledge of art history and contemporary culture with a level of engagement with artists that includes mentorship, field work, critical discourse, and an administrative dimension of direction and production for new projects. Furthermore, my role as a curator of contemporary art is one that acts as a cultural conduit between artists and audiences. My responsibilities lie in advocating for the artist's integrity and creative processes while articulating the role of the artist and the value of art to the general public.

BASHA: *What would you say you most care about when presenting emerging artists to the public?*

GARCIA: Being that my role is at least two-fold, I seek to work with artists who are at critical stages in their career or the development of artistic

process wherein the resources I can provide (exhibition space, writing, catalog) via my institution will serve to push their work into deeper, more complex territory, helping them grow as artists over a long span. In short, I am more interested in nurturing and supporting the process rather than an end result.

BASHA: *Indeed, that process might include advisement to the artist as well. In an ever more diffused and challenging art world, how would you recommend an artist identify her/his own particular goals and career path?*

GARCIA: I often speak to students in BFA and MFA programs who are confused about the practicalities of the "real" world and the contemporary art scene. In my opinion, many are seduced by the romantic myth of the artist as an intellectual, creative genius—a bohemian whose originality and rebellion are beloved by the patrons of the day. When I speak to these students, I make sure to let them know the challenges that lie ahead. Because I view my own curatorial role as a vocation and am deeply fulfilled and enriched by my own life's choices, I am also aware of the advantages to following one's passion/calling. Hence, I try to reinforce that they should charge ahead, work harder than they ever thought possible (socially as well as in the studio), and be extremely sure that this is the only thing they want to pursue because it really will be rewarding if there is true love.

BASHA: *If you could change, improve, or revisit anything about the art world (besides funding), what would it be?*

GARCIA: Given that my role is to advocate on behalf of practicing artists, I think that the most pressing issue in the contemporary American art world is reception and understanding. The "one" thing I would change or like to see happen is a widespread appreciation for art and artists in this country, beginning obviously with more interdisciplinary attention to how the arts affect our lives in public school curricula, required percent for art programs, and more financial allowances for artists (tax breaks, studio spaces, travel budgets). It is my hope that we will see contemporary art and artists truly integrated into the life of our society.

Paul Ha has been Director of the Contemporary Art Museum St. Louis for the past eight years. Prior to that he was Deputy Director of Programs and External Affairs at the Yale University Art Gallery. He began his directorial career at a space for emerging artists, White Columns in New York, where he also curated numerous exhibitions.

REGINE BASHA: *In your current position, what is your particular scope (for instance, regional, international, genre-specific, or site-specific)?*

PAUL HA: For our programs, we reach out to the international community of artists. We also have a strong engagement with the local artists' community.

BASHA: *Though you are presently Director of the Contemporary Art Museum St. Louis, from your perspective and position, what is the primary role of the curator today?*

HA: I believe that curators will always be asking, in addition to some others, these three questions: Why this artist? Why here? and Why now?

BASHA: *But there is also the "why care?" What would you say you most care about when presenting emerging contemporary art?*

HA: First is to make sure that the young [artists are] having a rewarding experience. That we are helping them achieve what they are striving for. To use the network and knowledge we've gained working in the field as a curator and to be a resource for them. You want in the end for the artists to feel that they are voicing exactly what they want.

BASHA: *How would you recommend an artist find that voice? In an ever more diffused art world, how would you recommend an artist identify his/her own particular goals and career path?*

HA: Much has changed in the art world, but in some ways, much has not changed at all. I think one of the most important things that [artists] just starting out can do is for them to get involved and to build a community. Go to openings, get on mailing lists, go on studio visits, hang out, and get to know everyone. A lot happens just by hanging out.

BASHA: *If you could change, improve, or revisit anything about the art world today (besides funding), what would it be?*

HA: I'm constantly thinking about how a museum fits into a modern-day person's daily life. How we as museums can be a more comfortable place for those who are uncomfortable with contemporary art. If I could change anything about the art world today, I would try to find ways that museums can be meaningful to a non-art person and to make [that person] more comfortable within it. I would also find ways that we would be more of an automatic daily ritual to a person, like

logging on to their favorite Web site or dashing off to their favorite coffee stop.

Betti-Sue Hertz became Director of Visual Arts at the Yerba Buena Center for the Arts in San Francisco in 2009. For more than eight years she served as Curator at the San Diego Museum of Art (SDMA), where she organized major special exhibitions, collection-based installations, and commissioned projects. Before her time in California, she spent a considerable amount of her career in New York (the Bronx specifically) first as Director of the Bronx River Arts Center in the 1980s and then as Director of the Longwood Arts Project in the 1990s. She has also organized major exhibitions for the Bronx Museum of the Arts and the Smithsonian Institution, amongst several other independent curatorial projects.

REGINE BASHA: *Betti-Sue, in your current position at Yerba Buena, what would you say is your particular scope and how has this institution framed your own curatorial vision?*

BETTI-SUE HERTZ: When it comes to curatorial practice I consider myself a generalist. Both because I tend to do best when I can roam through lots of artistic practices and ideas, and because I want to expose audiences to an extensive range of cultural references from various geographical regions globally. Over the years I have developed and built relationships with contemporary arts communities in Latin America and East Asia, which has been very rewarding. So although I do not consider myself a specialist I have accumulated pockets of knowledge about the art scene in certain regions. After working in the South Bronx for a very long time it was a bit of a shock to find myself working at a general art museum in Southern California. However, my experience in the Bronx, where I exhibited many international artists living in the New York metropolitan area, was a good background for negotiating a cultural landscape marked by the sharp division between the cities of San Diego and Tijuana. Living in San Diego created a necessity for much more extensive travel in order to keep current with the ever-changing art world—especially new artists, emerging ideas, and developing ideological positions. Working in a historical museum, I became more sensitive to building programs that connected contemporary art to a vast repository of traditional art that is the mainstay of SDMA's identity. I am no longer thinking as much about linking the contemporary to the past or about how exhibitions relate to collecting priorities. Now that I am working at a multidisciplinary art center, rather than a collecting institution, I have shifted my attention to how contemporary

visual art is received and understood by audiences oriented to dance, theater, performance, music, film, and video. I am also more sensitive to the blurring of boundaries between the creative disciplines. Another side of my practice is directed toward scholarship, and I have become something of an expert on specific artists of historical importance, such as Gordon Matta-Clark, Eleanor Antin, and Renée Green.

BASHA: *Clearly you have had multiple roles as a curator. What would you consider the primary role of the curator today?*

HERTZ: The core consideration of curatorial practice is the intersection of art, artists, and audiences. As the sphere of curatorial practice has expanded, the definition of this role has also become more open ended. What is the curator's function exactly in a period when categories between artist, curator, critic, and historian are becoming more unstable? My own career has incorporated all these roles, but always from the position of primarily being a person who organizes objects, actions, and interpretive information into (hopefully) clear presentations to encourage audiences to look at and experience contemporary art's multitudinous forms. These priorities have been driven, in part, by [my] seeking out timely and progressive ways of thinking and being in art that have the capacity to ignite personal expansiveness and political awareness in viewers. The curator is primarily someone who believes she can play a role in this dynamic by being a handmaiden to culture's shifts by creating contexts for experiencing works of art. It's exciting to see more and more curators reinventing the job, and it would be hard to catalogue all the new operational paradigms that are in effect today.

BASHA: *What is it that you most care about when presenting emerging contemporary art to the public?*

HERTZ: When I'm putting together an exhibition I ask myself a series of questions. What topics appear to be particularly relevant? What themes are emerging in the works of younger artists and how are they communicating ideas, feelings, strategies, and ways of being in the world? Does this exhibition represent a vital concept with a unique set of underlying principles? How can theorists, historians, and literary writers help me clarify and refine my thinking about a topic, and how can I translate what I learn from engaging with these texts into my thinking about an exhibition? What art works do I feel passionate about and what is the best way to share this passion with others? Are

my ideas for an exhibition relevant to what artists are doing and what they are thinking about?

BASHA: *Emerging artists face new challenges in an ever more diffused art world. How would you recommend an artist identify her/his own particular goals and career path?*

HERTZ: Each person is different and each artist makes a slew of decisions in order to create a satisfying career. My recommendation is that artists be honest with themselves about their goals and how much they want to devote themselves to their work. [All the really exceptional artists I know have] placed being an artist at the top of their list of what is most important to them. This usually means that they are thinking about and doing their work pretty much all the time. I don't mean that they are in the studio or on the computer all the time, but that they plan out their lives and make decisions to support their vision and commit to create important work that pushes boundaries challenging both themselves and their audiences. There are artists who do really well in the commercial marketplace and others who would feel suffocated by that system of social relationship and monetary exchange. Some artists are fantastic at navigating the issues of bureaucracy associated with sanctioned public art and thrive on it. It's like anything else in life—it's best to build on your strengths and work on your weaknesses, keeping your focus on what is most important to you. Working smartly and pushing yourself to the next level, constantly evaluating process, materials, and motives, while working toward an even deeper relationship with questions of meaning or anti-meaning and how they can be communicated, is at the core of the artistic process. In other words, a studied consciousness about what you are doing, what is important about it, and why someone else should care are all helpful questions when considering one's art practice. Also, taking risks and being fearless about leaping into new territories that express your values and personal identity, with an awareness of the larger landscape of current and past artistic production, often yield compelling works of art.

BASHA: *If you could change, improve, or revisit anything about the art world today (besides funding), what would it be?*

HERTZ: The art world is a very big place and it is constantly expanding, so it's hard to wrap my head around it as something unitary. Before the economic downturn the art market was so strong that it was difficult to think about art without referencing it. Some of us were pleased

to see the market tumble because it meant that the conversation about art could shift to more thoughtful consideration of its other values. I would like to see a deeper integration between the art world and the academy, because I believe that when viewers take the time to access various histories and ideas that are relevant to artists' production, they can better engage the complexity of art intellectually, emotionally, and spiritually. For me, it's been great to see the curatorial sector broaden exponentially, and I'm very excited about what this means for artists, the presentation of art to various publics, and the diversification of venues and contexts. How can the art world better support the most sensitive, daring, and bold artists working as active agents for progressive ideas and politics? I would like to see efforts for democratization worldwide continue to support more fluid access and interconnection of artists to each other, to achieve even more inclusiveness in today's growing art world.

Jennifer McGregor occupies a unique position as a curator of a garden and sculpture park in the Bronx called Wave Hill, which she has been engaged with since 1990. She began as a private consultant when she started McGregor Consulting, to work on a variety of projects, art commissions, public art master plans, and exhibition planning. She was hired as a consultant to Wave Hill but then moved into the permanent position of curator and has been there for eleven years.

REGINE BASHA: *What would you say is your particular scope at Wave Hill?*

JENNIFER McGREGOR: I have always been interested in developing opportunities for artists to create new work and engage with the public. Working at Wave Hill I am particularly focused on fostering a connection between nature, culture, and site. The exhibitions that I curate are topical and usually relate to the experience of the garden, environmental issues, or other timely topics. Here I work with emerging and midcareer artists, mostly from the New York area. For group shows, I particularly like to mix artists from different generations and perspectives. Group shows are a very creative way to draw connections between different artists and to put their work in a fresh context.

BASHA: *From your perspective and position, what is the primary role of the curator today?*

McGREGOR: Just as the role of the artist has expanded, the role of the curator has as well. Because curators see so much work, I see them as

pollinators, exchanging ideas, finding ways to present art with a fresh perspective. While artists have found many ways to relate directly to the public, curators have an important role in finding new contexts and framing the way that the work interfaces with the public.

BASHA: *What is it that you most care about when presenting emerging art to the public at Wave Hill?*

McGREGOR: Wave Hill's public is very engaged and pretty vocal about likes and dislikes. I particularly enjoy being in the gallery to hear visitors' responses. I love when people describe a project from several years ago that has stuck with them, that they remember when they reenter the gallery. My exhibits usually expand people's concept about how an artist works. Break down preconceived ideas about what an artist does. I want to offer visitors a direct experience with contemporary art that engages their mind, their senses, and their curiosity.

BASHA: *Considering the new challenges facing emerging artists in an ever more diffused art world, how would you recommend an artist identify her/his own particular goals and career path?*

McGREGOR: There are so many different ways to define the role of the artist, object maker, activist, catalyst, investigator, storyteller, etc. I would recommend that an artist investigate different models and think hard about what fits best. Why are you an artist in the first place? Also look at the relationship between making art and supporting oneself. Landing a lifelong, secure teaching job or selling out an exhibition every year is a myth. I am very interested to see different hybrid ways that some artists find to support both themselves and their work. Embarking on a career that doesn't have a clear road map requires flexibility and as much creativity as you devote to the work itself.

BASHA: *Besides funding, if you could change, improve, or revisit anything about the art world today, what would it be?*

McGREGOR: "The art world" is a pretty amorphous term. Seeking the next new thing is part of the picture. However, there is a pitfall in the quest for instant star power—MFA students being picked up before they graduate and selling out their first shows. While this is a nice boost, if you look back at the careers where it's happened, it wasn't necessarily the best thing for that artist and his or her art. The fallacy of instant commercial success creates a false sense of expectation and a false definition of success. Working on the fringes of the art world, I see many "successful" artists who have carved out influential, effective, and highly creative career paths but whose work will never be big news for auction houses.

"*I always thought that your work looks so much better in reproduction than in real life.*"

THE CRITIC

*"I just think you would be a better artist if you had someone
else conceive and make your work."*

Art Criticism at Present: Five Voices

RAPHAEL RUBINSTEIN

Like cultural critics in general, art critics have lately been contending with strong headwinds. The long unraveling of modernism, the rise of the curatoriate, and the current transformation of publishing media have presented serious challenges to serious art critics. Happily, some very perceptive writers are still at work, and their commentary is still indispensable.

Here, five critics discuss the current state of criticism, their response to technological change, their openness (or lack thereof) to emerging artists, and their advice for young artists and for other critics. Together, these five writers have been important contributors to a range of publications: Eleanor Heartney at *Art in America*; Barry Schwabsky at *Artforum* and, more recently, *The Nation*; Martha Schwendener at *The New York Times* and the *Village Voice*; Katy Siegal at *Artforum*; and John Yau at *The Brooklyn Rail*. Two of them have full-time teaching positions (Siegal at Hunter College, Yau at Rutgers University); one is an ex–New Yorker who lives in London (Schwabsky); and two others (Heartney and Schwendener) are that increasingly rare creature, the freelance art critic. Schwabsky and Yau epitomize another valuable tradition, that of the poet-critic.

As several of the participants here point out, the critics who are most important for a young artist to connect with are those of her or his own generation. Despite the embattled nature of art criticism in recent decades (the subject of my 2006 anthology *Critical Mess: Art Critics on the State of Their Practice*, to which Heartney and Siegal contributed provocative essays), a new generation of art critics seems to be emerging. Contrary to the hype about blogging, many of the most promising young art critics are to be found in the pages of *The Brooklyn Rail* and coming out of the Art Criticism and Writing MFA program at the School of Visual Arts. (Full disclosure: I teach a writing class there.) Online publications such as *ArtNet* and *artcritical* can also introduce new critics. Some of these

emerging critics are themselves artists. It would be great to see even more young artists contribute to the critical discourse. History has shown that it is often artists who produce the most valuable commentary on the art of their time. It's surely no accident that the only item to show up on more than one of the must-read lists below was written by an artist, the *Collected Writings* of Robert Smithson.

RAPHAEL RUBINSTEIN: *How important is the Internet to your activities as an art critic? For instance, is it a source for finding out about new artists?*

BARRY SCHWABSKY: I use the Web all the time for research. But hardly at all about art, even less so about new art—but rather about non-art matters that inevitably come up in the course of writing. An example that comes to mind: A couple of years ago I wrote a piece about the painter Maureen Gallace in which I mentioned a painting she'd done of the Merritt Parkway in Connecticut. I know the road, but I'm not exactly a font of information about it, yet I wanted to be able to give the reader a basic explanation of what it is. Thanks to Wikipedia, I quickly knew far more about the Merritt Parkway than I ever needed to know. I don't think anything I mentioned about it in passing in the article was something I actually learned from the Wikipedia entry— certainly I already knew it had been the subject of a painting by de Kooning and a poem by Denise Levertov—but being able to read the entry gave me the confidence that I wasn't saying anything about it that was wrong or misleading. Chances are that if I hadn't been able to access that information quickly I wouldn't have bothered to mention anything about the parkway at all.

JOHN YAU: More and more information that was found only in libraries or, worse, their dusty storerooms is now being housed on the Web. The Web and library enable a different kind of browsing to take place, with each offering a different kind of possibility. I am interested in browsing, in wandering off any of the beaten paths I go down. That can happen on the Web, in a library, and also in a second-hand book-store (if you are lucky enough to find one).

ELEANOR HEARTNEY: The Internet is crucial to my research—when I am working on articles, essays, books, or lectures, I do a lot of my back-ground research on artists, shows, etcetera online. However, I don't see discovering new artists as part of my job. To quote my colleague Peter Plagens, I don't look at unpublished work. By this, he and I mean that we see the critic's job as examining art that has already

been culled by gallerists, curators, and art institutions. In part, this is a response to a practical problem: In contrast to the glory days of Ab Ex when the New York art world could fit into a single room, the field is just too vast to know in its entirety. But this focus on the "published" also reflects the fact that curators and writers have different functions, and that critics are more involved in evaluating art and art trends that have come to the surface and in examining why those have come forward at that particular moment, while curators are more likely to be involved in unearthing or even creating those trends. Plus, most magazines won't consider articles or reviews of artists who aren't showing somewhere, so I would have no place to write about an "unpublished" artist anyway.

MARTHA SCHWENDENER: [The Internet] is most important to me as a way of surveying the landscape to find out what's going on where and when. I don't use it much to look for new artists. I access the Internet through the same device (the computer) where I do my work (writing), so I need to limit my time online.

RUBINSTEIN: *Have you written for Web-based publications? Do you read Web-based publications, such as blogs or online journals? Anything of value there? Do you approach writing for Web-based venues differently from when you are writing for a print publication?*

SCHWABSKY: I've rarely written art criticism for online publications, nor do I normally read online art writing. It's just not my medium. I like print, and there's already more to read in print than I have time for.

YAU: I have written for Web-based publications, and I do read Web-based publications, ranging from literary blogs such as those run by Ron Silliman and Pierre Joris to the Poetry Foundation's Web page and Tyler Green's *Modern Art Notes*. I approach both print publications and Web-based publications with the same mindset—I'm not interested in the casual offhand remark passed off as wisdom.

HEARTNEY: I haven't written for specifically Web-based blogs, though some of my articles written for print have also been posted on the Web. I think there is a difference between things written for print and directly for Web, the latter being more personal, anecdotal, and often more gossip-oriented than articles that go through the editing process for a print magazine. When I am doing research, I find some blogs helpful (for instance, artcritical.com), but many are too informal and not sufficiently rigorously researched or thought through to be useful

to me. On the other hand, the gossip and "opinionatedness" found in blog writing can be more fun than the writing in articles created for print.

KATY SIEGAL: I don't write for [online publications], but not as policy, just because I don't have the time and haven't been asked.

SCHWENDENER: For me, practically all writing is online writing now. I am currently writing for the *Times* and the *Voice*, and most people read me online. I was one of the first "Critics' Picks" writers for Artforum.com, so I've been a part of the transition from print to online arts writing. As a point of reference, I used to deliver my reviews on floppy disk to the *Time Out* office on Lower Broadway. I can't even remember what I did in the earliest days, with *Flash Art*, *New Art Examiner*, *Art Papers*, *Art in America*. I read some online publications, but not religiously. As I said, I have to be careful when I'm on the computer, because I need to write. And when I'm not writing I feel that I should be out looking at art.

I don't do any social networking for the same reason. I am already swamped with information and people contacting me. I get about twenty pieces of art-related mail in the mail every day, and I look at that carefully, too.

RUBINSTEIN: *Do you attend art fairs? If so, do you find them useful to you as a critic? What is your best source for discovering new artists?*

SIEGAL: I go to the Armory, but other fairs only if I am speaking. I like seeing all the art, even if it's like going to Costco, and do see new artists.

YAU: I have gone to art fairs, particularly if they are nearby. If I see something that I haven't seen before, and I want to know about it and who made it, then an art fair is useful. It is also interesting to see what's being promoted, and what is being pushed. Art fairs are planned situations that never quite go according to plan because one can wander through [them] aimlessly. I don't have a particular source for discovering new artists—it happens because I am open to the possibility.

HEARTNEY: I will attend art fairs as a social opportunity, but I have trouble with the art fair mode of art presentation. As a critic, I don't absorb art presented in such a scattershot way. Art fairs are for collectors who are looking for things to acquire, and perhaps also curators who are scouting out artists to show. But I am more interested in exhibitions that are based on ideas and have a curatorial point of view. As a critic, that gives me something to think and write about.

SCHWABSKY: I regularly attend the Basel and Frieze fairs, and occasionally others as well. Basel in particular I consider an outstanding source of information. However, I no longer consider that finding out about new artists is a primary function of my work. For a long time it was, but now that I have been a critic for more than twenty-five years, I imagine that others, closer in age and sensibility to the young artists, are better suited to that occupation than I am now. By the same token, in the past few years I have become much more interested in writing about historical subjects than I ever used to be. Still, I will always consider the essence of the critic's task to consist in the fresh response to what is unfamiliar and not yet entirely codified.

SCHWENDENER: I do attend art fairs, but mostly in New York. The downside of the boom market for writers is that my workload has increased about 500 percent. When I started writing, I followed what was going on in about fifty galleries and the museums. Things have changed radically during the course of my career.

RUBINSTEIN: *Do you make studio visits?*

SCHWABSKY: Unlike when I was younger, I very rarely do studio visits except when it is in preparation for some particular project (writing or curatorial). It happens occasionally, but no more than that. Mainly because I just don't have the time. In any case, I would advise young artists that critics have much more to learn from conversation with them than vice versa.

SIEGAL: I do make them, and would make more if I had the time. I enjoy it. I have a young child, so I do less of everything now. Independent curator Bob Nickas says that museum curators visit fewer studios now because they have so many other professional obligations (like talking to trustees and raising money).

SCHWENDENER: I love doing studio visits, but I limit them now because [a visit] effectively takes up half a day. At this point, I am also more mercenary. I have ample opportunity to talk with art students, but the people I tend to make time for—dedicate studio visits to—are at a similar stage in their careers to me. That is, they've been working for a while, ran into some problems or roadblocks, worked through those and presumably (if they're still working and have a studio) came out the other side. They're committed to what they do. Studio visits with much younger artists—particularly students—can feel like downloading information (or giving blood). Not always, but sometimes.

HEARTNEY: I only do studio visits that are connected to something I am working on—a book, an article, or perhaps a lecture. Time is too limited and there are just too many artists out there for me to do studio visits without some specific purpose. Again this goes back to the notion of looking at "published" artists. I think for curators, studio visits are as important as ever, but for me, they need to be focused on something I'm doing.

YAU: I continue to go to studios. If I go to fewer, which I am not sure I do, it may simply be a case of being older, being married, and having a young daughter.

RUBINSTEIN: *Are you responsive to young artists' contacting you? What kinds of approaches work/don't work? Would you visit the studio of an artist previously unknown to you based only on material he or she sent? Do you have any advice for young artists interested in developing dialogues with art critics?*

SCHWENDENER: I am—sort of. Critics work extraordinarily hard (remember writing papers in high school/college? It's like that except now it's going on the Internet—forever) and we're on the lowest end of the economic spectrum in the art world, alongside artists who don't make money from their work or have another source of wealth/income. So it's pragmatic: Why is this person contacting me? Would they be better off contacting a different writer? Am I part of a carpet-bombing campaign? Mail works; e-mail sometimes works; face-to-face if you see me at an opening can work.

I probably would not visit an artist I didn't previously know. However, I have done studio visits with people I've met out and about. It's simply a time/money issue. If I had a grant to do studio visits, I would do more of them. But this is unpaid time and I already have ample interface with art and artists, so at this point I generally just do studio visits with artists whose work interests me.

Advice for young artists who want to get to know critics? Talk to them when you see them or are introduced. Don't expect them to respond to your e-mails, because they're probably getting 60–100 e-mails per day, [so] don't be offended if they don't respond to something you send by mail or e-mail. Also, don't treat them like an ATM; they're not there to dispense something (a review! an introduction! instant advice!). Most important, treat them with respect. We're not PR people put here to advance your career; we're writers working alongside your work.

YAU: Sometimes I am responsive, sometimes not. I have no hard-and-fast rule about this. Advice—be respectful, and spell his or her name correctly if you send them a letter (I have gotten many letters with my name misspelled, and it has only three letters). Treat a critic like a human being, not like a steppingstone. Talk to your peers. Help build a community.

SIEGAL: I am responsive to young artists, but my teaching (at Hunter College) already entails many people. I might contact a young artist if I were interested in the work. The best way to make contact with a critic is to find someone close to your own age, who might not only be more sensitive to your work but who might have the luxury of time to meet and talk. I think the best approach is to ask if [the critic] would meet you at a show where you have work up and to talk briefly in front of the work. This will be an irritating reply for people who are already frustrated by [the fact that they are] not [currently] showing, of course.

HEARTNEY: As I mentioned, I work with the filter provided by existing art institutions, so you are better off going to curators, gallerists, or the editors of art magazines.

RUBINSTEIN: *Do you think that criticizing public institutions (not their exhibition programming and collecting choices, but how they are run, and by whom, etc.) is something art critics should get involved in? Is the question of institutional ethics something that you personally pursue?*

HEARTNEY: Yes, I do think these are important questions, and if critics don't pursue them, who will? As it is, there is a powerful tendency to see critics primarily as publicists for artists and institutions, and of course it's more pleasant to have everyone love you, but without institutional criticism, important questions about the relationship of art and society never get addressed.

YAU: Yes, I think one should criticize public institutions. In my role as arts editor at *The Brooklyn Rail*, I and the other editors commissioned William Powhida to make a drawing about the New Museum, its director and curators. I am interested in institutional ethics. Museums have a public responsibility, and curators are hired by museums.

SCHWABSKY: I agree that the criticism of art institutions is part of the critic's job, but it has never been a duty that I have taken up with any relish. I am bored easily, so I have lazily allowed others to do this, though I'm not convinced many have done it very well.

SCHWENDENER: Art exists in context. Art journalists/reporters tend to cover these issues, but when [the issues] spill into the exhibition space, that becomes the province of critics.

RUBINSTEIN: *Do you curate? What, for you, are the main differences between curating and writing criticism? That is, do you adopt different attitudes when curating a show from when you are writing?*

SIEGAL: Yes. One is social and more material in coming up against resistant reality (money, loans, venues). The other is solitary and more infinitely creative. Both are really, really fun. Criticism pushes you toward criticizing the world that exists, and curating pushes you toward either creating a new world (like an artist) or, in the case of a historical show, trying to recover the world as it once existed. Curating makes you vulnerable, leaves you open to criticism and you, as a critic, ashamed of every gratuitously mean barb you ever slung at a curator or an artist.

SCHWABSKY: I have curated or co-curated about half a dozen exhibitions over the years. I enjoy it enormously, but I never seek opportunities to do it. If someone comes to me asking me to curate, and the situation seems sympathetic, I will agree. The exhibitions I do are very different from my writing. They are never based on a text—hardly even on a theme. They are about perceiving the precise character of works exhibited; in other words, they are very concrete, very "phenomenological," if you will, more than discursive.

YAU: I have curated exhibitions, and I will continue to do so when the opportunity arises. Both curating and criticism offer a perspective; neither gives a complete picture. Everything I do is related to everything else I do. They are all parts of the project.

SCHWENDENER: I don't curate shows. Generally, I see [writing and curating] as incompatible because you can't write objectively about an artist you want to show later. How do you write critically about an artist or institution if you're also hoping to work with [the artist or institution] in another capacity in the future?

HEARTNEY: I have done a small amount of curating, but I see myself primarily as a critic. I think the two are very different—Curators by necessity have a much closer relationship with artists, and they are interested in promoting those they feel are doing interesting or important work. I think critics need to have a bit more distance: Even when

writing criticism about artists they feel supportive of, they need to feel free to be critical and ask difficult questions.

RUBINSTEIN: *If you had to suggest a five-item reading list to a young artist, what/who would be on it?*

YAU: *The Painter of Modern Life* by Charles Baudelaire, and his poetry; the letters of Vincent Van Gogh; Delacroix's journals; Ann Truitt's diaries; Robert Smithson's *Collected Writings*.

SCHWABSKY: Five books I think every artist should read are the stories of Franz Kafka, *In Search of Lost Time* by Marcel Proust, *The Image in Form* by Adrian Stokes, *Kant After Duchamp* by Thierry de Duve, the writings of Robert Smithson, and David Sylvester's interviews with Francis Bacon. What, you say that's more than five? Well, even someone who failed math can become an art critic.

SIEGAL: Anything by Richard Schiff; Jan Vermoert's *Exhaustion and Exuberance*; anything by Lane Relyea; Howard Singerman's *Subjects of the Artist*; Gerhard Richter's *Daily Practice of Painting*; essays by Hito Steyerl.

HEARTNEY: I think it's important to keep abreast of larger developments in the art world, so I would recommend (at least for New York–based artists) looking at the reviews in *The New York Times*, keeping up with *Art in America* and *Artforum*, maybe also publications like *The Brooklyn Rail* and *ArtNet*. You don't have to read every article, but it's good to know what is going on. On the other hand, you don't want to fall into the trap of making work shaped around what you see in publications, so it's important to read other things as well— literature, political essays and commentary, and materials connected to your own specific interests.

SCHWENDENER: This really depends on the artist. What are you interested in? Read up on that. I suppose it helps to know about the art world, so you don't have romantic illusions. You could read oral histories or biographies—although these might depress you rather than inspire you. Some of my best conversations with artists are about other artists and art history. Otherwise, I suppose read art magazines—but with skepticism rather than blanket scorn or acceptance.

RUBINSTEIN: *Do you think the role of the art critic has evolved in recent years? Is there anything in particular that you would like to see change in current art criticism? How do you see your role as an art critic? Are there particular forms of critical writing that you are most interested in?*

SIEGAL: It's a cliché, but I'll say it: Criticism has declined, or at least changed. Fewer people are willing to write "real" criticism: serious reviews, polemical essays, in part because even fewer places are paying, and even the cultural capital involved has gone more toward news items, lists, comparisons, blurbs, and curating or pointing to things, which is partly because of the [relatively] new venue of the Internet.

SCHWABSKY: The limitations of art criticism today are fundamentally the limitations of the publications in which it appears. Having for a while edited a magazine myself, it is probably natural that when I peruse a magazine, no matter how good [it is] and no matter how happy I might be to contribute to it, I primarily see in it everything that I would have done otherwise. That's always a lot. In my opinion, the art magazines are not pushing their contributors (or their readers) to become more intellectually ambitious, or at least not doing so enough. And I hope I don't need to say that by "ambitious" I don't mean "academic."

HEARTNEY: I am concerned about the tendency to turn critics into publicists. There is less and less support, financial and otherwise, for writing that doesn't fit into that mold, even though I think it's very important to write critically about artists, examine the art system, talk about larger connections between society and art, and do other kinds of writing that doesn't simply enhance the marketability of artists and institutions. While it is possible to do some of this in existing art magazines, their base of support, especially those supported by advertising from galleries, leads them to focus more on prominent artists and shows. Meanwhile academic publications, with a not-for-profit status that might circumvent this situation, are little read and often unreadable. And blogs, often touted as the answer to this problem, tend to be self-indulgent and not well researched, which may not be surprising because their writers are rarely compensated. I myself tend to write in many formats and in particular have been focusing on books as forums for more complex and less commercial ideas.

SCHWENDENER: The role of the critic has become blurry. There is the art historian/critic; the curator/critic; etc. Also, "contemporary art history." These things are all in flux at the moment, perhaps more so than in other periods. Although we're also in a period of extreme scrutiny, so much of what Clement Greenberg or others did, outside of writing, would be viewed as a conflict of interest.

Is there anything in particular that I would like to see change in current art criticism? Better pay.

I see [my] role as an art critic as an advocate for and interpreter of art and as a sort of truth teller—that is, my truth, which may or may not coincide with the truth of others. Given the politics of the art world, artists and curators often can't say what they think, or are not comfortable going on permanent record. So critics assume that role. It is gratifying to me when someone says, "I'm so glad you said that!" Or when an artist says, "You said exactly what I've always wanted to say about my work, but I couldn't put it into words." My job is to articulate how I experience the work, but it feels more like being a conduit than a generator. Writing criticism is an abstract activity—sitting at home asking yourself, What do I think about this? What needs to be said? But after you've done a great deal of it, suddenly you've produced a corpus and before you realize it you have established a "voice" and a "position" vis-à-vis art.

I'm interested in hybrid forms (fiction-criticism; "paraliterature"; criticism that doesn't read like expository writing); art theory; and artists' writings, which are critical in their own way. I also like non-art criticism: food, wine, television, music, books, film, automobiles, technology—even product reviews (see Kevin Killian's 2,300-plus product reviews on Amazon). In his interviews with Pierre Cabanne, which I read when I was a teenager, Marcel Duchamp repeats that he made or did something because it amused him. I feel the same way about both reading and writing criticism. If I'm not amused, what's the point?

YAU: I wouldn't say "evolved." It has changed, in part, because many current critics are art historians who believe in master narratives. The art world seems to prize its ideologues. The best blogs, in fact, seem to offer a healthy antidote to the widespread institutionalizing of criticism. I would like to read more criticism that doesn't cite the usual authorities; it would be a radical act for critics to actually engage with the work, rather than [fall] back on leading authorities and approved-of thinkers. Some criticism reads like an extended set of footnotes to a narrative that is so well known it is assumed to be true. I would like there to be more interrogation of presumed truths. I am a poet. I think this is essential to how I define my role as art critic. I believe in being independent. I am not interested in joining any club. I am still learning. I am interested in all forms of criticism, but I am particularly interested in critical writing that doesn't reject the imagination in favor of conventional wisdom and received ideas. Have I learned something I didn't know or hadn't thought of before? Does it make me think? Those are the measures I try to live by.

*"Too untalented to be an artist, too financially unsavvy to be
a dealer, too socially awkward to be a curator, too
unsophisticated to be a theorist . . . have you
considered art criticism?"*

AIM in Review

The Critics' Perspective

BRIAN SHOLIS

Those who created the Artist in the Marketplace program recognized important, and relatively new, aspects of the art world in 1980: its increasing complexity and the differentiation of roles within it. Successful artists based in New York would henceforth have to negotiate not only with dealers, the small coterie that had been their professional face for decades, but also with curators, lawyers, critics, and others. To run a studio, the program's founders suggested, required management skills that until roughly that time one could mostly avoid having. The title of the program, and particularly the use of the word "marketplace," acknowledged another new reality. Despite the rapid proliferation of "arts professionals," power, however one wished to define it, was increasingly concentrated in the abstract space of the "marketplace"—a space into which only a few people could see clearly. The definition of artistic success had been channeled into a narrower frame: market acceptance. Artist in the Marketplace aimed to demystify both developments. It would introduce emerging artists to the dense thicket of people they would have to engage and it would explain many of the ground rules for that engagement.

Critics sensitive to such systemic changes recorded them in print, though their tone was not often one of such pragmatic adjustment. Rather, they lamented the flight of power from their hands. Peter Schjeldahl inaugurated his column in the *Village Voice* in 1981, only one year after AIM's founding. His opening salvo explained the ascendant dynamic with typical flair: "Such purposeful power as critics used to have disappeared with the time lag between the appearance of something new and its acceptance, a transition dealers manage now seemingly in a matter of hours. The art-worldly function of critics has become largely ceremonial: after-dinner speakers at the victory party. Thus critics tend to dig in their heels."[1] Indeed they did, and in subsequent decades critical handwringing became its own art form, as evidenced in the contentious

collections *The Crisis of Criticism* (1998)[2] and *Critical Mess: Art Critics on the State of Their Practice* (2003).[3] Though each participant in these debates offered a different answer to the question of what is to be done, a majority voiced Schjeldahl's concern that the elevation of artists to canonical status was no longer a slow, thoughtful process in which critics actively participated. What was to become of connoisseurship and taste?

Such rhetoric, of course, should be taken with a grain of salt. The glory days, for which the height of Clement Greenberg's career in the 1950s and early 1960s is shorthand, were not always glorious. And the downward trajectory these critics lament hasn't been a slide into complete irrelevance: Artists still seek thoughtful critical responses to their work; being selected for the cover of an art magazine remains an important career milestone; and critics are, after all, still invited to speak with AIM participants each year. One ironic result of this (at times overwrought) concern with supersession was that some critics unselfconsciously followed the dictates against which they railed. As one critic phrased it in a review of a group exhibition in 1987, "Few if any of these artists have yet staked out a personal territory. Partly, it is a matter of youth but mostly it has to do with the press's view of artists as athletes and its compulsion to beat the bushes for ever younger champions."[4] By seeking to ensure their own influence upon art, at least some writers felt they ended up playing the game by the marketplace's rules.

The mild *mea culpa* offered by this writer was published in a review of the 1987 AIM exhibition. Tracing the developments outlined above through reviews of AIM exhibitions is difficult; *The New York Times* has been the only consistent venue for interpretation of these shows. (That fact in itself prompts useful thoughts about what is considered the proper object of traditional forms of art criticism.) The sample size is not only small—limited to a handful of the paper's staff critics—but also atypical. Unlike trade magazines such as *Artforum*, *Frieze*, and *Art in America*, which often feature writing by congenital worriers who contribute to books on the state of art criticism, the *Times* has a mass audience. Its writers must demystify the arcana of contemporary art objects—in a manner akin to the AIM program's mandate to explain the social milieu that surrounds those objects.

While one can't precisely diagnose the health of art criticism through these reviews, reading thirty years' worth of them does offer interesting lessons about the possibilities and limitations of the form. It quickly becomes apparent that AIM program exhibitions are a kind of Rorschach blot. The shows are large and include work in a range of artistic media. The artists are represented by only one or two objects and are often

unknown to the writer. *Times* critics therefore have neither the ability nor the space to engage with any individual artist or object in depth. In many instances, they use the cross-disciplinary "representativeness" of the exhibition, as well as the selectivity of the AIM program, to make grand pronouncements about the state of art. Vivien Raynor, writing in 1992, claimed that that year's exhibition reflected "a sense of confusion mixed with desperation, a quality for which the official term is diversity. There is so much talk of diversity these days that one wonders if it has not become a school in itself."[5] Benjamin Genocchio, writing in 2004, believed the show demonstrated that "politics seems to be beside the point of art's role in American society. Sadly, we want things that can sell, and little more."[6] While not the clearest statements committed to print, and while reflective as much of the writer's background assumptions and biases as anything in the shows themselves, they do hint at larger trends in art. One year before the "Whitney Biennial 1993," which has become infamous for its concentration of "identity art," Raynor noticed an uptick in "talk of diversity." In 2004, as the interest of a new class of collectors infused (and inflated) the art world and a Republican president was leading an unpopular war, Genocchio lamented the lack of "politics" and the popularity of fungible art objects.

It can be argued that comments in individual reviews provide a narrow prism through which to view broader trends. Yet the regularity of *Times* reviews—one per year, every year—allows us to draw lessons as well from how the language these critics use changes across time. At a basic level, one can track the swings of the art market—for instance, the slowdown of the early 1990s. In 1991, Raynor noted quite bluntly, "it is not the best of times in the marketplace."[7] Three years later, Holland Cotter suggested that AIM "can't be an easy course to teach these days, with the market still becalmed."[8] A little more than a decade later, the situation had changed. Genocchio wondered, apropos of the "craft fetish" sweeping the visual arts, "Why get hung up on categories when collectors are hankering after anything even remotely handmade?"[9] If one reads a little further between the lines, one sees comments on the participating artists' relative youth that give evidence of another art world development. Early reviewers mention the amateurish or undeveloped quality of some of the art on view, ascribing it to inexperience. During the mid-1990s such observations sharpened, as the critics commented upon the uniform proficiency, if not sophistication, engendered by the participants' art school education. By the middle part of the decade just past, this had curdled into acidic appraisals of the value of MFA programs: After suggesting that the 2003 exhibition was filled with "the kinds of

work that graduate students all over the nation are producing," Ken Johnson asserted that "what is most urgently needed here is not career coaching but some constructive critical input."[10] Roberta Smith took this still further in 2008, suggesting that "perhaps an overfamiliarity with Conceptual Art and especially the theories it inspired can leave young artists with no sense of how to make an artwork that holds together as an experience."[11] While the artists it churns out may not often meet these critics' standards, through their comments we can see that over the past two decades the MFA program has become an institutionalized part of the art world landscape.

Motivations for these writers' sharply critical orientation cannot be divined. But it's worth noting that the value judgments inherent in these observations about the *art world*—what seems like a consistent negativity—are counterbalanced by regular praise for individual *artists* included in the exhibitions. What remains unexplored in these texts is the unique structure of the AIM program itself. The newspaper review must adhere closely to the objects readers will encounter upon a visit to the gallery, and the trade magazine editor often won't consider nonthematic group exhibitions of young artists worth analyzing in her pages. Yet these annual summertime presentations are not regular group shows; they are the culmination of an intensive, months-long educational and social process. Should the AIM program's distinctive structure—and its effects, if any, upon the objects presented in the gallery—be analyzed critically? This is where a more broadly conceived criticism should step in. The singular nature of the AIM program calls out for equally idiosyncratic examination; critics should feel encouraged to explore the boundaries of the review format. The changing media environment that we are currently navigating—especially the proliferation of new distribution technologies—may provide opportunities for such efforts. What would it mean for a critic to "embed" with an AIM cohort for some time prior to reviewing the exhibition? Or to discuss the maturation process itself? The newspaper review remains an important rite of passage for young artists; it allows them to see how the ambiguousness and richness of their work is distilled by the mind of an astute viewer, and it introduces them to a wider audience than they might otherwise have found. But during the past thirty years, both criticism and the marketplace have undergone fundamental changes. Marking the anniversary of Artist in the Marketplace provides an opportunity to rethink the ways in which critics evaluate the capstone exhibitions. Doing so thoughtfully could provide benefits to both artists and critics.

Notes

1. Peter Schjeldahl, *The Hydrogen Jukebox: Selected Writings of Peter Schjeldahl, 1978–1990* (Berkeley: University of California Press, 1993), 63.

2. Maurice Berger, ed., *The Crisis of Criticism* (New York: The New Press, 1998).

3. Raphael Rubenstein, ed., *Critical Mess: Art Critics on the State of Their Practice* (Lenox, Mass.: Hard Press Editions, 2006).

4. Vivien Raynor, "Two Shows at the Bronx Museum of Arts," *New York Times*, June 14, 1987.

5. Vivien Raynor, "Show Serves as a Cosmopolitan Clearinghouse for New Talent," *New York Times*, July 26, 1992.

6. Benjamin Genocchio, "A Chance to Fill Up on Visual Treats," *New York Times*, April 25, 2004.

7. Vivien Raynor, "Introspection and Obsession Fill the 1991 'Marketplace' Show," *New York Times*, July 21, 1991.

8. Holland Cotter, "A Showcase for Artists Learning the Business," *New York Times*, August 19, 1994.

9. Benjamin Genocchio, "When Artists Discover Craft-Oriented Kitsch," *New York Times*, August 21, 2005.

10. Ken Johnson, "From Small Sculptures to Glimpses of Signs, a Mix of Works in the Bronx," *New York Times*, August 15, 2003.

11. Roberta Smith, "'How Soon Is Now?' Exhibition at the Bronx Museum of the Arts," *New York Times*, July 25, 2008.

"The artist is conceptual, the work is immaterial, the agreement is verbal, and we only accept cash."

THE DEALER

*"Your videos aren't connecting with
white European collectors."*

Gallerists and the Marketplace

CARLA STELLWEG

The Bronx Museum of the Arts' invitation to contribute to the anniversary publication of its Artist in the Marketplace program recalls my experiences of the 1980s when the program was initiated and I took part in it as a guest speaker. My gallery began in 1988 and was shaped by a vision to create a hybrid space that could provide the New York art world with exposure to the international Latin American and Latino artists and art market. Secondary market revenues enabled me to jumpstart the careers of those artists I had worked with previously, as an editor, writer, curator, and friend, in addition to a roster of a select group of then-unknown "emerging" artists. It took a lot of effort by the artists and me, as well as the interest of colleagues at alternative spaces, museums, independent curators, and a small group of collectors, to propel several into the curatorial and critical spotlight and, eventually, into the international marketplace.

Revisiting the 1980s gallery–artist relationships, I find it striking that most small outposts mimicked the relationships of a family, with its interdependencies and disagreements, often leading to separations and eventually ending in divorce. Today, by contrast, New York galleries are more professional and exhibit a business acumen that has in turn radically transformed the artists' role, to the degree that in seeking gallery representation, artists from around the world have appropriated the methods and strategies of "art as business."[1] These and other aspects of the complex gallery–artist–market relationships have over the past three decades resulted in an array of scholarly publications focusing on the "architecture of the art market and the change from disinterested promoters and patrons to merchants and marketeers."[2]

The foregoing is especially relevant in considering the unique role of the select group of gallery owners herein invited to partake in an electronic interview. Rather than follow the route of art as commodity only, their determination and resolve has been and is to work in tandem with

their artists, nurturing and building their careers in a relationship that is first dialogic and second lucrative.[3] In exploring their background and their role in the overall marketplace, it is remarkable how recent the history of the "art gallery" is: Galleries became a principal driving force and rose to prominence only in the 1880s![4] At that time a group of forward-thinking critics and dealers, joined by several adventuresome collectors, facing the academy's closed doors, joined in a powerful alliance to start what is today commonly accepted as the marketplace.

In examining the overused cliché that a gallery is *the* testing ground for artists seeking critical, curatorial, collecting, and institutional attention—the stage where they either make or break it—it also holds true that galleries would not exist if it were not for the risk-taking, innovative, and talented contemporary artists they choose to launch into the art market's ideology. This often chilling ideology of "money talks" can be opaque and offputting not just to the general public but especially to young and inexperienced artists whose work requires a complex set of exchange values.[5] The gallery world is on the one hand a capitalist world while on the other hand galleries are also cultural institutions and serve as gatekeepers to the art world.[6] The gallery is also a construction of social and financial networks—the nerve center from which the artist's work is projected into the public sphere, resulting, one hopes, in renowned and prestigious public and private collections that at the same time validate all involved: the gallery, the artist, the collector, and the institution.[7]

From the many galleries that participate in today's marketplace, the five New York–based galleries that agreed to participate in an electronic interview are Carolyn Alexander (Alexander and Bonin), Augusto Arbizo (11 Rivington), Josée Bienvenu (Josée Bienvenu Gallery), Louky Keysers Koning (LMAK), and Brent Sikkema (Sikkema Jenkins & Associates). Their example provides a slice of the broad-ranging current gallery and market realities. Their responses are not just useful but also clear evidence and a testimonial of their vision and mission, in addition to specific gallery practices and policies in regard to signing new artists and the kind of interchanges artists may expect.

The five galleries all evolved from earlier experiences in the art world, with various incarnations that have shaped their current focus and identity. Notwithstanding each gallery's transformations, none have wavered in their conviction that their success is intimately linked to that of their roster of artists, who all come from distinctly diverse backgrounds and work in a variety of media.

Carolyn Alexander and co-partner Ted Bonin grew out of Brooke Alexander Gallery while Josée Bienvenu began at 123 Watts where she focused strictly on drawing resulting from what she describes as ". . . two encounters that shaped the future. The first was with Uruguayan artist Marco Maggi, who had his first solo show at 123 Watts in 1998 and the second with a great collector, Wynn Kramarsky, who had heard [that] the gallery showed interesting drawings and knocked on the door one day . . ." Today Bienvenu has expanded from drawing only to concept-based art, mostly from Latin America.

The common thread between the artists I show is their attention to the time involved in making a work and the time required in viewing their works, to question the very notion of time. With that in mind, in 1999 I began a series of exhibitions titled "microwave" that captured these concerns: attention to detail, scale, and time as tools to slow down and start thinking about the invisible (whether it is the stock market, the Internet or the oil pipes mapping the underground, the most powerful forces at play today are all invisible).

Louky Keysers Koning's gallery history began in 2005 and went through several processes and changes: ". . . the gallery first had two spaces: one in Chelsea (main gallery space) and one in Williamsburg (project space) that focused on events such as lectures, performances, and screenings. It allowed for a very dynamic atmosphere and a hybrid program that brought artists and collectors together." In 2008 LMAK gallery moved to the Lower East Side, with Bart Keysers Koning joining as co-director. The gallery focuses on artists who are dedicated to working full-time in their studio:

They are from all over the world and demonstrate their commitment to the process and time each artwork requires. We are keen on how this is reflected in their work. Generally the artists' focus is not driven by one particular medium but rather by what befits their ideas. In addition, we are devoted to [introducing] and [fostering] collectors to new horizons of visual culture and knowledge, through a variety of visual, sound or concept works. Our new location, in an accessible neighborhood that welcomes collectors, calls for a focused program.

Carolyn Alexander noted that Ted Bonin and she prefer to work long-term with artists:

We have looked at artists whose careers we could and can build through exhibitions in our own gallery and others and encouraged

their participation in biennials, museum exhibitions, and public art commissions. We've always wanted to work with a diverse group both in terms of medium (sculpture, painting, video, installation, etc.) and origin. The artists are not connected thematically, but you could say they have a strong conceptual base. It's too varied a group for me to make generalizations.

Augusto Arbizo, referring to his gallery's history, said, "The gallery is a younger outpost of Greenberg Van Doren on 57th Street, focusing on emerging and international artists. I am very active in doing regular studio visits, and my primary interest is to be part of a dialogue with artists and to find, nurture, and sometimes rediscover talent." When asked how receptive his gallery is to identifying new talent and where and how he looks for new talent (artists, collectors, etc.), he replied:

I am always curious and definitely always listen to artists who already are part of the program, or artists whom I had an opportunity to work with before, and to curators who are active in seeing new work. It's like a network. I try to be open and objective and don't necessarily go on visits with the goal of finding artists for the gallery but want to find out what young artists are doing, what they are looking at and are responding to, what they like and don't like. On the flip side I am also very much there to help, whether it's to connect them with other arts professionals, or just give them very practical advice on their work, and help them to see and imagine it outside of their studio.

Brent Sikkema's gallery began in 1991 when, as he recounts,

[A]fter moving from Boston to New York, I opened Wooster Gardens in SoHo. In 2001 the gallery moved to Chelsea and the name changed to Brent Sikkema Gallery. Later, after Michael Jenkins joined the gallery as a business partner, the name changed again to Sikkema Jenkins & Co. The gallery does not focus on any particular type of contemporary art and represents artists of many different backgrounds who work in a variety of media: painting, sculpture, photography, video, works on paper, installation, etc.

In regard to taking on new talent, Sikkema clarifies: "We have been showing less-established artists that are not on our roster in smaller shows in the gallery's smaller rooms for a while now. We might consider an artist for a show after seeing [his or her] work in a group show or on the recommendation from a curator. Of course there is then a process of

visiting the studio and getting to know the artist." Similarly, Louky Keysers Koning summarizes her approach to new artists as follows:

> [W]hile the gallery expands and enriches its existing program, we [remain] involved in new talent by listening to suggestions from artists we know, to art professionals and collectors. We also do a lot of legwork visiting open studios, exhibits, and fairs. Reading catalogues, Internet articles, and art magazines also keeps us informed.

Carolyn Alexander adds:

> [Ted and I] travel a great deal throughout Europe and South America and see many exhibitions in galleries and museums and at international exhibitions such as biennials. We pay attention to recommendations from our artists and curators who are familiar with the gallery. Since we work with more than twenty artists and want to be in close contact with each of them we decided in 1995 to have a small staff and stay focused on the artists for whom we are the primary representatives. We have not changed our way of working since.

On the subject of whether artists should contact a gallery by e-mail, portfolio, or in person, and what advice would they give artists interested in working with a gallery in order to nurture relationships and develop strategies that will help them effectively and proactively manage their careers, Carolyn Alexander offered the following: "Young artists should contact young galleries. We don't accept portfolios and very rarely meet with artists. Artists should work from within their own communities. Art schools, nonprofit spaces, get to know young curators, keep up their contacts with their peers." Meanwhile Louky Keysers Koning suggests that for artists to

> become familiar with a gallery and its program they should regularly visit the exhibitions and attend events. Artists should avoid being like strangers walking in off the street. First find out if there is a natural "fit" for your work while offering the gallery an opportunity to notice your interest in [its] work. As to open submission policies, check gallery Web sites, and if no mention is made, call to ask if [open submission] is acceptable. If so, ask what is the best way and who is the contact person in charge. Artists should not contact a gallery if [it doesn't] accept submissions. A follow-up phone call is very important. Moreover, once the artist has gallery representation, they must become a team as it is paramount to gain each other's trust and share

"So it's a deal: You make the works; pay for production, installation, and promotion; we use your collectors and contacts; and in exchange we say you are cool."

information. Once that kind of gallery–artist relationship exists, he/she can develop a successful career.

Josée Bienvenu added:

To show up out of the blue with a portfolio is never a good way to approach a gallery. I recall critic Jerry Saltz saying how he hates dealers' giving him a sales pitch about their show; well, for a dealer nothing is worse than [artists] at the front desk asking to show their work and wanting to leave their material right there and show you the paintings they are carrying under their arm. It is like a stranger coming up to you to ask you out for coffee. However, I think it is important for an artist to go in person to galleries on a regular basis, follow their shows to understand the programs, and then think about how to approach them and introduce their work if they feel that they are in tune. I also know many artists who established relationships by having day jobs at galleries, working as art handlers or registrars. It is a good way to develop ties in the art world. Collier Schor was an intern at 303, Cindy Sherman worked the front desk at Artist Space, and Jeff Koons used to sell memberships at MoMA. My advice is to try to understand the multilayered gallery map, to detect a few galleries they can work with and then find a way to contact them.

Augusto Arbizo of 11 Rivington noted:

An artist has to see shows all the time and have galleries see you visiting their spaces on a regular basis. The most organic way is to start a dialogue, not about work necessarily, but other things, to see if you have shared interests and ideas; this is one way to make a connection. But really, the primary advice I give artists is to really just focus on working, and to maintain a rigorous work practice; you can do a lot of strategizing and campaigning to get people for visits, but you have to have work, and a lot of work, in the studio for a gallerist to be able to visualize seeing *your* work in *their* space."

About this, Brent Sikkema says:

Because there would be just too much interest, we really don't have the ability to review submissions to the gallery. The gallery must therefore enforce a strict policy of not accepting unsolicited submissions. Developing relationships with other artists, curators, and galleries is important, but it's best if these relationships develop naturally and are not for the sole purpose of advancing [one's] career or getting into a show.

As to the question of what artists should know prior to agreeing to work with a gallery vis-à-vis contracts, commissions, discounts, and so on, the comments were equally illuminating and revealing. Brent Sikkema said, "Galleries often work under casual agreements with artists. Artists must be proactive and protect themselves by being familiar with gallery policies—commission, splits on discounts, etc. They shouldn't be afraid to ask questions about these issues and, if they feel it is necessary, outline their concerns in a contract or written consignment to the gallery." Augusto Arbizo believes [that]

> you have to find yourself in a nurturing environment, with you and the gallery having shared goals to grow together over time. All the basic terms are more or less standard (commission splits, archiving of artwork, insuring work, transport coverage), but it's also important to have trust and transparent communication. It's a collaboration in which both the artist and the gallery must fully support one another. It's not enough to just give the gallery artwork to sell and have shows every one or two years; you must also be supportive of your dealer and the gallery.

Louky Keysers Koning further noted:

> When artists start working with a gallery, they don't know how the relationship will unfold, therefore I suggest [they] begin with a consignment agreement instead of a contract. In general, gallery commissions are 50 percent. Artists should find out what the gallery's policy is regarding discounts. At the outset, make the consignment agreement for a fixed period of around six months to continue moving the work after the show. Avoid misunderstandings and address issues such as commissions, retail prices, and possible discounts and find out if the works are insured. Even though we all wish for sold-out shows prior to the opening, reality is different—especially in the current market. In general I think consignments are sufficient if the relationship between artist and gallery is built upon trust. Still, artists should create an inventory with notes and the works' location and condition in order to build the relationship and let the gallery know what is available, with details of price, location, etc.

Josée Bienvenu elaborates on this topic, saying:

> The art world is very unregulated, which is both a blessing and a curse and allows a lot of freedom; at the same time, there is no standard protocol for galleries and artists. Customary protocol is to split sale

proceeds 50/50 and agree to share or not share discounts. My advice is to enter the field from the perspective [that] a gallery is a "partner-in-crime," instead of a client/purveyor or mother/child relationship (in France the "primary" gallery is still called the "mother gallery"). The most important factors are teamwork and trust. Perhaps some key elements in writing (not necessarily a contract but at least by e-mail) before the first solo show to avoid future misunderstandings. In a gallery–artist relationship artists should know [that] the gallery isn't going to take care of their entire career while they hide and work in their studios. Artists need to be engaged with their community of fellow artists, curators, art critics, and collectors to develop and nurture relationships that will benefit his/her career.

Carolyn Alexander adds:

Artists should feel confident that the gallerist is convinced [of] and enthusiastic about their work. They need to have a clear under-standing of what the gallery commitment involves in terms of exhibi-tions, promotion, and finances. The commission the gallery takes, their policy in terms of discounts, what the gallery is paying for. [Artists need] to recognize that they are also making a commitment.

Finally, when asked how they operate under today's difficult economic circumstances and whether this has affected their ability or willingness to work with new talent, Josée Bienvenu offered some sobering but encouraging words:

[The year] 2009 was a difficult [one], for about nine months when no one was buying much and people stopped going to visit shows at the gallery. Surviving this crisis taught me to be more careful about the way I run my business, and its small infrastructure makes it easier to expand when the market is booming and compress when expenses surpass income. I don't think crisis affects the ability to work with new talent. To the contrary, it is an opportunity for artists and a gallery to reevaluate what really matters since new talent is the heart of a dynamic program. Also, when sales are slow you have to invent new ways to communicate and reach out. For instance, during the crisis the art world started to become friends on Facebook and, since not much was going on, [updated] their pages with stimulating infor-mation, which resulted in dealers' looking at each others' galleries more.

Louky Keysers Koning concurred:

As the market changed, we noticed collectors really want to be informed about the artist developments (e.g., shows, articles, etc.). Artists need to provide clear and easy-to-read information; quality instead of quantity matters more. Use Internet tools; [the Web] is a great platform with which to launch a user-friendly, interactive Web site (e.g., video interviews, blogs), keep it updated to promote return viewers. It is a great time for full-time committed artists. Don't wait: a downturn market offers great new chances for upstart projects.

Carolyn Alexander added:

Today's market has not affected my disposition to work with new talent—it's more about how much time and energy I have. I won't commit to an artist unless I feel I can do something for [his or her] work. In general, as a result of the state of the art market, we have reduced the number of exhibitions we have and are more conservative in terms of production support.

Brent Sikkema observes: "Today's economy does pose many challenges, but we find that great art still attracts the attention of collectors and institutions. We are willing to show new art that we think has this quality." Augusto Arbizo stated: "In terms of operating a gallery, one must operate responsibly and on low overhead, no matter what the economic circumstances. This is the way to run a business. At the end of the day it is very much a retail operation, so it has to run efficiently and effectively and when it becomes difficult, one has to be even more creative and enterprising." And Louky Keysers Koning concluded:

[W]e used the time for self-reflection and efficiency, creating a consistent and enduring dialogue between our artists and their audience. A well-organized gallery can focus on promotion. We also enforced stricter "rules" with regard to the issue of artist–gallery teamwork and discontinued our relationship with those artists where this was not the case. It didn't affect our interest in new talent, as it is always fascinating and inspiring to discover new talent and to develop that artist's career.

Notes

1. Daniel Grant, *The Business of Being an Artist*. New York: Allworth Press, 1991.

2. Olav Velthuis, *Talking Prices: Symbolic Meanings of Prices on the Market for Contemporary Art.* Princeton: Princeton University Press, 2005, 21–23.

3. Arjun Appadurai, *The Social Life of Things: Commodities in Cultural Perspective.* Cambridge: Cambridge University Press, 1986.

4. Kevin F. McCarthy, Elizabeth Heneghan Ondaatje, Arthur Brooks, and Andras Szanto, *A Portrait of the Visual Arts: Meeting the Challenges of a New Era.* Arlington, Va.: The Rand Corporation, 2005.

5. Frederic Jameson, "Postmodernism or the Cultural Logic of Late Capitalism." *New Left Review* no. 146, 1984.

6. Diane Crane, "Reward Systems in Art, Science and Religion." *American Behavioral Scientist* 10 no. 6, 1976, 719–34.

7. Laura de Coppet and Alan Jones, *The Art Dealers: The Powers Behind the Scene—Tell Me How the Art World Really Works.* New York: Cooper Square Press, 2002.

"Since we couldn't afford a landscape architect,
I hired a land artist."

THE COLLECTOR

"Would you have anything a bit more pretentious?"

The Scoop on Miami

AXEL STEIN

Miami's recent history was not exactly propitious with regard to what Miami has become today. In a sketchy picture, remember the 1980s—the "Miami Vice" years during which construction, generously financed by laundered funds from the illegal drug trade, flourished. Then came Hurricane Andrew with its devastating effects in 1992; and in 1996, the city was awarded the title of the fourth-poorest city in the country. But in the 2000s the city picked up new steam, and although the current financial climate is far from brilliant because of the recent global economic downturn, the national perception has rapidly upgraded Miami from dormant-sunny-spot-for-retirees-with-Seaquarium-and-Calle-8 to a complex city with an international flavor.

In the past ten years Miami has changed its profile to that of a city of the arts. Without question, the choosing of Miami as a winter venue for the prestigious contemporary Art Basel Fair has brought the city national and international attention.

Interestingly, by the mid- to late 1990s two prominent Miami contemporary art collectors had opened private spaces in Wynwood, a depressed and relatively inexpensive industrial zone just north of downtown, to exhibit their collections. The Rubell Family Collection, which houses the collection of Don and Mera Rubell, led the way in 1994 by opening an exhibition space in an old Drug Enforcement Administration storage facility; the example was soon after followed in 1999 by prominent developer Marty Z. Margulies. While the Rubells, who are developers as well as hoteliers, have concentrated on collecting contemporary art from the 1970s onward, Margulies focuses mostly on twentieth-century sculpture, photography, and video installations. In the early 2000s, Venezuelan telecommunications entrepreneur and developer Ella Fontanals-Cisneros founded Miami Art Central,[1] a short-lived museumlike exhibition space for rotating presentations of international contemporary art. In parallel, Cisneros refurbished yet another warehouse, which she

named CIFO, to exhibit her collection of modern and contemporary art from Latin America as well as contemporary photography. And, in December 2010, longtime patrons of the arts Carlos and Rosa de la Cruz inaugurated their new building in Miami's Design District to house a large part of their cutting-edge contemporary art collection. Smaller private spaces like Dennis and Debra Scholl's World Class Boxing and more recent initiatives like Tanya Brillembourg's Ideobox have also opened in Wynwood.

Of course, there are other collectors in Miami who prefer to keep a lower profile, but it's also true that, should someone have the right introduction, most are happy to welcome visitors. Many elegantly display their art collections in their homes while a few have recently constructed additions to accommodate part of their collections in a dedicated space.

While this active community of collectors is certainly beneficial to Miami's local art scene and its growing international visibility, one could argue that it does not necessarily help to strengthen the efforts of local museums or their roles within the larger community. Indeed, the offerings at the art warehouses successfully compete with and in most cases surpass in quality the menu of the relatively small, mostly underfunded local museums (Museum of Contemporary Art, North Miami (MoCA); Miami Art Museum (MAM); Bass Museum of Art; the Patricia and Phillip Frost Art Museum at Florida International University; and the Lowe Art Museum at the University of Miami. While the city plans to build a new facility for MAM along Biscayne Bay and many locals support these plans, it is also true that others oppose these efforts, arguing that public funds should go toward exhibition and education programs rather than to a new building. Meanwhile, it's not certain what institution(s), if any, will someday benefit from the remarkable collections amassed by these local collectors.

Last, it is important to mention that the Miami arts and cultural sector is deeply indebted to the Knight Foundation, which has set aside a $460 million endowment to support exhibitions and educational programs to ensure that the city's cultural institutions continue to keep the flag flying high well into the foreseeable future.

I met with some of Miami's most prominent collectors: Ella Fontanals-Cisneros, Dennis Scholl, Gonzalo Parodi, and Mónica and Javier G. Mora; I also had a more informal exchange with Jason Rubell (son of Don and Mera Rubell), whose current exhibition at the Rubell Collection, titled "Time Capsule," surveys his rather precocious forays into collecting from the age of thirteen to twenty-one. We discussed the scope

of their collections, how their collections have evolved over time, their criteria for acquiring new work, and their receptivity to emerging artists, as well as their broader civic and philanthropic activities within the arts community and the city of Miami. In the process, what has emerged is a snapshot of Miami's current art scene as seen through a sampling of some of its most dynamic and diverse collectors whose presence and commitment to contemporary art greatly enliven and enrich this city, while certainly enhancing Miami's profile within the broader international contemporary art field.

The Collectors

Ella Fontanals-Cisneros divides her time between Miami and Madrid. She is an avid art collector, philanthropist, and entrepreneur whose businesses span telecommunications, industrial glass, and sugar industries in Venezuela. In 2002, Fontanals-Cisneros founded CIFO (Cisneros Fontanals Arts Foundation), which has recently signed a partnership agreement with Museo Reina Sofía in Madrid aimed at jointly organizing and presenting cultural projects that contribute to raising general awareness about contemporary art, with a particular emphasis on artists from Latin America. Fontanals-Cisneros serves on the boards of MAM, the American Patrons of the Tate, the Cintas Foundation, and the United States Artists.

AXEL STEIN: *Ella, you are one of the most active and high-profile of Miami's collectors. When did you first get infected with the art virus?*

ELLA FONTANALS-CISNEROS: When I was twenty-one, I partnered with a friend to open a gallery in Caracas. We exhibited established local midcareer artists. I then became a collector and, yes, my relationship with the fascinating world of art started at the gallery.

STEIN: *As a former gallery owner and now as a collector, what would you recommend to a young artist right out of his or her MFA?*

FONTANALS-CISNEROS: My first recommendation is not to start a relationship with a gallery right away. Rather, begin to establish a relationship with curators. Why? Because I think a gallery does not want unnecessary risks and thus works principally on the level of what is "known," although they might also feature a couple of maverick artists. On the other hand, curators will take the time to discuss the work

with you, connect your ideas with other interesting artists, and per-haps, with time, include you in a group exhibition. My second recom-mendation is to work very hard, and with time, if you have talent, most probably you will not have to look for galleries to represent you; the galleries will look for you.

STEIN: *Many young artists generally think the opposite.*

FONTANALS-CISNEROS: I can give you an example of the dynamics of that process. As you may know, I founded the Cisneros Fontanals Art Foundation (CIFO). The goal of its Grants and Commissions Program is to offer exposure to emerging artists from Latin America. Once a year, we exhibit the work of twelve artists from the region, each of whom receives a cash award. And, here comes the interesting part for the artists: It's common to see gallery owners at the opening exhibi-tion. We also send e-blasts and press packages with the catalogue that we produce as well as information about the artists to galleries and museums around the world. The purpose of the program is to offer a fertile ground for emerging artists to—emerge!

STEIN: *Tell me more about the Foundation's Grants and Commissions Program. How does it work?*

FONTANALS-CISNEROS: The original idea was to establish a residence and a scholarship program for Latin American emerging artists. But we quickly realized that was too complicated and ineffective. We are now focusing on an awards and exhibition program. The selection process is the responsibility of a team of more than two dozen of CIFO's inter-national associate curators who nominate the artists. The curators meet in Miami once a year with the Foundation's Board and we jointly review about 200 portfolios and choose the final 12 artists who will be showcased in our annual exhibition. The Foundation acquires all of the artwork for its collection. The next goal is to circulate these works in the United States and Europe. This program is our way of supporting and nurturing the emerging artists community in Latin America, who, because of the distance, are often seemingly isolated from the international art circuit and audience they wish to reach.

Dennis Scholl is the founder of Betts and Scholl, a maker of fine wines in Australia, California, and Italy. He is a member of the Guggenheim Museum's Photography Acquisition Committee and the Tate Modern's American Artists Acquisition Committee. Scholl currently serves as Vice

President and Arts and Miami Program Director of the Knight Foundation in Miami.

AXEL STEIN: *The Bronx Museum's forthcoming publication* Taking AIM! The Business of Being an Artist Today *is a guide for emerging artists. How recent is the art you collect?*

DENNIS SCHOLL: Sometimes [my wife] Debra and I joke about it and we say that we collect art made last Tuesday.

STEIN: *How do you go about finding or learning about young artists?*

SCHOLL: The first line of learning is through the gallery. The dealers do a tremendous amount of work in selecting people. Young artists don't like to acknowledge this, but there is a system. You get out of a good MFA program and people begin to look at your work. There's a system in which, if you have a certain talent, you get to be included in a summer group show in a New York or in a London gallery. From that, if things go well, you might be offered gallery representation and you might have a solo show. After that, maybe you get into a museum group exhibition. Again, there's a real system that takes place, and many people don't like to hear that because that system is very much like a winnowing process. It limits and cuts down the number of artists who are seen and represented, but I have to say that we do use the dealers in that process quite a bit, maybe less so now than we used to because we now have more personal experience and knowledge. When we don't find artists through dealers, they generally come from two other sources. One is from art curators all over the country. We have a relationship with many of them. The second source, interestingly enough, is through other artists who maybe are a little further along in their career and are very generous in recommending young artists whom we might go take a look at. We've had a lot of success in looking at work that's been recommended to us by both curators and by other artists.

STEIN: *Do you visit artists in their studio? Do you engage, maintain a relationship with the artists you collect?*

SCHOLL: We do studio visits, but we don't do them as often as one might think. Sometimes we'll do a studio visit of an artist [whose work] we've been collecting for a while because I think that it helps us understand the work better, but when I'm trying to decide what to acquire for the collection, which is a big decision for us, I don't always think

"I would kick him out, but every time he wakes up he buys yet another artwork."

a studio visit is so helpful. This is because seeing the work in the context of the studio is different from seeing it in the context of a gallery or a museum or even another collector's home because that's how the work is going to be seen in our collection: at home or at our public space in the Wynwood district. Again, we let the dealers and the curators make that winnowing process and bring the number of artists whom we consider down to a—I wouldn't call it a manageable level because there are so many good artists that we will never get to see, but to a level that we can handle.

STEIN: *What would you recommend a young artist do in the first few years of his or her career?*

SCHOLL: I think that if you're going to be part of a subculture—and the contemporary art world is a subculture—you have to show up. You have to be involved. You have to go to other artists' openings and meet people. You have to put yourself out there in a way that creates the connections that will allow people to see your work, be interested in your work. There are too many artists who think of themselves as *Bohemian* artists—they're working up in the garret and they just wait for somebody to climb the five flights of stairs and show up at their door. It just doesn't work that way. The art scene is a very social and engaged community. Artists have to do the work. Many artists think it's 99 percent making the work and 1 percent putting it out there, but it's really closer to 70 percent making the work and 30 percent getting out there and establishing relationships and finding ways to have people see the work. That's hard for some artists, but I think it's critical.

STEIN: *In 2003 you refurbished a space in Wynwood to exhibit selected works from your collection. What led you to open World Class Boxing?*

SCHOLL: The space was a necessity. We started acquiring works that were too big for our home. It is sad to acquire a work that you can't show. It all began when we acquired a work by [British artist] Simon Starling, *Inverted Retrograde Theme, USA (House for a Songbird)*. It was 400 square feet. We didn't have a space at that time. We were just in love with it and thought it was a really important work and really couldn't bear not to have it. So we acquired it, and then the space followed. We thought immediately to open the doors of WCB. One of the joys of having a public space for our private collection has been to commission work from artists who maybe for the first time are getting a big white box and are able to do whatever they want in it.

STEIN: *How is your wife, Debra Scholl (Chair, Board of Directors, Locust Project, Miami), involved in the acquisition process?*

SCHOLL: Yes, we don't collect separately. We don't say, "You get one and I'll get one." We have a two-vote rule, so anything that we're interested in, we have to both agree upon. That makes us collectively, the two of us, a better collector than either of us separately. Sometimes, in front of a work, I get really excited and I want to go crazy when Debra goes in the opposite direction. So, when we collect together, we balance each other out and we wind up with just about the right stuff most of the time, which is a lot of fun.

Gonzalo Parodi is a former professor of philosophy–turned–banker and trader. He is on the Board of Trustees of the Miami Art Museum and works closely with the museum and the University of Miami to promote programs that expand the discourse on contemporary art and philosophy. The primary focus of Parodi's collection is contemporary Latin American art and photography.

AXEL STEIN: *When did you start collecting?*

GONZALO PARODI: I started in my early twenties, probably at the age of twenty-four, and it was the direct consequence of two events. The first is that I come from a family where there's an artist—my mother was a ceramicist and a painter before becoming fully immersed in the fashion industry. The second is my own educational background. I studied and taught philosophy at the university level before I embarked on my current profession in the financial world. And what I discovered, as I saw my parents collect and when I came to the United States as a philosophy student, were some areas that I found very interesting and that have become the fundamental basis of my collection, which is abstract art from Latin America.

When I was growing up in Venezuela we were surrounded at the time with quite a bit of abstraction, mostly of the kinetic type. When that kind of geometric abstraction was exhausted, artists turned to more conceptual strategies. In Venezuela, these strategies were not as obvious as in other parts. Conceptual art or minimalism in Venezuela took a very different shape than in Brazil, for example. Exploring the diverse routes of Latin American, American, and European *passages* from the sea of abstraction to the open oceans of conceptualism is what I enjoy doing today.

STEIN: *And so, who are the artists that you started collecting? I don't mean the masters like Jesus Soto, Alejandro Otero, Carlos Cruz Diez,*

or Gego. Who were the artists standing on the newly discovered shores of your journey as a collector?

PARODI: I was very interested in the case of Venezuela, where I had immediate access to work and to artists, to all of Gego's students such as Eugenio Espinoza and his astute deconstruction of Venezuelan tyrannical kinetic formulae. I also started looking at Claudio Perna, a brilliant mind who is one of the leading figures of the postgeometric renaissance. I discovered that in Venezuela there was real sensibility toward criticizing the exhaustion of this geometric vocabulary. I became fascinated with understanding this, sort of like a postmodern critique in the work of Héctor Fuenmayor and other artists of the 1970s whose work you can see on my walls.

STEIN: *Do you know these artists personally, or did you come to know about them by visiting galleries?*

PARODI: It's a combination—I've done my own research, worked with dealers, and met artists who have led me to other artists. I also read a lot. Curators have also helped in that respect quite a bit. So it's a combination that makes up this art world and my experience. I know personally about half of the artists I've collected. Today, my collecting has changed radically as I have matured. I'm more interested in seeing the work of living artists and pushing the proposals of *young* artists.

STEIN: *How would you describe your interaction with young artists? Do you visit studios? Do you buy from them directly, or would you rather invest in artists who are represented by a gallery?*

PARODI: Initially, I like to go to artists' studios. I certainly get dealers involved (if any is closely associated with the artist) and I will ask a lot of questions to understand what the artist is trying to achieve. I try to understand the artist's thought process, and in some cases the result is what could be perceived as a collaborative process to which I feel a strong bond and identification. Yes, rather unconventional as a collector, I enjoy being a part of the intellectual and creative process. Obviously, in most cases, I acquire works with which I have an emotional and intellectual entanglement. To me, the most satisfying aspect of collecting art today is my ability to have a dialogue with the artist.

STEIN: *You live in a relatively small space by the standards of a typical collector here in Miami. How does this affect your collecting?*

PARODI: Collectors are always concerned about accumulating objects and exhausting our space capabilities. I also consider the whole issue of

conservation and insurance in *carrying* a collection. I regularly ask myself how and what will be the development and the final destination of the collection. As much as we get extremely excited about work we still have these concerns, and in a way that has shaped my way of collecting because I don't live in a large space. And as a collector, I don't intend to have a public space. My hope is to engage institutions that understand and care about the work I am interested in and want to carry it forward into the future.

Having the piece is beautiful . . . it's great. But sharing the work is even more satisfying. And eventually these objects will find themselves having a life of their own, maybe in an institution, maybe in the marketplace, but to me the most important thing about collecting contemporary art by living artists is to meet them, to share with them, and to some extent be a part of their creative process.

STEIN: *So, if you were to imagine yourself as an artist, if you worked in a studio and were looking for a way to reach the public, what do you think artists do right or wrong in searching for communication channels? What would you recommend to a young artist, perhaps just out of school? What should he or she do after framing that diploma?*

PARODI: This is a very good question. I think that, first of all, I would tell them not to fall into the trap of thinking that just because the art world has changed dramatically and there are tons of opportunities, tons of collecting, tons of mechanisms to disseminate the information, that it's easy to find the right representative or dealer for their work. The first piece of advice is to be very patient. Take the time to find dealers who are courageous and willing to support their proposals. Also, the artist should support the dealer by being patient and actively engaging the collecting community and being part of events where they can articulate exactly what they are trying to achieve. I think that along the way, so much is going on in the art world that inevitably, if the artist exposes him- or herself to such environments, such a network, inevitably [the artist] will find the right combination, the right dialogue.

STEIN: *Most young professionals shortly after coming out of school want to make a start, and many think of the mythical "instant success" stories. Parallel to the development of their talent, artists are honestly trying to have a place in the art market, so what should they be aware of?*

PARODI: Certainly, art has become an asset class. And, you know, I don't want to complicate my answer, but when collectors and dealers think

of buying art, they take very seriously the kind of commitment they make toward buying something and they don't see it just for the pleasure and the joy; they see it also as a financial commitment. The dealer must address that with the clients. I think artists need to understand how important and how serious is the commercial aspect of their artwork and how their dealer is managing such expectations on the collector level.

And so I think that it's very important for young artists to be patient with a dealer who knows how to disseminate their work, knows how to place it properly among a very wide universe of collectors. And that takes time, but eventually it pays off because from the market perspective and also from the point of view of understanding and sharing the artist's process and evolution it's really the best way to go about it.

So, thinking you're going to have the life of a rock star could be a trap . . . a trap that the "easy" market mechanisms offer. Quick success is very dangerous. I would recommend patience and real hard work as in any other profession.

Javier and Mónica Mora are a Cuban–Venezuelan couple based in Miami since 2001. Javier Mora is a banker and trader. The Moras have two overlapping collections—the first is dedicated to arts of the Americas with an emphasis on Venezuelan and Cuban art from pre-Columbian to modern art. The second collection is much more dynamic and ever-changing; it focuses on cutting-edge contemporary art with an emphasis on art produced since the early 2000s. The Moras share their passion for collecting with their children, Javier (twenty-four), Daniel (twenty-two), Mónica (seventeen), and Andrea (fifteen).

AXEL STEIN: *When did you start collecting?*

MÓNICA MORA: Javier was the first into the equation. He was contaminated with the art virus during a summer internship in a Washington, D.C., gallery.

STEIN: *But Mónica, you grew up with beautiful art on both sides of your family.*

MÓNICA MORA: True, but the kids in those days were not involved in the art decisions; it was only my parents' territory. We visited museums [during] our trips to Europe, but we were not really involved at all. Javier and I did the exact opposite of my parents.

STEIN: *That's very interesting. So what do you do with your kids?*

MÓNICA MORA: We take our kids on trips to New York, on occasion to Europe; we go to the galleries, museums, and art fairs. If we like an artist, we share the images with [the children] so they can have their own opinion. Sometimes we have very passionate conversations at the dinner table.

STEIN: *To what extent do your children participate in the decision making?*

MÓNICA MORA: We listen to their [opinions]. We have artwork on the walls here that were picked by them, but we have veto power.

STEIN: *I remember you started your collection with some modest pieces of modern Venezuelan and Cuban art. Thirty years later, you are in Miami collecting international contemporary art. Who were your mentors?*

JAVIER MORA: In the early 1990s we met Marcantonio Vilaça, a brilliant Brazilian art dealer and founder of Camargo Vilaça Gallery [today Fortes Vilaça] in São Paulo. He introduced us to artists like Vik Muniz, Ernesto Neto, Beatriz Milhazes, Adriana Varejão, and Jac Leirner. We spent a great deal of time with him, and he was the person who really opened the doors of contemporary art to us. After that formative period we moved to Miami, and our arrival coincided with the first edition of Miami Art Basel. Soon after, we were opening our home in Coral Gables to curators, dealers, and collectors who visited Miami for the Fair. This refreshing contact gave us a new impetus to keep refining our collection.

STEIN: *Do you collect work by emerging artists, and if so how do you find them?*

JAVIER MORA: Here in Miami we often go to the New World School of the Arts student exhibitions and we regularly visit young and established galleries in Miami and in New York.

STEIN: *Do you have any recommendations for an emerging artist coming out of school?*

JAVIER MORA: One basic thought that comes to mind is to just be yourself, be completely independent. We personally don't like art that's derivative. We like strong individualistic expression. Obviously it is desirable that young artists get the best possible representation as soon as possible. If the artist is successful, some dealers will perhaps ask the artist

to continue to produce work from a successfully commercial series or body of work. Artists should resist that. That is a big turnoff for us as collectors of younger artists. We've seen artists too often who bend to the dealer's pressure and they lose [their] credibility as true originators. But we understand that at the same time, artists need the galleries . . . so it's complicated.

STEIN: *How do you continue to encourage your kids to follow in your footsteps as collectors?*

JAVIER MORA: My oldest son has a small budget now of his own to start his personal collection. We will supervise his "first flights," but we believe that the new generation must be free from parental pressure so they can develop their personal taste. We wish him a good journey.

Indeed, as Miami's impressive group of collectors continues to grow and the baton is eventually passed to a new, even more intrepid generation of collectors, their combined efforts can only seal this vibrant city's new-found reputation and profile as one of the most exciting venues for contemporary art. One need only visit the current exhibition at the Rubell Family Collection, "Time Capsule," which documents the impressive collection amassed by Jason Rubell as a mere teenager, to know that Miami's collectors are an integral part of its art scene and are well poised to maintain their position and impact well into the future.

Note

1. In its brief history from 2003–6, MAC brought important international art to Miami, including a video art exhibition from the Centre Pompidou and a solo show of the work of South African artist William Kentridge, among others. In December 2006, Fontanals-Cisneros, who at the time was a member of the Miami Art Museum's Board of Trustees, made the decision to fuse MAC with MAM in an effort to strengthen the museum's contemporary programming.

"And then Goldilocks pondered which artist to collect...The first one was too hot, the second too uncool, but the third was just right."

Cultivating Young Collectors
through The Contemporaries

RODNEY REID

There was no art hanging on my walls when I was growing up. In fact, my first exposure to art was not through a family trip to the local museum but through my time spent sketching muscle men, dragons, and race cars as a kid and competing for Scholastic and Kaleidoscope art prizes as a teenager. Growing up at the crossroads of Atlanta's urban streets and rural backwaters, I assumed that collecting art was the exclusive domain of the Rockefellers and Guggenheims. Looking back on my childhood, I would have never guessed that I would one day found The Contemporaries, the largest independent organization for young collectors.

My inspiration for creating The Contemporaries can be traced back to my first visits to museums in my early twenties. Seeking a way to infuse art into my life, I started visiting museums; however, these visits left me feeling disconnected from the mostly nineteenth- and early-twentieth-century works on exhibit. Through a series of coincidences, I befriended a young collector who recognized my limited exposure to contemporary art and began introducing me to it and to the ideals of collecting. Once introduced to contemporary art, I was like a sponge absorbing as much information as possible. I pored over magazines and books to grow my limited knowledge, while tagging along with my friend to galleries and artist studios to develop my eye. Before long I was nervously thinking about buying art but repeatedly talked myself out of it. Eventually unable to resist a charcoal figure study during a studio visit with a young artist, I finally plunked down a few hundred dollars and acquired my first work of art. That purchase cemented my emotional attachment to contemporary art and launched me down the path of collecting.

Arriving in Cambridge only a couple of years later to attend Harvard Business School, I began inviting a handful of my classmates to explore the local art scene with me. Initially my classmates were hesitant, as they assumed I wanted us to stroll through sleepy museums peering at art by

117

old masters. To my classmates' delight, our outings to events like the Somerville Open Studios and the MassArt Auction exposed them to young artists they could relate to and prompted them to tell others about their experiences. As interest in the art outings increased, I teamed up with my classmate and fellow art enthusiast Moran Bar-Kochva in the fall of 2003 to establish The Contemporaries, a not-for-profit platform for guiding our peers through the dense and, at times, formidable world of contemporary art.

Considering that Moran served in Israel's public sector before embarking on an entrepreneurial career and I had struck a path from the South to Wall Street, we made a seemingly unlikely pair to start The Contemporaries. However, our different backgrounds combined with our shared passion for contemporary art have allowed us to connect with a broad and diverse group of young professionals. Since The Contemporaries' relocation to New York City in 2005, it has grown to become the largest independent art collective for young professionals, comprising a melting pot of more than 600 members. Encompassing members from more than 35 different countries, The Contemporaries is evenly split between male and female members and consists primarily of young professionals in their twenties and thirties. While there is a high degree of diversity within The Contemporaries, our by-invitation policy serves to maintain the social fabric of the group and create a valuable connection point between incoming and existing members.

Moran and I founded The Contemporaries as an independent organization to allow us maximum freedom to partner with different art world participants to provide our members access to contemporary art. Through numerous events such as a guided tour of Christie's First Open sale, an exhibition review with art dealer Marianne Boesky, a talk with artist Vik Muniz, and a private viewing of the Adam Sender Collection, Moran and I have exposed hundreds of our peers to contemporary art. The Contemporaries' independence has also afforded us the flexibility to expand the group's objectives to include building a generational support system whereby young collectors support young artists. Daunting student loans and economic uncertainty make young professionals reticent about spending tens of thousands of dollars on contemporary art. To help members find an affordable entry point to start collecting, Moran and I are directing them to media such as photography, prints, and drawings through events like a tutorial with Miety Heiden of Sotheby's on collecting photography and identifying new artists. The Contemporaries is also in the early stages of working with young artists to produce limited-edition prints exclusively for new and novice collectors. The Contemporaries' efforts, along with the spread of Web sites and art fairs

featuring affordable art work, are the building blocks of a support system by which young artists can reach a new generation of art buyers.

Looking ahead, we are considering expanding The Contemporaries beyond New York City to reach a wider audience of young professionals interested in collecting art. Several cities ranging from Los Angeles to London have experienced a spike in the number of young professionals interested in art and collecting. The Contemporaries' expansion into these cities would make it easier for aspiring collectors to connect to one another both locally and globally. Shared collecting experiences among members combined with knowledge passed down by experienced collectors, such as connoisseurship learned from a tour of Susan and Michael Hort's collection, will make it easier for the collecting spirit to flourish within The Contemporaries. Like my own fledgling collection, which has taken more than ten years to grow from the initial charcoal figure study to more than 200 works by artists ranging from Alec Soth and Pieter Hugo to Hiroshi Sugimoto and Chuck Close, I suspect The Contemporaries' cultivation of young collectors will take time as well.

*"I think I saw somewhere something about
you doing something somewhere."*

INTERSTICE

The Leibowitz Questionnaire

CARY LEIBOWITZ

Editor's Note: Artist Cary Leibowitz conducted this informal survey of a cross-section of art professionals about their views on the events, artists, exhibitions, and ideas that have helped shape the contemporary art landscape during the past three decades. What follows are the often candid, as well as thought-provoking, responses of this diverse group of individuals. We are grateful to all of them for their participation and insights.

Barbara Krakow, Barbara Krakow Gallery, Boston

Q: The most significant event(s) that have affected the art world since 1980?

A: Art fairs, expansion of auctions into gallery activity, and [the] Internet. Collectors building their own private museums and not supporting other museums. [A high] percentage of buyers is not made of scholars, and many use consultants of varying degrees of knowledge.

Q: The most influential artists in the past three decades?

A: Sol LeWitt, Kiki Smith, Bruce Nauman, Gerhard Richter, and Robert Gober.

Q: The greatest epiphany you have experienced in the art world?

A: I don't have epiphanies. I have slow growth. That's why I'm 5′2″.

Q: "I still learn and change my mind about art . . ."

A) Daily
B) Weekly
C) Yearly
D) Every few years
E) Not in a long time, but I am hopeful

Q: "Sometimes I feel an overwhelming need to get angry about . . ."

A) Art
B) Art writing
C) Art curating
D) Art buying
E) Art selling
F) All of the above

Q: "Sometimes I see a show or have a discussion that makes me feel so renewed and excited about art. This doesn't happen often, but when it does the joy can last for . . ."

A) Hours
B) Days
C) Months
D) More than a year

Q: True or false: "The most recent art shows I have seen have been the most exciting."

A: Sometimes yes, sometimes no.

Q: True or false: "They don't make art the way they used to."

A: Obviously it's not the same. But [I'm] not making a judgment [about] better or worse.

Matthew Higgs, Director and Chief Curator, White Columns, New York

Q: The most significant event(s) that have affected the art world since 1980?

A: The AIDS crisis, globalization, fall of the Berlin Wall, the Internet, biennials, and art fairs.

Q: The most influential artists in the past three decades?

A: Cindy Sherman, Richard Prince, Martin Kippenberger, Cady Noland, David Hammons, Mike Kelley, Andy Warhol (I think he set the 1980s, 1990s, and 2000s in motion).

Q: The most influential individual(s) in the past thirty years?

A: Kasper König and Catherine David (for "Documenta X," 1997)

Q: "I still learn and change my mind about art . . ."
A) Daily
B) Weekly
C) Yearly
D) Every few years
E) Not in a long time, but I am hopeful

Q: "Sometimes I feel an overwhelming need to get angry about . . ."
A) Art
B) Art writing
C) Art curating
D) Art buying
E) Art selling
F) None of the above

Q: "Sometimes I see a show or have a discussion that makes me feel so renewed and excited about art. This doesn't happen often, but when it does the joy can last for . . ."
A) Hours
B) Days
C) Months
D) More than a year

Q: True or false: "The most recent art shows I have seen have been the most exciting."
A: True.

Q: True or false: "They don't make art the way they used to."
A: False.

Hudson, Owner and Director, Feature Inc., New York

Q: The most significant event(s) that have affected the art world
 since 1980?
 A: Plurality (the good thing) and business/art as investment (the
 bad thing).

Q: The most influential artists in the past three decades?
 A: I would delete the word "most" from your question as I don't think
 that way or encourage people to think that way. Five 1980-ish
 artists [who] I feel strongly influenced the following few decades are
 Bruce Nauman, Mike Kelley, Raymond Pettibon, Charles Ray, and
 Tom Friedman. Yeah, I know, it looks nepotistic as I once
 represented three of them.

Q: The most influential individual(s) in the past thirty years?
 A: Toss-up between Larry Gagosian and Charles Saatchi, influential
 standard more so than important, but most would think it
 important as it made changes in the infrastructure.

Q: The greatest epiphany you have experienced in the art world?
 A: Given your parameters, I'll say in '82 or '83 though I'd prefer to
 say "in the late '60s."

Q: "I still learn and change my mind about art . . ."
 A) Daily
 B) Weekly
 C) Yearly
 D) Every few years
 E) Not in a long time, but I am hopeful

Q: "Sometimes I feel an overwhelming need to get angry about . . ."
 A) Art
 B) Art writing
 C) Art curating
 D) Art buying
 E) Art selling
 F) All of the above

Q: "Sometimes I see a show or have a discussion that makes me feel so
 renewed and excited about art. This doesn't happen often, but when it
 does the joy can last for . . ."
 A) Hours
 B) Days
 C) Months
 D) More than a year

Q: True or false: "The most recent art shows I have seen have been the
 most exciting."
 A: False.

Q: True or false: "They don't make art the way they used to."
 A: False.

Kenny Schachter, Art Dealer, London

Q: The most significant event(s) that have affected the art world since 1980?

A: Big Julian Schnabel and the neoexpressionists ushered in the glamour and money-centric world as we know it today; though the numbers then were more like baseball player Hank Aaron—they expanded the audience to the masses while opening future doors for athletes to earn corporate executive–level salaries. But Schnabel and company were never able to sort it out for themselves [as] Hirst managed to. Then of course along came Damien Hirst, who prints money at a rate faster then the Federal Reserve. Warhol is spinning in his grave with envy because he (and Koons) is as much responsible as Damien himself.

Q: The most influential artists in the past three decades?

A: Paul Thek, Vito Acconci, Warhol, Sigmar Polke, and—I hate to say it, but I'd be remiss if I didn't—Hirst.

Q: The most influential individual(s) in the past thirty years?

A: Vito Acconci and Paul Thek.

Q: The greatest epiphany you have experienced in the art world?

A: I was brought up totally alienated (fat kid) in the suburbs of Long Island with no notion of art or galleries. Procrastinating from a law exam, I hesitantly visited the estate sale of Andy Warhol, which opened my eyes to the commercial side of art. Prior to that, and because I had never before stepped into a commercial gallery, I naïvely thought paintings traveled nonstop from the studio to the museum. When I finally did enter the sterile white walls of a gallery, I was spontaneously smitten (and horrified), took an unsecured loan to acquire a Cy Twombly print, and soon began dealing in works on paper like an idiot savant. From there I went on to teach art history at the university level, curate, write about art, and even make it.

Q: "I still learn and change my mind about art . . ."
- A) Daily
- B) Weekly
- C) Yearly
- D) Every few years
- E) Not in a long time, but I am hopeful

Q: "Sometimes I feel an overwhelming need to get angry about . . ."
- A) Art
- B) Art writing
- C) Art curating

 D) Art buying
 E) Art selling
 F) All of the above all the time

Q: "Sometimes I see a show or have a discussion that makes me feel so
 renewed and excited about art. This doesn't happen often, but when it
 does the joy can last for . . ."
 A) Hours: my moods never last long
 B) Days
 C) Months
 D) More than a year

Q: True or false: "The most recent art shows I have seen have been the
 most exciting."
 A: True and false.

Q: True or false: "They don't make art the way they used to."
 A: True and false: Some do but no one cares about old-fashioned art,
 i.e. the kind that is actually handmade.

Nancy M. Doll, Director, Weatherspoon Art Museum, the University of North Carolina, Greensboro

Q: The most significant event(s) that have affected the art world since
 1980?
 A: Among exhibitions, "WACK! Art and the Feminist Revolution," "Out
 of Action: Between Performance and the Object, 1949–1979";
 " 'Primitivism' in 20th Century Art: Affinity of the Tribal and the
 Modern"; and the repatriation of art objects.

Q: The most influential artists in the past three decades?
 A: Louise Bourgeois, Bruce Nauman, and Bill Viola.

Q: The most influential individual(s) in the past thirty years?
 A: Elizabeth Murray: incredible grace and courage; Philip de
 Montebello: for audio guides (kidding); Kirk Varnedoe and Robert
 Rosenblum: for their scholarship and curatorial sensibilities; Okwui
 Enwezor; and the MacArthur Foundation.

Q: The greatest epiphany you have experienced in the art world?
 A: It's so recent—last Sunday. The Charles Burchfield exhibition at the
 Whitney was a revelation upon his work.

Q: "I still learn and change my mind about art . . ."
 A) Daily
 B) Weekly
 C) Yearly
 D) Every few years
 E) Not in a long time, but I am hopeful

Q: "Sometimes I feel an overwhelming need to get angry about . . ."
 A) Art
 B) Art writing
 C) Art curating: the rise of the global star curators who shape the
 majority of biennials and other international exhibitions
 D) Art buying: how the ever-increasing prices of contemporary art
 have made it difficult for institutions (particularly smaller ones
 without large acquisition budgets) to purchase works for their
 collections; also, the laziness of some collectors who buy according
 to a sanctioned (by someone) shopping list
 E) Art selling: the fact that artists receive no compensation when their
 work sells on the auction block
 F) All of the above

Q: "Sometimes I see a show or have a discussion that makes me feel so
 renewed and excited about art. This doesn't happen often, but when it
 does the joy can last for . . ."

 A) Hours
 B) Days
 C) Months
 D) More than a year

Q: True or false: "The most recent art shows I have seen have been the most exciting."
 A: False.

Q: True or false: "They don't make art the way they used to."
 A: False.

Julia Jacquette, Visual Artist

Q: The most significant event(s) that have affected the art world since
 1980?

A: 9/11 has been an event of huge importance, especially for artists,
who as a group feel compelled to "witness" and "process" the world
around them. But I don't think 9/11's effect has completely (or
even partially) manifested itself in the work of artists *yet*.
Another major event of the past thirty years has been the onset of
AIDs. One consequence it's had, and maybe this is not a bad one, is
the fact that so many artists brought their own personal
narratives/opinions/politics into their work. Many folks are a bit
weary at this point of artwork that focuses on "identity politics,"
but I am personally more compelled by work in which the maker
relates the content of the work to himself/herself.

Q: The most influential artists in the past three decades?

A: For me, one of the most influential artists of the late twentieth
century (who actually died in 1980 so I'm cheating a bit) is Philip
Guston. His artwork dovetailed the personal into the political
without ever being didactic, was always self-deprecating, and was
really visually interesting to boot. Louise Bourgeois was important
to me (and, I also believe, to other artists and the world in general)
for many of the same reasons, and also because she was an
individual who steadfastly kept creating compelling, gut-wrenching
work until the day she died—at ninety-nine years old. Just as
important is the critic Mira Schor. Her essays (and the journal she
created with artist Susan Bee, *M/E/A/N/I/N/G*) were so revelatory
to me as to be mind-bending. Her ideas have truly made me see the
world (especially the art world) differently, and the lens she filters
that world through is that of feminism.

Q: The most influential individual(s) in the past thirty years?

A: My own personal pantheon: Philip Guston, Louise Bourgeois,
Nayland Blake, Candyass, Mira Schor, Terry Winters, David
Wojnarowicz, John Berger, Robert Venturi and Denise Scott Brown,
David Hickey, Ellen Scarry, and Amy Sillman.

Q: The greatest epiphany you have experienced in the art world?

A: When I read Mira Schor's essay "Appropriated Sexuality" while I
was in my early twenties and in graduate school. In it she talks
about the art world's inability to take a particular artist to task for
creating misogynistic artwork. The essay wasn't so much an
indictment of the artist but was an elegantly and minutely observed
yet flabbergasted look at how the "opinion makers" of the art world

willfully ignored objectifying and humiliating imagery of women. It was a watershed moment for me.

Q: "I still learn and change my mind about art . . ."
A) Daily
B) Weekly
C) Yearly
D) Every few years
E) Not in a long time, but I am hopeful

Q: "Sometimes I feel an overwhelming need to get angry about . . ."
A) Art
B) Art writing
C) Art curating
D) Art buying
E) Art selling
F) All of the above

Q: "Sometimes I see a show or have a discussion that makes me feel so renewed and excited about art. This doesn't happen often, but when it does the joy can last for . . ."
A) Hours
B) Days
C) Months
D) More than a year

Q: True or false: "The most recent art shows I have seen have been the most exciting."
A: False.

Q: True or false: "They don't make art the way they used to."
A: False.

Ron Platt, Hugh Kaul Curator of Modern and Contemporary Art, Birmingham Museum of Art, Birmingham, Alabama

Q: The most significant event(s) that have affected the art world since 1980?
A: Politicians, artists, and obscenity; artists who died of AIDS-related illnesses; new "statement" or "destination" museum buildings and [these have] affected museum collections.

Q: The most influential artists in the past three decades?
A: Felix Gonzales-Torres, Jeff Wall, Jenny Holzer, Nan Goldin, and Fred Wilson's "Mining the Museum" at the Baltimore Historical Society.

Q: The most influential individual(s) in the past thirty years?
A: Kathy Halbreich, Dave Hickey, Greg Tate, and Mary Jane Jacob.

Q: The greatest epiphany you have experienced in the art world?
A: When I saw Philip Guston's 1995–96 retrospective—I hadn't realized until then that he had been so tough and inventive for so long.

Q: "I still learn and change my mind about art . . ."
A) Daily
B) Weekly
C) Yearly
D) Every few years
E) Not in a long time, but I am hopeful

Q: "Sometimes I feel an overwhelming need to get angry about . . ."
A) Art
B) Art writing
C) Art curating
D) Art buying
E) Art selling
F) All of the above

Q: "Sometimes I see a show or have a discussion that makes me feel so renewed and excited about art. This doesn't happen often, but when it does the joy can last for . . ."
A) Hours
B) Days
C) Months
D) More than a year

Q: True or false: "The most recent art shows I have seen have been the most exciting."

A: False.

Q: True or false: "They don't make art the way they used to."

A: False, but there sure is a lot more of it.

Kay Rosen, Visual Artist

Q: The most significant events that have affected the art world since 1980?

A: The AIDS crisis, the Reagan administration, and the financial market booms of the 1990s/2000s.

Q: The most influential artists in the past three decades?

A: Cindy Sherman and Felix Gonzales-Torres.

Q; The most influential individual(s) in the past thirty years?

A: This may seem weird, [but] I think the longevity of *Artforum*'s publisher (one of three) Knight Landesman and his excellent stewardship of the magazine for at least thirty years are impressive (not to mention his distinguished presence on the art scene). He is an institution all by himself. Also, from what I've read lately about John Baldessari, it seems that he has been an extremely influential educator.

Q: "I still learn and change my mind about art . . ."
 A) Daily
 B) Weekly
 C) Yearly
 D) Every few years
 E) Not in a long time, but I am hopeful

Q: True or false: "The most recent art shows I have seen have been the most exciting."

A: True.

Q: True or false: "They don't make art the way they used to."

A: True.

Paola Morsiani, Curator of Contemporary Art, the Cleveland Museum of Art, Cleveland, Ohio

Q: The "most significant events" that have affected the art world since 1980?

A: Resetting of geo-political realities and consequential migrations of people. Artists' mobility. The World Wide Web. The proliferation and restructuring of art museums as accessible educational centers. The proliferation of art galleries and the circulation of art objects as forms of economic investment. The proliferation of art forms.

Q: The most influential artists in the past three decades?

A: From this geographical and cultural location: Yoko Ono, Sturtevant, Adrian Piper, and Andrea Zittel.

Q: The most influential individual(s) in the past thirty years?

A: Félix Guattari and Hélène Cixous.

Q: The greatest epiphany you have experienced in the art world?

A: At a museum.

Q: "I still learn and change my mind about art . . ."

A) Daily
B) Weekly
C) Yearly
D) Every few years
E) Not in a long time, but I am hopeful

Q: "Sometimes I feel an overwhelming need to get angry about . . ."

A) Art
B) Art writing
C) Art curating
D) Art buying
E) Art selling
F) All of the above

Q: "Sometimes I see a show or have a discussion that makes me feel so renewed and excited about art. This doesn't happen often, but when it does the joy can last for . . ."

A) Hours
B) Days
C) Months
D) More than a year

Q: True or false: "The most recent art shows I have seen have been the most exciting."

A: False.

Q: True or false: "They don't make art the way they used to."

A: True.

Rafael Von Uslar, Independent Curator

Q: The most significant event(s) that have affected the art world since 1980?

A: Apart from the most obvious impact of political and cultural events such as AIDS, the fall of the Iron Curtain, the World Wide Web, and September 11, an important change of paradigm occurred which I would like to illustrate with "Documenta X" and "XI"—a deliberate shift toward a political perspective in the arts that is more multifaceted than previously established approaches in the 1960s and 1970s. More important, it is the beginning of a focus on non-Western contemporary art in the West.

Q: The most influential artists of the past three decades?

A: There are so many artists whose work I see as influential, groundbreaking, and important or which I simply love. But forced to strip this down to a one-digit answer I have three positions to name that throughout the past thirty years had the strongest persistent influence on my personal life and the way I think and live with art: Robert Filliou, Joseph Beuys, and Cary S. Leibowitz.

Q: The greatest epiphany you have experienced in the art world?

A: The most recent epiphany—and a really good one, too—I experienced last year in front of a Cranach painting. What excited me was the figure of Judas leaving the scene of a washing of the feet. This figure is performing one of those completely improbable acts that only become feasible within the logic of a pictorial narrative. Absolutely exciting!

Q: "I still learn and change my mind about art . . ."
 A) Daily
 B) Weekly
 C) Yearly
 D) Every few years
 E) Not in a long time, but I am hopeful

Q: "Sometimes I feel an overwhelming need to get angry about . . ."
 A) Art
 B) Art writing
 C) Art curating
 D) Art buying
 E) Art selling
 F) All of the above
 G) Myself

Q: "Sometimes I see a show or have a discussion that makes me feel so renewed and excited about art. This doesn't happen often, but when it does the joy can last for . . ."

A) Hours

B) Days

C) Months

D) More than a year. Absolutely more than a year. These are rare, cherished moments that need to serve as a nourishment for a long time.

Q: True or false: "The most recent art shows I have seen have been the most exciting."

A: False, and listing the shows that really excited me and still excite me to this very day would make me feel both slow and old.

Q: True or false: "They don't make art the way they used to."

A: Very true and very false at the same time. My impression is that I see far too much art around that looks like art they used to make.

Isolde Brielmaier, Curator, Creative Consultant, and Writer

Q: The most significant event(s) that have affected the art world since 1980?

A: The dot-com boom, the Internet, and the rise of Wall Street, hedge funds, etc.

Q: The most influential artists of the past three decades?

A: Matthew Barney, Jeff Koons, and Kara Walker.

Q: The most influential individual(s) in the past thirty years?

A: Thelma Golden, Okwui Enwezor, and Charles Saatchi.

Q: The greatest epiphany you have experienced in the art world?

A: Boundaries are made to bend and blur. . . .

Q: "I still learn and change my mind about art . . ."
A) Daily, often true
B) Weekly
C) Yearly
D) Every few years
E) Not in a long time, but I am hopeful

Q: "Sometimes I feel an overwhelming need to get angry about . . ."
A) Art
B) Art writing: "Angry" is a strong word, but there is a lack of good art criticism that has breadth, is supported by research, and features a diversity of artists, etc.
C) Art curating
D) Art buying
E) Art selling
F) All of the above

Q: "Sometimes I see a show or have a discussion that makes me feel so renewed and excited about art. This doesn't happen often, but when it does the joy can last for . . ."
A) Hours
B) Days
C) Months
D) More than a year

Q: True or false: "The most recent art shows I have seen have been the most exciting."

A: False.

Q: True or false: "They don't make art the way they used to."

A: Strange question. It's all relative!

Thelma Golden, Executive Director and Chief Curator, The Studio Museum in Harlem, New York

Q: The most influential artists of the past three decades?
A: Felix Gonzalez-Torres, David Hammons, and Adrian Piper.

Q: The greatest epiphany you have experienced in the art world?
A: One of the greatest epiphanies I experienced in the art world happened in 1993.

Q: "I still learn and change my mind about art . . ."
A) Daily
B) Weekly
C) Yearly
D) Every few years
E) Not in a long time, but I am hopeful

Q: "Sometimes I feel an overwhelming need to get angry about . . ."
A) Art
B) Art writing
C) Art curating
D) Art buying
E) Art selling
F) All of the above
G) None of the above

Q: "Sometimes I see a show or have a discussion that makes me feel so renewed and excited about art. This doesn't happen often, but when it does the joy can last for . . ."
A) Hours
B) Days
C) Months
D) More than a year
E) Sometimes I see a show or have a discussion that makes me feel so renewed and excited about art that the joy can last forever.

Q: True or false: "The most recent art shows I have seen have been the most exciting."
A: True

Q: True or false: "They don't make art the way they used to."
A: True.

Franklin Sirmans, Terri and Michael Smooke
Department Head and Curator of Contemporary Art,
Los Angeles County Art Museum, California

Q: The most significant event(s) that have affected the art world since
 1980?
 A: AIDS, Rodney King, and late-twentieth-century globalism.

Q: The most influential artists in the past three decades?
 A: David Hammons, Andy Warhol, Robert Gober, and Barbara Kruger.

Q: The greatest epiphany you have experienced in the art world?
 A: The world is bigger than New York City or Venice and Kassel or
 Munster, for that matter. 1997: Istanbul, Johannesburg, Kwangju,
 etc. . . . profoundly heralded the new.

Q: "I still learn and change my mind about art . . ."
 A) Daily
 B) Weekly
 C) Yearly
 D) Every few years
 E) Not in a long time, but I am hopeful

Q: "Sometimes I feel an overwhelming need to get angry about . . ."
 A) Art
 B) Art writing
 C) Art curating
 D) Art buying
 E) Art selling
 F) All of the above

Q: "Sometimes I see a show or have a discussion that makes me feel so
 renewed and excited about art. This doesn't happen often, but when it
 does the joy can last for . . ."
 A) Hours
 B) Days
 C) Months
 D) More than a year

Q: True or false: "The most recent art shows I have seen have been the
 most exciting."
 A: False.

Q: True or false: "They don't make art the way they used to."
 A: True.

Gabriela Rangel, Director of Visual Arts,
Americas Society, New York

Q: The most significant event(s) that have affected the art world since 1980?
A: September 11th (the WTC terrorist attack).

Q: The most influential artists of the past three decades?
A: Helio Oiticica, Gordon Matta-Clark, Andy Warhol, and Marina Abramović.

Q: The most influential individual(s) in the past thirty years?
A: Harald Szeemann.

Q: "I still learn and change my mind about art . . ."
A) Daily
B) Weekly
C) Yearly
D) Every few years
E) Not in a long time, but I am hopeful

Q: "Sometimes I feel an overwhelming need to get angry about . . ."
A) Art
B) Art writing
C) Art curating
D) Art buying
E) Art selling
F) All of the above

Q: "Sometimes I see a show or have a discussion that makes me feel so renewed and excited about art. This doesn't happen often, but when it does the joy can last for . . ."
A) Hours
B) Days
C) Months
D) More than a year

Q: True or false: "The most recent art shows I have seen have been the most exciting."
A: True.

Q: True or false: "They don't make art the way they used to."
A: False.

"The theory doesn't match the couch."

THE ART
ADVISOR AND
CORPORATE
CURATOR

*"Him? He came with the works you bought
in Miami two years ago."*

The Journey from the Studio to the Collection

Six Interviews with Art Advisors, Corporate Curators, and Others

BARBARA TOLL

Art doesn't fly off the walls of galleries right into collectors' homes anymore. With the proliferation of exhibition spaces—uptown, downtown, Chelsea, Lower East Side, SoHo—it has become difficult even for professionals to know where to best spend their time and their money. Art consultants, advisors, and, sometimes, even curators provide a way into the labyrinthine art world by scouting out worthy work and showing it to clients for a fee. Those fee arrangements vary. Some advisors charge a percentage of the value of the work for their knowledge and access. Some work only on a monthly, hourly, or daily retainer. Still others take their fee from the galleries, a model that can be fraught with conflicts.

In many ways, the art advisor is symptomatic of our times. He or she mediates the art experience. Like the tech consultants necessary to help us navigate our Internet-connected lives, art consultants help us through the "isms" (minimalism, realism, and conceptualism, to name a few) of the art world. Along with consultants, or advisors, corporate entities use in-house curators as their eyes and ears. And new forms of art "advising" have sprung up. One such entity is the Artists Pension Trust, which "advises" artists on advancing their careers and also plans to advise collectors who will pay a flat fee for a one-time consultation.

The six individuals interviewed here all operate differently, but they have much in common. One consistent theme that emerged from these interviews was the respect for galleries and their relationship with artists. (Candace Worth comments that galleries "do the heavy lifting.") Another was support for the artists of the interviewees' own generations. There is also the desire to encourage community support of artists. All of the interviewees find clients or their jobs through personal referral. It seems that one good client provides another. "Networking" is the watchword of our times.

Four of the six have graduate degrees. This is a highly educated group. When dealing with that indefinable element called "taste," it helps to

have some erudition at one's fingertips. Auction houses are a source of entry for several of the participants. The overview of the market one can accrue while working in an auction house provides exceptional perspective. Works come up for auction that are very valuable, that have been recently rediscovered, or that have been languishing in closets and won't be valuable again in our lifetimes. The inevitably rising market cannot impress these auction veterans.

The term "market" clearly takes on different meanings to some of the interview participants. To both Liz Christensen and Pamela Auchincloss, "market" implies the financial world. Franklin Boyd uses the term both in the financial sense and as shorthand for the "art market." These three talk of networked markets, models, and risk factors. The other participants speak of a self-referential art market that sustains its own pricing, valuation, and entry rules. Without these advisors' the accumulated knowledge, one would find it very difficult to assess the actual value of a work of art. The ultimate test, of course, is the auction house, the only transparent market for art in the world. But many artists' works don't come up for auction, leaving valuation subjective. Allan Schwartzman refers to the market as a "validating factor," while Franklin Boyd notes, "I don't think the market is always smart, meaning that expensive equals good." Everyone does agree that it is gratifying to see a work they advised their client to buy become more sought after.

The participants in most of these interviews were asked questions in four general areas. First they were asked how they began working in this field and what their art background was; how they found their clients; and what steps they took to familiarize themselves with the contemporary art scene. Second, they were asked if they dealt with artists who are not represented; how they found them; and what would lead them to encourage a client toward buying works of an untested artist. Third, they were asked how the market affects the choices they make. Fourth, they were asked to relate an incident or artwork that showed how their vision for an artist or client has worked out.

All six participants cited curators and other artists as sources for finding the work of new artists. However, everyone talked most about spending time at galleries, museums, and art fairs looking at art. There is no shortcut to being informed. Looking and listening are the best tools for acquiring knowledge. And it seems that having satisfied clients is the best way to have a successful career as an art advisor.

Allan Schwartzman (Allan Schwartzman, Inc.)

> **" I'm helping people to spend well the money
> they have already decided to spend on art. "**

Allan Schwartzman is an art consultant who has helped many prominent collectors form their collections. When he was asked how he began working as an art advisor, he answered:

> People came to me to help them evolve their collections because of my background as a curator and writer. I've avoided the veneer of styling myself as a corporate entity because of my background. I was trained as an art historian. My professional career started during a year off from college when I interned at the Whitney Museum. I was Marcia Tucker's assistant. When Marcia was fired she decided to create the New Museum. I was her first employee and later became part of the New Museum's first curatorial staff. I finished my undergraduate degree while working at the New Museum. I left the museum to enter the commercial world because I was curious as to how the "other" side worked. I became the director of the Barbara Gladstone Gallery but left after three years because I realized I missed writing and thinking about art in a different way. I decided to write full time, beginning by freelancing. At the time, there were only two kinds of art writers: people who knew about art and its language and wrote for art magazines [and] journalists who were better writers but didn't know as much about art. I decided to write about art for a general audience, but with an historical and critical perspective. I wrote for *Manhattan Inc.*, a magazine about business in New York City; *Art in Auction*; and *The New Yorker*. At *The New Yorker*, I was the principal writer for the art listings in the Goings-On section, which I revamped to have a more critical point of view. Then I was hired by *The New York Times* to do feature stories.
>
> A collector in Dallas, Howard Rachofsky, had just completed building a Richard Meier house. He realized that it was an important piece of architecture that would require rethinking his collection to make it worthy of the architecture. He also decided to leave the house to the Dallas Museum of Art in his will. He asked me to help him evolve the collection. The process of thinking about art was important to him. I became the luckiest art writer in the world. I had a long-term position with a major, evolving collection [that] would be a promised gift to a museum. The job became my graduate fellowship. All of this

is to say that I didn't start out to be an art advisor. I just had a relationship with this one collector. As the Rachofsky collection matured and became more visible, I was approached by other collectors.

When I start working with a collector, we begin with a six-month trial period. I recommend that they do little buying during that time. Collectors tend to be caught up in the details and don't really think about the big picture. Thinking about the "big" picture is something I have done as a writer, a curator, and an advisor. I help [collectors] develop their short-term and long-term goals. We talk about what is meaningful to them in their collection as well as what they wish they had bought. After six months I can come up with a set of recommendations. I help them analyze what their goals are in terms of the current art market. If there is a good rapport, things start to happen. I've always tried to help collectors create the best version of their collection. I only take on new projects that don't conflict with other collectors I work with. Even when the same artists are involved, it is never the same work.

When I asked Schwartzman if he deals with unrepresented artists and, if so, how he encourages his clients to respond to them, he answered:

Each collection I deal with is different. Even in historically focused collections, I always recommend that a certain amount of the budget go toward emerging artists. I think it is extremely important that people who collect [be] wedded to the realization that art is not just an object, that it's related to a real human being. I am not big on taking collectors to studios. I also don't want to encourage people to focus on student shows and immature artists who haven't completed their education. I don't believe in circumventing the system. [In helping a collector to form a collection] so much comes out of an ongoing dialogue. What we do is reactive, rather than proactive. We have identified the artist's work in advance. If [collectors aren't] available to see the work, sometimes they just have to go on faith.

In reference to the art market, he remarked: "Anyone spending above a certain amount of money wants to know his or her money is being well spent. I don't encourage buying art as an investment. I always tell a client how I perceive the market. It is a factor, but a validating factor, not a motivating factor."

Regarding an exceptionally successful experience, Schwartzman goes on:

I remember an exhibition of Tom Friedman's where two collectors were interested in buying. I chose one work for one client and one for

the other. They were completely opposite in materiality and content. After a few days, both collectors came in and went right to the work I had designated for them and didn't even look at the other work. Almost every one of my clients has continued to collect although there is a natural ebb and flow. We assess what we have done together each year and set goals for the future. I talk and share my enthusiasm. Sometimes a client connects, sometimes not. I'm not a salesperson. I'm helping people to spend well the money they have already decided to spend on art. Sometimes I'll put in a lot of time and effort to show that an opportunity is not to be missed. Sometimes I'm successful, sometimes, not. I don't want [the clients] to miss those opportunities.

Ana Sokoloff (Sokoloff & Associates)

 ❝ A collection will always have value if it is well curated. ❞

Sokoloff & Associates specializes in Latin American and South American art. The firm consists of Ana Sokoloff, who is founder and principal, and Jackie (Jeanette) van Campenhout plus two or more assistants. When asked how they got involved in the field, Ana answered:

I got involved because I graduated from law school in Colombia then moved to Montreal. In Canada I studied all kinds of things: architecture, graphics, cinema, and art history. I applied to the masters program at Columbia University and moved to New York in 1990. I was a foreign student but I worked as a receptionist in a SoHo gallery, Lawrence Monk. Bob Monk [as Lawrence Monk is known familiarly to his associates] is still a mentor to me. It was a great experience, great gallery, and small staff. You learned how to do everything. After two years, Mrs. Santo Domingo, the cultural attaché of the Colombian mission to the UN, hired me as a curator and cultural administrator. It was a part-time job that lasted nine years. From there I went to the Americas Society as director of exhibitions for two shows on Latin American themes.

 When Bob Monk went to Sotheby's, he asked me to come and work as a cataloguer in the Arcade department. It was a great experience because it made me a generalist. In 1994 I went back to finish my masters degree. Then Christie's called me to be a specialist in Latin American paintings. This was a full-time job that I held for nine years. I was totally immersed in the Latin American market. We revived the

department and put things in an historical perspective. In 2005 I left Christie's to open my own business.

Jackie, a political scientist in the Ministry of Foreign Affairs in Argentina, met Ana when she interned at Christie's. While at Christie's, Jackie and Ana developed an idea for a business that would grow organically outside the corporate structure of an auction house. They set up an art advisory service for private clients, buying, advising on, and taking care of collections. Now they do public relations for corporate clients in Latin America as well. They also advise on cultural travel for private clients and run benefit auctions for nonprofits. In New York, they work with clients to form collections. Through all of these activities and from their varied backgrounds, they have met clients through word-of-mouth. They want to be able to dedicate the right amount of time to their clients, so they keep the pool small.

Asked how she found and informed her clients, Ana responded:

Our clients range from the knowledgeable to the novice. What is important is the initial understanding of the goal of the collection. We spend a lot of time looking at books and images to decide where it is [the clients] want to take the collection. We have an extensive library of Latin American publications that we are looking to expand. We take the effort to educate the clients. Usually they make a first mistake, they ask for advice, and then they think they know!

We continue to have relationships with our clients after the collection is formed and they are no longer active. Some collectors buy to fill a space; some don't care about space. We also offer selling to upgrade the collection. We are revising constantly. We want the dialogue to continue. We send information to keep the clients informed and interested.

Asked if she deals with younger artists, Ana replied:

Sometimes we gather information from curatorial relationships. Dialogue with [curators] works both ways. We have access to Latin America. We give curators information and they give information to us. Socializing, we meet artists, we go to the studio and organically artists tell us who they think is interesting. We work through galleries if the artist is represented. If not, we go directly to the artist. We respect all parts of the art world.

When Ana encourages a collector to look at an artist's work, she sees it in the context of the collection. Does this artist's work fit any of the stories or curatorial lines within the collection? One collection we

work with is of contemporary geometric art from Latin America. The subject matter leads to research that brings other artists to our attention.

On the influence of the market, Ana notes: "The art market influences everyone, but we are in the middle of it." The firm's experience of working in an auction house is unique. As Ana puts it:

> When you see the liquidation of an estate, the collection as a whole is the "star" and not the individual objects per se. Stories well told will have value. Some are better than others; sometimes you can tell clients that certain works will increase in value. Even lesser works in major collections will do well. A collection will always have value if it is well curated.

Candace Worth (Worth Art Advisory)

" Decision making is knowledge plus instinct. **"**

Candace Worth spent five years at Christie's in the early 1990s after earning an undergraduate degree in art history and graduate work at Columbia University. She has been an art advisor for ten years, starting before the latest art boom. She views the depth and length of her experience as an advantage, knowing that the market boom spawned legions of "art advisor/hobbyists" who have given the business a bad reputation.

As to how she meets her clients, Worth says: "All of my clients are from referrals. Experience has taught me that my only real clients have come from personal reference." When Worth meets new clients, she shows them books and catalogues and lets them pick out things they like while starting a conversation about size, medium, price, and availability. Most people, she says, "don't realize how much goes into finding the right work of art for them. The first meeting lasts about two hours." Worth doesn't buy at auction, only in the primary market:

> I am a huge believer in supporting artists of our generation, both young and midcareer. You have access to the studios of living artists. These are people you can relate to. There is a real divide between old and new people in the art market. Clients familiar with the market understand how artists have lived for years without selling a picture. Younger clients, newer to the market, think that success comes right out of the gate. This attitude affects market pricing, among other things.

Worth says she doesn't really deal with unrepresented artists.

I'm not a market maker. Galleries do the heavy lifting; they make deci-
sions and spend money to move artists on in their careers. When
galleries are committed to an artist, they offer a safety net. They are a
vetting system. At some point you have to make a decision about what
is good for your client. You don't get paid by the artist.

When asked what would lead her to recommend an untested artist,
Worth said:

I look at a wide range of things. Some clients have more stomach for
risk than others. Some artists I have found have gone on to very good
dealers and great situations. It's not the norm, but sometimes there is
a buzz. Gallery assistants, shippers, preparators are a great source for
information on new artists, as many of them are artists themselves. In
the end, you look with your eyes, not your ears. Decision making is
knowledge plus instinct. Any decision is about risk, especially with
younger things from $10,000 to $20,000. With works from $20,000–
$250,000 it's a whole different ballgame. There is an auction history,
who is buying, who is looking, who is promoting. Information is a
game. In addition, I see where a particular piece fits into an artist's
body of work. I work with big budgets and small budgets. It's a lot of
running around and looking at everything.

I love to get something amazing for someone. If I find exactly the
right piece, they know it in five minutes. A good advisor knows his
client's sensibilities. If I work for several clients who may know each
other, I have a personal history with each. I would have to sell a work
that two clients wanted to the one I worked with first. Sometimes I
want to buy the piece myself.

Most people, Worth says, do go around on their own to look.

Some will go to a private collection and say, "There are three artists
in that apartment I love—let's look at them." I've never had anyone
say, "I want to collect X." I do have clients who won't collect
drawings, only paintings and photographic works, and I have clients
who won't collect photography. As an advisor, you have to be able to
take the hit when clients say no. The decision-making process is more
difficult in this [currrent] financial period. It is more selective.

I don't think there is a sense of linear thinking among my young
collectors. They are not filling in holes in their collections. I'm eager
to place the work of artists whom I find exciting. I have to look at so

many different things to keep informed. You really have to know whom you are dealing with. One of my ethos as an advisor is that I don't bullshit about art to my clients. They are not speculating. No one has sold art I've sold them. They understand why they are doing this. They make money in other ways.

Franklin Boyd (Boyd Level)

❝ We want clients to get over "art crushes." ❞

Boyd Level consists of two partners, Franklin Boyd and Jonathan Neal. Franklin studied at the Foreign Service School at Georgetown University before going to Christie's art program. She also holds a law degree from New York University with a specialty in art law. Her partner, Jonathan, has a doctorate in art history and has been an editor for various art publications. They have been in business together for five years.

Asked how Boyd Level finds clients, Franklin responded:

Clients hire us because of our combined expertise. Our clients find us by referral almost exclusively. We have had press, but haven't found it helpful in recruiting clients. It is helpful in legitimizing our business, however. We have also worked with interior designers. Sometimes that has worked well, sometimes not. We have often continued with the clients after the decorator's work is done. But we have a different economic model from decorators', which sometimes makes collaboration difficult. We try to be transparent with clients. We work on a flat fee either quarterly or annually. We don't want our clients to think we are clouded by the expense of an object. Often clients are very new to collecting so we spend a lot of time on education by just going out and looking at art. At art fairs, we try to keep our clients' wallets in their pockets. We want [clients] to get over "art crushes." We would rather have the collector have a long-term interest in the object. We pass along all discounts to the client. We are also upfront with galleries that we are being compensated by our clients.

Boyd Level offers collection management services along with advice on collecting.

Collection management is something we offer the collector who wants to move into contemporary art. Collectors have walls and closets full of art and a shopping bag full of documents. They may want to de-accession or organize what they have. As they have new pieces, we add

to their database. We track everything in hard copy, which we organize as catalogues, and also electronically. The catalogues are in two versions, public and private. The public version has images, but no market information. The private one includes purchase price and other market information. We don't do appraisals; we are not licensed appraisers. We see appraisals as a conflict of interest.

We work with an average of four to ten clients or projects. Some are long-term and some are just interested in acquiring a couple of objects. I am in client services. Some clients work on a monthly fee, even if it's only for one object. I have one client who has a standing Friday appointment to look at art even though he only buys one or two objects a year. He just likes learning.

When asked if Boyd Level looks at unrepresented artists, Franklin replied:

We do. It is a challenge. Artists without representation are sometimes uncomfortable setting prices. Our role gets confused in the studio. We want to have an open conversation between the client, the artist, and the advisor. More likely than an unrepresented artist is the artist who is between representation because of a gallery closing. There is a reason some artists aren't represented. It is rare to go to an open studio day and encounter an artist you think is amazing. Sometimes you'll see people you want to keep your eye on. Artists are a great source for finding other artists. We enjoy spending time with artists.

Franklin says that a work's price is often a "determining factor."

I think it is a very important, but secondary, factor. I tell my clients to only buy what [they] love. Clients often love things that are more than they can afford. It is responsible to find artists who might have more upside potential. You want to be able to perhaps sell things that do have a secondary market. Art costs a lot of money even at $20,000. That's a semester at college! The art market [affects] what we will show our clients. Someone who has caught the eye of international curators we might be more interested in. I don't think the market is always smart, that expensive equals good. But good things do move up. For clients who are less risk averse with a bigger budget, we look at the market through the artist's gallery and curators' interest. We have to be aware of curators' radar. The prevailing model is a networked market. The market shifts throughout the course of a year.

For an incident that Franklin felt exemplified her approach to collecting, she mentioned:

We have clients who bought a Florian Sussmayr painting. They said: "Our kids are terrified so we know we did something right." On paper they seemed like they were only thinking-inside-the-box type of clients. In the world of collecting, five years is too short a time to say value has tripled, but clients from five years ago are coming with us to Miami/Basel and still want to work with us to get a handle on what's out there.

Pamela Auchincloss (CEO, Artists Pension Trust)

❝ We are very artist-centric. ❞

Pamela Auchincloss ran an eponymous gallery in Santa Barbara and then in New York from 1980 to 1993. She founded Pamela Auchincloss Arts Management, which organized and circulated exhibitions promoting the works of individual artists from 1993 to 2005. Since 2004 she has worked for the Artists Pension Trust and has served as CEO since 2006.

The Artists Pension Trust seeks to find a way to fund a group of selected artists around the world by buying their work, holding it for at least five years, selling it, and then returning funds plus appreciation to the artists when they need them. It is not strictly a pension system as it invests only in other artists' work. It has a global reach, being organized into eight separate trusts that use the advice of regional curators around the world to acquire and store works of art. Its advisory board includes the artists John Baldessari, Kiki Smith, and Rirkrit Tiravanija and the curators Hans Ulrich Obrist, Bruce Ferguson, and David Ross. The Trust's directors are responsible for signing individual artists and selecting the artworks it holds.

Auchincloss is the generalist in charge of the New York trust, which covers the eastern United States. She is also the head of the Trust in India, traveling frequently to Mumbai. Her curatorial model is that loans to museums from the Trust's holdings will enhance the reputation of the artists in the Trust. She also organizes exhibitions to promote certain artists in the collection.

When asked if some of the participating artists are unrepresented, Auchincloss answered, "[The Trust] is an advisory service for artists. The core business is allowing artists to diversify risk. Artists want to know resources in other countries, other cities. They'll ask, 'Can you plug me into the scene?' or say, 'I need production money.' Artists join the Trust because they respect the participants." There is also a studio program

sponsored by the New York trust. Auchincloss adds that it allows artists from outside New York to get to know the scene. The space is rented at a discount. There is storage and a lot of support services.

She continues:

The track record of an artist is really with the curators. The artists have been vetted by a group of curators who have done international biennials. They have picked very good artists. Sometimes people ask me if I like the work. Things prove themselves in the marketplace much faster nowadays. Most galleries see what we are doing and our curatorial projects. More established galleries have not encouraged their artists to join. The Trust has worked as a speculative model, and established galleries are not as interested. Some have taken part because they like the mutuality of taking care of younger artists. The Trust was always seen as focused on emerging art.

In the first round, the decisions have been with the curators. There will be artists who don't seem to have commercial features who work more performatively. Look at Marina Abramović, for example. We're not quite there yet. We have 1,300 artists now. Mark Bradford wasn't well known, but his big reputation happened after he joined the Trust. A lot have jumped from nobody to being everywhere like the twin brothers and artistic collaborators Gert and Uxe Tobias.

When asked whether the Trust's encouragement has helped these artists move on with their work, Auchincloss answered:

Introducing the artist to more curators helps. Dan Cameron will be at a meeting and an artist will come up [and he will put that artist] in an exhibition, for instance. The studio residencies have resulted in gallery shows. People are seeking us out more and more. Curators are coming to us for recommendations. We also have a video collection that we are thinking of using as an open archive or research tool.

When I noted that there are a lot of moving parts in this system, Auchincloss responded:

The vision of the APT has worked out very well. Selling is the one area where we are not completely set up. We want to place works in institutions and set records for the work. The first twenty sales need to be newsworthy. A young curator who is moving to India may know an industrialist who wants to start an Indian Storm King Art Center. How can APT get involved in that? APT's curators know where the young artists are. Seventy-two percent of APT's proceeds go to the

artists. We are subsidizing cultural activity. We are very artist-centric. The artist is our client, and our business model is centered on the artist. We may create new possibilities for ownership. The art world is changing. There has been a lot of institutional trickledown to the commercial art world, but the dealer Jeffrey Deitch's becoming director of MoCA, Los Angeles shows there is also trickle-up.

Liz Christensen (Curator for the Americas, Deutsche Bank Collection)

> ❝ Art reflects our identity as a cutting-edge bank, fostering creativity and innovation. ❞

Liz Christensen started working in the art world after attending graduate school in art history in California. She worked in galleries and then worked privately for art advisors on company projects. "I was recommended to assist Deutsche Bank with their inventory when it was still a small bank branch over fifteen years ago. It was providential because, as the bank grew, its presence in New York grew and I got the chance to grow with it."

The Deutsche Bank Americas collection has concentrated on works on paper by young artists since 1980. The bank has a retail banking presence in Europe, and contemporary art at the branches was a novel idea, seen as reflecting a modern image. The collection has a global mix and is focused on works on paper by emerging younger and underrecognized artists. The curatorial staff stays aware of new trends, genres, and talents by regularly visiting galleries, museums, and art fairs. "We want to keep the collection fresh, living and breathing, so to speak," Christensen says. There are curators covering each part of the globe, with bases located in Hong Kong, London, Germany, and New York.

Works enter the collection via an art committee made up of senior managers from all areas of the bank. The art department makes annual presentations of potential works to the committee based on budget and need. Works are purchased mainly from galleries and are never bought at auctions. "We try to support the gallery system. If an artist doesn't have a gallery, that's fine."

The bank views support for art and culture as part of its corporate social responsibility. As Christensen notes, "We don't buy art to profit from it but consider ourselves more like patrons. We only sell rarely, to help refresh the collection. The art collection is both an asset of the bank

and part of our philanthropic mission. The purpose of the collection is to stimulate the work environment, help artists, and allow staff and visitors the chance to see contemporary art in a space outside of a museum. Art reflects our identity as a cutting-edge bank, fostering creativity and innovation."

The Wall Street headquarters in New York has an in-house gallery presenting three to four exhibitions a year. One of the exhibitions features works organized from the collection and two are guest-curated or theme-related to partner organizations. Deutsche Bank Americas is also involved with contemporary art through its museum sponsorships, whereby there are funding relationships with The Whitney Museum of American Art, the Orange County Museum of Art, the New Museum of Contemporary Art, and, of course, the Deutsche Guggenheim, a global partner since 1997. The bank is also starting to develop relationships with museums in Latin America.

The bank regularly shares its collection with the public by organizing exhibitions of its art and partnering with art institutions to exhibit it. In 2010 Christensen and the art department organized an exhibition of Joseph Beuys and his students that will travel to six South American museums over the next two years. "It is a collaborative initiative that encompasses both art and education, two things that are very important to Deutsche Bank," says Christensen. This will be the third exhibition of works from the bank's collection that has traveled throughout Latin America.

Working with different local arts organizations in the city, around the state, and across the country is also an important component.

> We gain exposure to new artists through our partnerships with the New York Foundation for the Arts [NYFA] and the Artists Fellowship Program, for instance. Each year, Deutsche Bank awards a fellowship to an outstanding artist living and working in New York, in addition to buying [the artist's] work. Through NYFA, we also sponsor a program to match artists who know the ropes in New York City with immigrant artists who are looking for help. It is one of Deutsche Bank America Foundation's grant programs for Art and Community Revitalization. The Bronx Museum has also been a recipient of the bank's "Art and Enterprise" grant. Deutsche Bank believes that supporting art and culture in urban centers helps communities thrive.

The bank has resumed an "Artist of the Year" program that identifies a stand-out, emerging talent who has already achieved a strong body of work and who will be given an exhibition at the Guggenheim in Berlin.

The artist is selected by a distinguished panel of curators independent of the bank's in-house curatorial staff. The relationship with the Guggenheim has not only created exhibitions in Berlin and New York; it has also allowed Deutsche Bank to own important works through a joint agreement with the museum. "We couldn't afford or procure these works otherwise," adds Christensen. The Deutsche Guggenheim has brought James Rosenquist, Jeff Koons, Anish Kapor, Cai Guo Qiang, Julie Mehretu, and Wangechi Mutu to this partnership. Programming is decided upon jointly.

As far as her vision's being borne out goes, Christensen says:

> I didn't source it, but the Richter in the lobby is a really beautiful and important piece by a major German artist. We moved here after [the terrorist attacks of] 9/11 destroyed our building. The lobby was all dark, gray granite blocks, to emphasize solidity, with high ceilings. The first thing we did was put in new lighting and then put up the enormous three-paneled Richter painting, which immediately energized the whole lobby. It has since become a signature piece for Deutsche Bank's New York headquarters. It was probably—and literally—one of the "more brilliant" moves we made.

No school teaches one how to become an art advisor. Taking the job seriously demands a deep background in art history, great familiarity with the art trade, and the ability to help clients hone their own taste. All six of the participants in these interviews have made successful careers of a balancing act of knowledge and tact. In diverse ways, each has found a way to support artists while helping their clients spend their money well.

The new ART FAIR **G. P. S.**

THE ART FAIR DIRECTOR

ART FAIR
~ DOT INDICATORS ~

○ RED — SOLD

○ YELLOW - CAME AND LIKED IT
BUT HASN'T CONVINCED
SPOUSE

○ BLACK - WANTS AN OBSCENE
DISCOUNT

○ PURPLE - WILL COME BACK
AFTER LUNCH BUT
MAYBE YES

○ BROWN - GAVE A
BAD
CHECK

○ PINK - DEALER
BOUGHT IT
TO MAKE SEEM
SOMETHING SOLD

The Art Fair Effect

OMAR LOPEZ-CHAHOUD AND IAN COFRÉ

In Europe, Art Cologne (founded in 1967), Art Basel (founded in 1970), and ARCO Madrid (the *Feria Internacional de Arte Contemporáneo*, first held in 1982) had already been cultivating unique international stages for contemporary art by the time a small East Coast fair emerged in New York in the mid-1990s. The spiritual predecessor to the Armory Show, The Gramercy International Art Fair, began as a creative response by four contemporary art dealers to a market downturn. Founders Colin de Land, Pat Hearn, Matthew Marks, and Paul Morris invited other dealers and gallerists to show their artists in individual rooms at the Gramercy Hotel, setting one of the most recent and influential precedents to the art fair as we know it. What they could not have predicted then was the art boom that would skew a large segment of the marketplace toward contemporary art, cause an explosion of regional fairs throughout the world, and change their small fair into a leading stop along the global circuit of major fairs.

In the past ten years, as art fairs have flourished, they have played a role in the art season similar to that of the Grand Slams on the professional tennis tour. While insiders closely follow the developments of the entire cycle, the fairs are the annual markers everyone tunes in to whatever their levels of dedication the rest of the year. Unlike many other facets of the art world, access and exclusivity are secondary to the size of the crowds (in the tens of thousands attending each major fair), which turn host cities into a chaotic swirl of art appreciation, education, and commerce.

The effect on a host city, however temporary, can be described only as transformative—most similar to that of a biennial. Drawing so many satellite fairs, hotel fairs, curated projects, and other events organized because of or in response to a fair, a city finds its cultural climate effectively changed. A great example is Miami and the residual effects it experienced in under a decade. What was to be the inaugural Art Basel Miami

Beach was canceled because of the events of September 11, 2001, yet the organizers of Fast Forward Miami at the Nash Hotel pressed on to fill the resulting void; over the years, private collectors have opened their collections to the public—notably the de la Cruz, Margulies, and Rubell Family Collections—even starting important nonprofits like The Moore Space. Finally, responding by internationalizing their programming, institutions like the Bass Museum and MOCA North Miami became more visible: all results of a fair now in its eighth edition.

At its core, an art fair is a gathering of dealers showing their best, most recent, or remaining inventory. Though a forum for hyperactive commerce, it can transcend this central purpose through creative execution, becoming instrumental in giving broad exposure to emerging and underrepresented artists. Speaking to directors from three leading art fairs around the world revealed a range of approaches and how geographically diverse they can be. The participants included Annette Schönholzer and Marc Spiegler (Art Basel, Switzerland and Miami), Amanda Coulson, VOLTA (Basel, Switzerland and New York), and Zélika García (Zona MACO, Mexico City).

The Prerequisites

OMAR LOPEZ-CHAHOUD AND IAN COFRÉ: *How is your art fair different from other art fairs?*

ANNETTE SCHÖNHOLZER: Art Basel and Art Basel Miami Beach present artworks from 1900 to today. Different sectors provide platforms for a wide variety in formats and media—aside from the classic gallery stands. For example, large-scale formats are presented at Art Unlimited, and young galleries can present one-person shows at Art Statements (Art Basel) and Art Positions (Art Basel Miami Beach).

MARC SPIEGLER: Both shows stage panel discussions on timely topics in the art world. The Art Basel Conversations in the morning offer firsthand information on various aspects regarding art collecting, production, or exhibition-making from leading personalities of the international art world. In the past, we had speakers such as Hans Ulrich Obrist, Glenn Lowry, Paul McCarthy, Marina Abramović, Eugenio Lopez, Maja Hoffmann, Jeff Koons, Norman Rosenthal, Ai Weiwei, RoseLee Goldberg, Jeffrey Deitch, and many more. Art Salon includes more informal discussions and book presentations every day in the afternoon.

AMANDA COULSON: At VOLTA we only work with emerging art—100 percent! Although by this, I do not mean "young." There are some fairs that focus on "young" art and have an age limit under which the artists must be. However, there are artists who only hit their stride or find their voice later in life, or they were underrated at a certain point and are being "rediscovered." I would like to include also those artists as "emerging." In Basel, we use a committee made up of curators not of other galleries; this is unusual and I think brings a different perspective to the selection process. In New York, we only allow solo projects, meaning with eighty galleries there are eighty artists. This completely changes the flavor of the fair and allows for a much deeper look into an artist's practice. With both decisions, curators and solo shows, we are hoping to put the focus back on the artists as much as on the participating galleries. In New York we also share the OPEN FORUM with The Armory Show, which includes talks with artists, curators, critics, and such.

ZÉLIKA GARCÍA: Zona MACO takes place in Mexico City and it has different projects within the fair. We have a mix of galleries: some bluechip, others midcareer, and an area with emerging. We have a special invitation-only section currently curated by Adriano Pedrosa that presents solo projects by midcareer Latin American artists. This year we will also present Zona MACO DESIGN and hold panels mainly for a general public that is eager to learn more about contemporary art.

LOPEZ-CHAHOUD AND COFRÉ: *What steps can an artist take in order to participate in an art fair?*

GARCÍA: The artists *must* have a gallery that represents the work as we only take applications from galleries.

SCHÖNHOLZER: Artists cannot apply to our shows themselves. They must be presented by their gallery. Therefore, gallery representation is an essential requirement for an artist to be present at Art Basel. After that, it's just a question of producing compelling work.

COULSON: All the fairs I know work through galleries. [As] the business end of the artist's career, they rent the booth, know the collectors, etc. So, the first thing an artist needs to get into a fair is a good gallery who will help them get there!

LOPEZ-CHAHOUD AND COFRÉ: *On what do you base your selection of galleries?*

SCHÖNHOLZER: The galleries are chosen by the Selection Committees, which consist of internationally renowned gallerists. Depending on the sector the respective galleries have applied for, the Selection Committee considers the general gallery program or a specific project proposal.

COULSON: For Basel there is an open application process to which anybody can apply. This is publicly announced and the submissions are reviewed by a board of international freelance curators. We base the selection on the artwork and booth concept being presented, but [we also] look closely at the gallery and how [it has developed its] artists. We try very hard to support "mother galleries"—that is, those that work with artists very early in their career.

GARCÍA: We have a selection committee [comprising] representatives from five international galleries. Emerging galleries represent around 20 percent of the fair in our New Proposals section.

The Substance

LOPEZ-CHAHOUD AND COFRÉ: *What kind of different exposure does a participating artist get in an art fair as opposed to gallery or museum shows?*

GARCÍA: The fair will receive more attendees than a museum in Mexico will in any given five days. It is a way of reaching out to a larger amount of viewers and buyers. We also have an international collectors program that includes special guests who visit the fair. It can be beneficial to see the works of many artists in one place, which would otherwise be difficult, definitely in such a short time. It's a treat when visitors can discover new galleries or artists.

SCHÖNHOLZER: The conditions are of course much different to a gallery space or museum architecture. But the interesting aspect of being present at our show is the wide exposure: Art Basel and Art Basel Miami Beach are attended by members from all fields of the international art world, including the most important collectors, curators, museum directors, and critics—so being present in our shows can be a crucial moment, especially in an artist's early career.

COULSON: I think you get a lot of the same crossover, although of course the context is different. For VOLTA in particular, we are looking for artists theoretically *before* they would secure an institutional show,

and one of the goals of the fair is to secure institutional invitations. The difference from a gallery show is that you are getting a much broader audience in terms of countries: Fairs are places where people fly to from all over the world, whereas usually for a gallery show, you just get locals.

LOPEZ-CHAHOUD AND COFRÉ: *What kind of audience do you get beyond art world insiders (e.g., collectors, museum directors, curators, artists, etc.)?*

GARCÍA: Besides this audience, we also have a great many people interested in art or sometimes even in buying art, even though they are not regular collectors and do not travel to other art fairs. There is also a young segment of the general public (some are students) that starts getting involved in contemporary art because the fair sparks their interest.

COULSON: We get a lot of art students coming to see what is out there (Are they insiders?) and also just local people who are interested in art but aren't "in the business." A lot of families come during the weekend, that's for sure. I think it's similar to a big show at a museum, a large event where people can see things from all over the world. Anybody curious about art is going to go to that.

LOPEZ-CHAHOUD AND COFRÉ: *What kind of solo projects do you present, and how are they integrated into your fair?*

COULSON: As stated, at VOLTA NY the *entire fair* is solo projects. In Basel, we have a solo section and are pushing harder for more solos this year with a prize that will be awarded to the best solo presentation. The curators have a free hand to select the galleries. We try not to base our decisions too much on what other galleries say, because, of course, there is a high level of competition and also a clear conflict of interest. However, we will sometimes ask a trusted colleague [his or her] opinion if we feel we need more background than we were provided on the application.

GARCÍA: The projects I described are titled Zona MACO Sur. As we are in Mexico, we thought it was important to present midcareer Latin American artists each year. Currently, participation is by invitation only, selected by curator Adriano Pedrosa.

SCHÖNHOLZER: At Art Basel we present solo shows by young artists in the Art Statements sector. They have a special architecture and an

extra opening one day ahead of the VIP preview of Art Galleries, the main sector of the show. In the Art Unlimited sector, participating galleries have the chance to present large-scale projects by artists— works that exceed the constraints of a normal gallery booth. At Art Basel Miami Beach we have the Art Positions sector, which displays one piece by a younger artist, and Art Kabinett, with curated solo shows with the possibility of presenting an emerging artist or historical material.

The Effects

LOPEZ-CHAHOUD AND COFRÉ: *Can you cite some examples of the results/ effects for an artist's career of participating in a fair?*

SCHÖNHOLZER: Art Statements traditionally is a launching pad for such careers. Artists such as William Kentridge, Pierre Huyghe, Elizabeth Peyton, Gregor Schneider, Jorge Pardo, Ugo Rondinone, Kara Walker, Manfred Pernice, and Ernesto Neto are only a few of the artists who made their appearance there before going on to become world-famous. Besides sales, of course, it can be interesting for artists when the works are placed in important private collections or museum collections as well as in exhibitions like biennials.

GARCÍA: Many Mexican artists become known and better connected with international galleries, curators, and collectors. The international scene also gets involved in projects in Mexico with local collectors and institutions.

COULSON: Milliken Gallery from Stockholm presented a performance by Tris-Vonna Michell at VOLTA3 in Basel 2007 and the following year in 2008, Tris had a Statements at Art Basel and a show at Palais de Tokyo in 2009. Adrian Williams was presented in 2008 at VOLTA NY, this year [2010] had a Statements at Art Basel, and was subsequently invited to do shows at the MMK and Schirn in Frankfurt; she is now doing an international residency in San Antonio because the curator saw the work there. Sue Collis, represented by Seventeen Gallery from London, had a solo presentation at VOLTA NY in 2009. After that, she was accepted to the Frame section of Frieze (also for solo projects), and then selected as The Armory Show's artist for the year to do their edition and brand the fair for 2010. Both of these [were] a huge step for her in terms of institutional shows and of course

the pricing of her work. In 2009 we also had a solo by Maria Nepo-muceno represented by A Gentil Carioca from Rio [de Janeiro]. This year [in 2010] she had a solo in the Statements section of Art Basel and was taken up by Victoria Miro gallery. These are just a few exam-ples off the top of my head but I could come up with many, many more.

"I think it's the people from your art school student loan."

FOUNDATIONS AND ARTS COUNCILS

"Your work was rejected by the committee, but you can still become a member and support the work of artists that we consider better than you."

Funding Artists

An Inside Perspective

MELISSA RACHLEFF

When artists graduate from studio art programs, they join the more than 2.5 million other self-identified artists striving to maintain an art practice while supporting themselves (and, often, families).[1] Recent graduates are suddenly, and with very little ceremony, independent. Art world superstars notwithstanding, the majority of artists make a living not from the sale of their art but from art-related or other jobs. How their careers progress depends on how well they sustain their creative practice despite uncertainty and seize opportunities that luck throws in their path.

One aspect of career sustainability is grants. Funding by foundations or by government agencies/affiliates lends an artist credibility and helps the artist build a base of support. Obtaining grant funds requires careful reading of guidelines, deliberative preparation of work samples, and clarity of purpose. What is not always obvious is that funders are keen to support pivotal moments in artists' careers. However, with hundreds—if not thousands—of visual artists competing for the same pool of resources, is seeking such support practical?

To answer this question, as well as a host of related concerns about preparing proposals, it is helpful to understand the decision-making processes at foundations. Knowing what goes on behind the scenes can strengthen an artist's chances. For some insider perspective, I turned to experts who have fostered grant opportunities for individual artists throughout their careers. Conversations with William (Bill) Aguado of the Bronx Council on the Arts, Fritzie Brown of CEC ArtsLink, Amada Cruz of United States Artists, Ruby Lerner of Creative Capital, Kerry McCarthy of the New York Community Trust, and Melissa Levin and Kay Takeda of the Lower Manhattan Cultural Council revealed the policies behind direct artist support. Each funder made clear that regularly applying for monetary or other material support is vital to an artist's career. In fact, the application process forms a critical link to the broader

arts community beyond the artist's immediate network. Each funder conceives of the process he or she has designed as a means of strengthening the articulation of an artist's ideas. An artist who understands the values and goals of the funder will have a sense of the right time at which and the right project with which to apply, and which funder could meet his or her needs.

Unlike many "how to write grants" texts, this chapter investigates the basics from the funder's perspective, not the artist's. Because funders contribute to American arts policy, their practical observations are situated within the context of the current funding climate for visual artists. Programs, government and private, are outlined and inform the analysis on preparing applications. The chapter closes with thoughts on additional prospects.

Government Support for Artists: Think Local, Act Local

More than twenty years separate our current era from that of the "culture wars," the virulent political debate initiated by Rev. Donald Wildmon in 1989, and subsequently taken up by U.S. Senators Jesse Helms and Alfonse D'Amato, that ultimately resulted in the derailment of federal funding for individual artists, followed by similar restrictions at state and local levels. In fact, the 1995 cessation of direct artist grants by the National Endowment for the Arts (NEA) still affects arts policymakers.[2] Although the passions have diminished somewhat, the practice of funding artists directly has stagnated. The growth of private foundations suggests they might play a role in mitigating the effects of the NEA's policy.[3] However, most private funding programs do not have the capacity to serve more than a limited number of applicants and restrict proposals by a closed, invitation-only process. In 2004 a study revealed that $214 million was granted to individual artists between 1999 and 2000, representing the aggregation of public (government) and private foundations. This figure has declined since the onset of the economic crisis that began in 2008.[4]

The first grant an artist receives typically comes from a local organization, and the major benefactor for artists remains the government, through block grants given to local arts service organizations, public/private entities that arose with the proliferation of national arts funding initiatives during the late 1960s.[5] "The role of the arts council is to mentor, to provide leadership, to help develop policy," said William (Bill)

Aguado, president of the Bronx Council on the Arts since the early 1980s.

One study suggests there are 4,000 local arts agencies that in the aggregate spend $711 million on their programs.[6] Where do these local funds come from? Artists need to know, because the purpose of the local grant is very often tethered to an entity separate from the ostensible resource, usually from state and municipal sources. This funder-behind-a-funder system is called re-granting, a practice in which a nonprofit organization administers grants for another, usually government, entity. In government, the process is commonly referred to as decentralization.

New York City's largest re-grant program is administered by the Lower Manhattan Cultural Council (LMCC), and funds are for Manhattan residents only. The director of grants and services, Kay Takeda, points out, "We are more than a middleman" with funding, and the LMCC provides a host of services in recognition of artists' professional development needs at a variety of career stages.[7] Indeed, the organization Grantmakers in the Arts found that in addition to monetary support, artists listed services as an area of need. Travel funds, job listings, directories of grants, and career and business training are some of the services subsidized by grant makers, both public and private. Aguado sees such services as reinforcing his goal of making community a central purpose at the Bronx Council on the Arts: "Without the creative impulse you don't have a creative community. . . . There have to be more creative venues to support artists. And my second priority is the notion of community. Artists come out of communities, we live in communities, there are legacies in our communities."[8]

Takeda underscored the connection of community to the re-grant program's adoption of its benefactor's criteria. The rationale for using a local council network is that local organizations have a closer relationship to their community and are better able to measure needs and evaluate projects. Yet, though allowed autonomy in the decision-making process, they are asked to further government arts policy. In workshops required for all applicants, Takeda is upfront about government goals by emphasizing the public component of the project. "The goal of the funding isn't simply to further the creative goal of an artist, but rather to help enable that artist to bring [his or her] work to the public," she clarified.[9]

To put the impact of local arts councils in context, it is helpful to examine the amount of funds allocated. In fiscal year 2010 (the most recent year for which comparable figures are available), the New York State Council on the Arts granted $5,993,401 to arts service organizations across the state.[10] In New York City, five borough arts councils

received a total of $586,256 for granting to artists and to small arts organizations.[11] In comparison, the New York City Department of Cultural Affairs provided a total of $902,175 to the borough arts councils.[12] For both re-grant programs the maximum award is $5,000, and that has remained the cap for a decade; however, most recipients get less. Aguado acknowledged the frustration experienced by many artists for whom the grant amounts to little more than token support. However, he is bound by city and state requirements attached to the re-grant funding. "A $1,500 award, you know [the level] is so ridiculous. I tell people: listen, if you can afford to do it on your own, don't apply. You wait four months to get a check for $750 or maybe $2,500. There has to be a better way and artists have to be part of it. . . . Why can't they get the same amount as we would give to local entrepreneurs?"[13] Changing the funding level will require advocacy outside of the local arts council network. Local councils cannot, of course, antagonize their benefactors; Aguado is one of the more fearless and outspoken advocates for his community. Ultimately, for change to occur, artists need to be an active part of the strategy.

Writing the Grant for the Local Arts Council

Applying for re-grant funding requires careful planning and deliberation about both the project and how that project matches the goal of furthering the local arts environment. It is also important to note that a grant is not a fellowship. A grant is given to help offset the costs of a specific project. For that reason, artists must use straightforward, descriptive language, what Takeda calls "concreteness." An important factor in writing a concrete grant proposal is to situate ideas in the real world rather than in conceptual imaginings. "I like to emphasize that grant writing is a form of storytelling or journalism," she explained. The proposal does not need to be an expression of your innermost personality, or dreams, but really just a clear description that gives the facts of what you plan to do and how you plan to accomplish it."[14] Like many grant makers, Takeda advises having someone—even someone without a background in the arts—read the narrative draft. If that person can imagine what you are trying to do, even if your project will change as you develop it, you will have realized the purpose of the narrative portion.

What happens to your proposal after you have submitted it to the arts council? The art council deploys a peer review process composed of artists and arts professionals. Panelists read the proposals, then meet to review work samples and make decisions. "A really strong work sample

is something that is going to help a panel to take a leap of faith," Takeda explained. "The panel may have questions about the proposal—they may have felt that something was a little unclear, they are not sure how you are going to carry something out—but if they see that the work you have done in the past is really strong, then they will say, 'Well, that fills in that gap for me, I can see this artist is capable of doing something really strong.'"[15] And the reverse is also true. There are cases where the proposal is strong, but when the panel sees the work samples, doubt creeps in. Common missteps include samples in the wrong format and samples that do not illustrate adequately the capabilities of the artist or, a common mistake when artists conflate grants and fellowships, if the work samples have no relationship to the proposed project. Takeda cautioned that choosing the work samples which best support your proposal is not an "exact science." Despite the challenges, local arts councils are, on the whole, more accessible and likely to provide funding than nearly any other grant program. At the Lower Manhattan Cultural Council, the re-grant programs fund on average 50 percent of the applicant pool.

After reviewing work samples and discussing an application's merits, panelists are asked to vote yes or no to fund, thereby moving a percentage of the applications forward. Throughout this process monetary need is not discussed. The focus is predominantly on the artistic excellence, feasibility, and public dimension of each project. The final grant amounts are allocated between all funded projects based on the strength of the proposals, with $5,000 as the maximum. "I always tell people that it is very important when you are writing your proposal to compare it to the funding criteria," Takeda said. "Address your proposal to these criteria specifically, because that is what is going to drive the panel discussion."[16] Funding recommendations are then submitted to the council's governing board for approval.

Generally speaking, re-grant organizations derive their grant budgets from government sources. Government in turn derives its revenue from state and local taxes. Because the funding comes from the populace, most re-grant programs require a strong community component. Private support, however, is given in a far more nuanced process having to do with the history of the benefactor and the perpetuation of legacies.

Private Foundations and Artists: Impact and Strategies

Foundations in the United States grew after passage of the Tax Reform Act of 1969, in which charities were divided into categories including private foundations (operating from an endowment) and public charities

(grant-making entities that can raise money).[17] Artists today are also benefiting from the estates of American artists; Richard Avedon, Adolph Gottlieb, Roy Lichtenstein, Joan Mitchell, Robert Motherwell, Jackson Pollock and Lee Krasner, and George Sugarman established grant-making programs as part of their legacies.[18] Other recent trends include the proliferation of family foundations and venture philanthropy, reflecting the fortunes made in the new technology and finance industries, though relatively few have concentrated their giving on artists. "E-philanthropy," or user-generated contests, is another trend, and sites like http://www.kickstarter.com offer new strategies for project support.

Some experts maintain that foundations are the key sector for artists and arts advocates to cultivate, and the reason the arts lag in comparative charitable giving is that they have not made an emotional impact on potential supporters. "People give to causes which touch them directly or indirectly or which relate to their most strongly held values and beliefs," noted David Fishel, author of a study on Australian philanthropy. "Until arts organizations focus on the emotional and value-based appeal of the arts, they cannot maximize philanthropic giving."[19] For opportunities to expand, particularly for individual artists, advocacy is crucial. Currently most of the arts advocacy organizations are run by arts managers, the vast majority of whom did not study studio art; and while they will invite prominent artists to high-profile events, their efforts are primarily targeted toward government.

Each foundation establishes its own priorities based upon a benefactor's wishes or a charity's mission. In researching private foundation opportunities, or if invited to apply, one must acquire a considered understanding of the goals that govern the distribution of foundation dollars and address those priorities in the proposal and work samples.

Cultural Exchange Grants

A growing number of foundations and other entities will support projects abroad. One CEC ArtsLink awards program provides funds to American artists pursuing projects in a thirty-country region that was once part of the former Soviet bloc plus Turkey and Afghanistan. The selection process begins with a formal written application, which is then reviewed by a peer panel. Executive Director Fritzie Brown stresses that although the awards are sometimes referred to as residencies, "project" is the more apt term, as the artist is not expected to work isolated from communities. "What we are seeking is community engagement. . . . The first criterion

is artistic merit and excellence, and the quality and feasibility of the project itself, and then the most important is potential for interactive dialogue and mutual benefit."[20] These criteria are crucial for a program that is based upon a cultural exchange. Proposals must demonstrate how a project meets all three requirements.

Each year, CEC ArtsLink receives 85 to 120 applications for projects by American artists, and approximately 20 are funded as fully as possible based upon the budget submitted. This policy is known as funding for success, which means that rather than being spread across many projects, funds are concentrated on a few. For Brown, having the means to do the proposed project is a paramount criterion, because no funder will cover all the costs of a project grant. When a grant is attached to a cultural exchange, showing feasibility is especially important. Brown noted, "There are also travel costs. An artist can't just arrive without enough money to pay for food or hotel, or [he or she is] going to be a liability and [he or she is] not going to get [the] work done."[21]

Preparing for a project abroad requires that the artist do research and find collaborators, and even additional financial support, prior to submitting an application. The more artists can demonstrate that a planning phase has taken place, the better they can anticipate their budgetary needs and ultimately prove the feasibility of their ideas. "There was a project where the artist listed under 'other costs' a line item for 'bribes,'" Brown recalled. "It was a fairly hefty amount. This was a film project in one of the former Soviet states, and knowing the climate there at that time, bribes seemed absolutely realistic. The artist got the grant because he clearly knew the realities on the ground."[22] Not every proposal will have such unusual budget lines, but a project budget must reflect the material conditions governing the project's execution.

Brown shared her concern about proposals that "smell like vacations" or are without a sense of purpose. To measure an idea against its potential viability through CEC ArtsLink's evaluative process, a great place to start is their Web site. "This is absolutely vital to look at," Brown noted. If artists do not see any project funded remotely like their own, that is likely an indication theirs would not be supported.

Project-based foundations want to see clarity about the specific project an artist is planning to achieve and for which funds are being sought and less interested in the so-called artist's statement. Given the emphasis BFA and MFA programs place on writing artist statements, many emerging artists are slower to omit them given the time/effort that went into their development. Because grants are for projects, funders expect to see that their specific (and often practical) application questions are answered, as

those answers form the basis for the evaluation of the proposal. "The artist statement is exhausting and beside the point," Brown explained. With panelists reading on average one hundred narratives and budgets, the artist must ensure that the proposal "relates to the project. It has to be very specific. . . . I think it is important, always, for applicants to walk in the shoes of the panelist. . . . [Y]ou want to make it easy for them." Moreover, Brown and other foundations see the work samples as functioning as the visual equivalent of the artist statement. Brown noted, "The most important way to [convey artwork] is with work samples." On this point Kerry McCarthy of the New York Community Trust agrees: "The most successful arts proposals are clearly written in simple language; they clearly set out what they want to do, who is going to do it, how they are going to do it, when they are going to do it, how they are going to know if it is successful."[23] McCarthy and Brown underscore that an excellent grant application to a foundation reflects the project's ultimate purpose, and that purpose must relate to the mission or goals of the funding entity. Artists must demonstrate cognizance of their managerial role, which means showing an ability to envision the project's administration as well as its creation.

Fellowships

Sometimes artists need the time and space to make artwork that is unattached to any public purpose. Those seeking the time and monetary resources to create without having to manage a specific project should not look for a grant but should instead seek fellowship opportunities. The challenge is that fellowships have far fewer open application processes, and each foundation places value on different criteria. The Pollock-Krasner Foundation, for example, has a mandate to fund only artists with a demonstrable financial need. This correlates to the financial struggles of the artist benefactors, Lee Krasner and her husband, Jackson Pollock, before they became successful beginning in the early 1950s, in their midcareers.[24]

Fellowship opportunities by invitation often use a nomination process in order to diversify the applicant pool while keeping the number of applications manageable. Although the system varies from foundation to foundation, in general a diverse group of artists and arts professionals are asked to recommend one or more artists who they believe deserve consideration. The nominated artists are invited by the foundation to apply to the program and given specific application instructions. Another group of professionals are asked to serve as panelists; they review each

application, rank them, and determine fellowship recipients. Even in this much smaller pool, funding is not assured, however. Artists who are invited to apply for a fellowship would benefit from speaking with the potential funders to learn as much as possible about how applications are reviewed, as this process varies. And unlike the grant proposal strategy (discussed earlier), fellowship applications require a different approach because the award decision is based upon an artist's career stage, work, and process.

Amada Cruz is the program director at the United States Artists, a public charity that has awarded $50,000 fellowships to 50 artists in all disciplines each year since 2005. Cruz invites 150 nominators from a potential pool of thousands of arts experts from every state and asks them to nominate up to three artists each. Every year Cruz seeks different nominators. "And we make sure that we are going high to low—the head of a symphony to some kid who has a funky gallery in his living room."[25] A list of past recipients of United States Artists shows a striking range of artists supported, from the better established to the underrecognized.[26] Conversations with private funders emphasize the importance of maintaining artist networks. Former professors, curators (emerging and well established), and other artists are the core nominators in these processes. An artist who maintains relationships that are valuable professionally as well as personally has a stronger chance of being nominated.

The application process for a fellowship is different from the grant-application process. Whereas grants are awarded based on the feasibility and public component of the project, fellowships are not project-based but are rather awarded for an applicant's artistic vision. However, as Cruz articulated, the artist must explain how his or her work matches the foundation's criteria. Indeed, looking for a match between foundation goals and an artist's work/process forms the critical evaluation by an expert panel. "The best applications are very clearly and directly written. What I usually tell artists is that they need to think of the panel as a group of people [who] don't know [the artist's] work at all, and they should explain very clearly what it is about."[27] However, as Cruz further explained, clarity is still important:

> I don't ask for an artist statement, because if you leave it that open-ended the answers are kind of all over the place. We ask artists to answer three specific questions: (1) explain your general artistic concerns, themes, or perspectives; (2) how has your work evolved?; and (3) describe the potential significance of a U.S.A. grant on your creative work. I advise artists that they need to think really clearly

about their work, why they do it, think about those three questions that we ask, and answer them very succinctly, directly, and honestly, and not to think, "Oh, what would this panel want to hear?" Because that usually shows through. It is important to be sincere.[28]

The samples are the most important component of the fellowship application. The panelists want to get a sense of the depth of an artist's practice. "The work samples are very important because that is really the only way to gauge what that artist has done," Cruz noted.[29] Poor samples, including images that are difficult to see, have a calculable negative impact during the peer review process.

To be sure work samples are not hindering their chances, artists should take advantage of the advice offered by the foundation's or charity's staff. Program officers routinely advise artists on the preparation of the work samples and narrative components of their applications. However, no program officer can guarantee an outcome. The decision is left to the peer panel, and the dynamic among panelists is a factor no one can predict. Demonstrating a cohesive and consistent body of work is the strategic approach in fellowships.

Venture Philanthropy: Creative Capital

The rise of the new technology industry during the 1990s popularized investment-based funding called venture capital, premised on multi-year, graduated cash investments for the development of new products that had the potential to yield monetary returns. This investment model was introduced to philanthropy during the late 1990s as those who were newly wealthy from this sector began giving. Nina Kresner Cobb, a consultant to nonprofit organizations, notes three trends: "an increase in available funds, an expansion in modes of giving, and a greater democratization of philanthropy."[30] Venture capitalists have not been particularly generous to the arts and artists, tending to choose broader, socially oriented projects in areas such as education and human development. Nonetheless, the model of venture capital investment did cross over to the arts as venture philanthropy, and one program, Creative Capital, designed specifically for artists, not organizations, is especially effective as a grant maker.

Creative Capital, which started with approximately $5 million in seed money from 22 funders, especially the Andy Warhol Foundation for the Visual Arts (where its offices are located), has been directed by Ruby

Lerner since its founding in 1999. It continues to raise funds for the purposes of re-granting and to offset the costs of its artist services. As of this writing, Creative Capital has funded 325 projects by artists in all media. As in a venture capitalist model, Creative Capital makes a provision for grant monies to be recoverable—that is, having the artists pay back a percentage of their profits. However, Lerner emphasizes that the reinvestment portion is not burdensome, nor is it the ultimate goal of the program. Rather, grant recipients—the program supports projects; it is not a fellowship—go through a several-years-long process in which funds are released as benchmarks are met. Creative Capital also runs a retreat for recipients in order to bring their work to a broader audience in their field, and in related fields. Artists are nurtured throughout the life of the grant, which lasts three years, sometimes longer—building sustainability into the process.

The type of project Creative Capital seeks to support is best described as catalytic, representing a significant direction in the artist's career. "[Artists who believe] that their project is different, the project they hope will catapult them into the next phase of their career" is how Lerner characterizes the ideal candidate. "When we hit somebody at that moment—and this can be a young artist, a midcareer artist, this can be a mature artist; it is absolutely not age related—that point in a trajectory is just more critical. We think that is a moment for us to enter the practice."[31] The Creative Capital Web site features all of its funded projects, and potential applicants are encouraged to familiarize themselves with the type of projects supported. Such scrutiny is the best measure for determining one's own "catalytic moment."

Remarkably, Creative Capital's application process is open; artists can apply in the year their art form is being considered. For each deadline Creative Capital receives on average 2,000 to 2,500 applications for approximately 40 grants per cycle over two years. After an initial review by Creative Capital staff and consultant readers/evaluators, the 2,000-odd applicant pool is winnowed down to 100 to 125 applications that are brought to a peer panel of experts in the artistic discipline. If an evaluator finds artists' proposals intriguing, Lerner encourages action: "Get in touch with them immediately and tell them where you found out about them!"[32] In this way the application process disseminates artwork to the field, and even if the artist is not selected for Creative Capital, it is not impossible that projects will be realized through other means. Ultimately, an average of 90 artists are supported in various phases of their projects at any given time. After the two-year cycle there is a third year

of follow-up with each artist individually, and a major retreat for the recent grantees.

The Creative Capital staff also takes notes during the peer panel meeting on the projects under review. Like all funders that offer panel feedback, they strongly encourage artists to solicit the information. "We always make panelists frame things in a positive way: 'It would have been stronger if,' 'Your work sample needed X,'" Lerner described. Such comments can be beneficial in artists' careers, particularly in seeking other support. Lerner noted, "As I run into people who did not get grants from us, they say the feedback was so helpful that they rewrote their proposal and submitted it somewhere else and got the grant."[33]

Creative Capital's grant support is based upon tenets from venture capitalism, simply put: money, meetings, and mentoring. The project development process is not formulaic. "A lot of the projects take a long time to develop," Lerner explained. "Some take a long time to raise money. In order for the projects to have a long life in the world—if we are doing our job right—we expect to have long relationships with the artists." The relationship has four aspects: supporting the project, supporting the person, nurturing the community, and engaging the public. Each phase is accompanied by investment funds, professional development services, and retreats. Investment funding is capped at $50,000; however, the professional services given are worth more than $40,000 per artist. In the first phase artists can receive up to $15,000, and they are encouraged to build an infrastructure including paid support staff, or "anything that will help people stabilize their practice even beyond our project, part of making people . . . stronger when they leave our program," Lerner explained.[34] Throughout the life of the grant, an additional $20,000 can be requested for direct project costs. Creative Capital also sets aside $15,000 to be used for the project's premiere and future project dissemination. In doing so, Creative Capital ensures that each project has a budget for marketing, a crucial component for media and public awareness. Lerner embraces this strategic funding decision in the last phase as "one of the smartest things we've ever done."[35]

The benchmark approach is more than merely demonstrating that funds were spent on the project. Creative Capital is interested in the development from every aspect, and as Lerner described, that includes partners such as dealers, curators, and venues. Thus, the funding is used to advance both the project and the artist. Nurturing the artist as a person incorporates training in strategic planning and goal setting. And, simultaneous with this service, Creative Capital also fosters community among its "class" of recipients (reflecting the two-year funding cycle).

The retreat is the heart of this process: Artists not only meet other recipients and share work via formal presentations; they also meet professionals and artists in their field in focused, individual meetings. "We try to deflate expectations there, and really our goal is just to set relationships in motion that are sustainable, hopefully, long after we are out of the picture," Lerner said. "But concrete things do happen. People get commercial gallery representation out of it, they end up getting residency opportunities, they might be invited to a film festival or [to] meet a book publisher."[36]

Creative Capital is systematic, long-term, and intensive. Not every artist will be amenable to the process, and careful consideration of the commitment expected is required. Indeed, no other arts funder provides such an integrated approach, and the vast majority of Creative Capital artists have found the technical support a key strength of the program. Creative Capital's model is slow to proliferate among traditional philanthropy sectors. More studies are needed to determine if the multilevel approach pioneered by Lerner is more effective and sustainable than those of traditional programs. Promisingly, the venture capitalist model addresses the values of America's new wealth sector.

Artist Residency Programs

Artist residency programs are steeped in a long tradition dating back to nineteenth-century artist colonies. Because residencies are often private, isolated experiences, there is no public component, and in the post–culture wars period artist residency programs are attractive candidates for public and private support compared with the publicly situated artist grant programs.[37]

Perhaps some of the most popular artist residency programs in New York City are the Lower Manhattan Cultural Council's (LMCC) Workspace and Swing Space programs, both of which are currently directed by Melissa Levin. Workspace is a nine-month studio residency for approximately twenty visual artists and eight writers per year. Professional development is part of the residency, and weekly meetings introduce each "class" to established artists, curators, critics, and other arts professionals. The Swing Space program is concentrated on short-term project-based residencies, focused use of space for visual and performing artists and arts groups' rehearsals or other short-term needs. Both programs also expose participating artists to new audiences through open studios, open rehearsals, and other public events.

Workspace grew out of LMCC's World Views program, which was based at the World Trade Center from 1997 until the buildings were destroyed in 2001. Swing Space was created in 2005. Since 2001, LMCC has partnered with generous building owners in lower Manhattan to adapt temporarily unoccupied office, basement, and storefront space for use as artist studios, rehearsal space, and exhibition and performance space for its artist residency programs. LMCC has also secured long-term use of Building 110: LMCC's Arts Center at Governors Island, which includes a gallery, two rehearsal spaces, and twenty visual art studios to serve their Swing Space program.

Each year LMCC receives as many as 350 applications for the Swing Space program and up to 900 applications for the Workspace program, daunting figures considering the few slots available. The volume of applications especially for the Workspace program begs the question: How are all 900 processed and evaluated? How can 20 artists be selected from such a broad pool? Levin candidly reported that a number of applications are rejected outright for being late, ineligible, or incomplete. Additionally, Workspace is specifically for emerging artists who are willing and able to make the commitment to weekly meetings, and not every application indicates recognition of this vital aspect of the program. As Levin put it, "Essentially it boils down to: Is an artist at the right stage in [his or her] career to benefit from the resources we offer? We then present the applications that we determine reflect the criteria of the program to the panel."[38]

The Workspace application itself is not complex. It consists of a total of 400 words plus work samples. Like a fellowship grant, Workspace concentrates on artistic excellence and career stage. However, like a project grant, it asks the artist to think about what he or she wants to accomplish. "We are looking for an artist with a clear idea of how [he or she is] going to think and work during the program," Levin explained. Diversity is also a factor in the selection process. "We are looking for artists across media, across background, and we always end up with a group of people who mimic the makeup of the New York art world. It is always a diverse group, it is international, with the self-taught to MFA artists. We also don't define 'emerging' by age, and we are really looking at the career stage that would most benefit from the program."[39]

How can artists communicate why they are the right candidate for the Workspace program? Levin's insights are complementary to those offered by Amada Cruz:

There are many ways that artists can talk about their work; however, this can be a real stumbling block. We find that 100 words for an artist

statement is too much for some people and too little for others. The limitations can be flipped into a positive, and artists should ask themselves, "How can I best express myself within these limits?" One of my biggest pieces of advice is to be honest about what you are working on and what your ideas are for the future. Artists can reflect their ideas while still demonstrating their openness to learning from peers and going in new directions with their work. Artists also really need to know what they're applying for and should be familiar with the resources provided by the program as described in the application guidelines. Proposals should then articulate why an artist feels [he or she is] a good match for the program.[40]

Work samples are also key. LMCC's artist residency programs have specific formats for still and moving images, not for bureaucratic purposes but to present the work in the best possible light and to "put all applicants on a level playing field," Levin added. "That is the reason we ask for work samples the way we do—we know that this size looks the best the way that we project it." The best work samples demonstrate not just excellence but also professionalism, and for that reason, work in progress is discouraged. Levin explained, "The panel is taking a leap of faith based on the fact that an artist has done great work in the past, that [the artist] will do great work in the future. The panel is relying on the merit of the past work to move an applicant forward in the selection process. Showing work in progress can hinder an application."[41] Finally, many artist residency opportunities offer workshops on how to apply. LMCC is a leader in preparing and coaching artists through the application process. Artists are strongly advised to take advantage of funder-sponsored training sessions no matter what their career stage.

Challenges/Opportunities Now

Nationally, cultural policy discussions regarding support for the arts have concentrated on sustaining organizations, providing access to a diverse population, and making the arts a partner in public education. This emphasis leaves out entirely the careers and needs of individual artists. Moreover, the lack of artist cultivation by arts policy proponents further limits direct artist support.

No one can predict the future, but there are several areas where support is being maintained and some areas to watch for further development. These include arts service organizations. Kerry McCarthy of the

New York Community Trust has made support of the borough arts councils a priority, and she pointed out that helping this vital sector is one way "for us to help as many artists and arts organizations as possible."[42]

Another area is economic development programs, particularly those outside of traditional arts networks. Bill Aguado says that the Bronx Council on the Arts has long been a recipient of federal and state investment funds. For a time, the Bronx Council even maintained a venture philanthropy fund, most of which was raised through public economic development initiatives. "In our part of the universe, that is where we are headed," Aguado explained. "[We are working] with community, [and we are] artist advocates, and [additionally] we are a business community—economic development specialists. You know, you can't just wear one hat and expect to survive. I don't have that base of support, nor will I ever have that base of support."[43] As organizations tap into new funding streams in areas outside of the arts, artists will need to stay abreast of the changes to determine how their work or ideas might be competitive under new funding models.

Increased funding for artist exchange and travel is an area that those who support artists see as vital. Creative Capital includes resources for travel as part of its finishing funds, and the CEC ArtsLink program is another important model in this area. Local arts funders are increasingly engaged in the holistic development of artist projects beyond the grant term. They are important actors in broader arts policy discussions, and the coming decade will see their increasing impact in shaping artist initiatives.

However, the future will not change the basics of seeking grant support. Knowing where you are in your career, knowing that the opportunity you need is matched to a funder's goal, and taking the time to think strategically about your career enable the clarity of purpose funders seek in their applicants. "I think it is really true that if you take the time to articulate what it is you want, you are much more likely to find it," Kay Takeda observed. "And you are much more likely to find the right match coming with the funding resource or residency opportunity that is out there."[44]

Notes

1. Both the Census Bureau and the National Endowment for the Arts track self-identifying artists. Recent figures cited by McCarthy et al. suggest that the number of visual artists (painters, sculptors, printmakers, and craft artists) is approximately 250,000 or 12 percent of the total. Fine art photographers and

performance artists are not considered "visual artists." Commercial professions (architecture, design, film) are considered artists. See Kevin F. McCarthy, Elizabeth H. Ondaatje, Arthur Brooks, and Adnras Szanto, *A Portrait of the Visual Arts: Meeting the Challenges of a New Era* (Arlington, Va.: The Rand Corporation, 2005), 45.

2. At its height in 1991, the NEA gave a total of $7,851 million to individual artists across all disciplines, representing 5 percent of the total budget. Ann M. Galligan and Joni Maya Cherbo, "Financial Support for Individual Artists," *Journal of Arts Management, Law and Society* 34, no. 1 (Spring 2004): 28.

3. In 1996 the NEA commissioned a study by Anne Focke to look at foundation support for artists. Her findings suggested there was enough support in the private sector to make up for the $7 million loss by the NEA. See Anne Focke, *Financial Support for Artists: A Study of Past and Current Support, with Reflections on the Findings and Recommendations for the Future* (Seattle, Wash.: Grantmakers in the Arts, 1996).

4. Because foundations are private, quantifying data on individual artist support requires extensive research. Public money is easier to track because of transparency rules; individual artists were granted $8,832,989 in 2009, a decrease of $1,209,370 from 2000. "See Support for Individual Artists: State Arts Agency Fact Sheet" (National Assembly of State Arts Agencies, April 2010). Those who are interested can download a PDF on recent statistics on funding individual artists from NASAA's Web site: http://www.nasaa-arts.org/Research/Grant-Making/index.php#artis ts (accessed August 28, 2010).

5. Galligan and Cherbo, *Financial Support for Individual Artists*, 24.

6. This study opens with the suggestion that local arts councils were not targeted during the culture wars and thus became important actors in the redistribution of government and private funding for artists. See Lawrence D. Mankin et al., "Executive Directors of Local Art Agencies: Who Are They?" *Journal of Arts Management, Law and Society* 36, no. 2 (Summer 2006): 86.

7. Kay Takeda, interview by the author, New York, August 24, 2010.

8. William (Bill) Aguado, interview by the author, New York, August 18, 2010.

9. Takeda, interview.

10. New York State Council on the Arts, Grant Search, http://www.nysca.org/public/search/index.htm (accessed August 27, 2010). All figures in note 5 come from using the search function at this site.

11. New York State Council on the Arts, Grant Search. NYSCA's re-grant funds for fiscal year 2010 were allocated as follows: Bronx Council on the Arts, $73,520; Brooklyn Arts Council, $83,560; Lower Manhattan Cultural Council, $295,000; Queens Council on the Arts, $87,600; and the Council on the Arts for Staten Island, $46,576. In fiscal year 2011, a 15 percent cut in NYSCA's overall allocation also cut re-grant programs. The decreases were not evenly applied, reflecting a new ranking system adopted by the agency: Bronx Council on the Arts, $66,150; Brooklyn Arts Council, $32,400; Lower Manhattan Cultural

Council, $267,500; Queens Council on the Arts, $63,300; Council on the Arts for Staten Island, $10,600. NYSCA is to be applauded for its transparency in releasing these figures. The disparities deserve further discussion, particularly in the boroughs most affected by the decreases.

12. The re-grant funds were allocated as follows: Bronx Council on the Arts, $174,615; Brooklyn Arts Council, $232,820; Council on the Arts for Staten Island, $75,665; Lower Manhattan Cultural Council, $291,025; Queens Council on the Arts, $128,050. Figures posted at: http://www.nyc.gov/html/dcla/down loads/pdf/fy10_cdf_awards_org.pdf (accessed August 27, 2010).

13. Aguado, interview.

14. Takeda, interview.

15. Ibid.

16. Ibid.

17. Foundations that support the arts represent 12 percent of the total arts giving nationwide of that percentage; visual arts accounts for 3 percent. Total arts giving grew from $1.8 billion to $3.7 billion between 1996 and 2000; however, arts donations fell way below social services and religious giving. See Nina Kresner Cobb, "The New Philanthropy: Its Impact on Funding Arts and Culture," *Journal of Arts Management, Law and Society* 32, no. 2 (Summer 2002): 128. See also the Foundation Center Web site, a resource on foundation history: http://foundationcenter.org/getstarted/onlinebooks/ff/text.html (accessed August 28, 2010).

18. See Daniel Grant, "Finding a Helping Hand in Artist Foundations," *American Artist* 66, no. 720 (July 2002).

19. Optional citation of Fishel in Kevin V. Mulcahy, "Entrepreneurship or Cultural Darwinism? Privatization and American Cultural Patronage," *Journal of Arts Management, Law and Society* 33 no. 3 (Fall 2003): 174.

20. Fritzie Brown, interview by the author, New York, July 21, 2010.

21. Ibid.

22. Ibid.

23. Kerry McCarthy, interview by the author, New York, July 29, 2010.

24. Jackson Pollock died in 1956 at age forty-four. Lee Krasner tended to his estate until her death in 1984. The Pollock-Krasner Foundation was established in 1985. Information about the foundation and how to apply can be obtained at http://www.pkf.org/.

25. Amada Cruz, telephone interview by the author, August 4, 2010.

26. United States Artists Web site at http://www.unitedstatesartists.org/Public2 /Home/index.cfm.

27. Cruz, interview.

28. Ibid.

29. Ibid.

30. Cobb, "The New Philanthropy," 125.

31. Ruby Lerner, interview by the author, New York, September 2, 2010.

32. Ibid.

33. Ibid.

34. Ibid.

35. Ibid.

36. Ibid.

37. The membership organization the Alliance for Artist Communities maintains a database and newsletter about residency opportunities for artists worldwide. See http://www.artistcommunities.org/.

38. Melissa Levin, interview by the author, New York, August 24, 2010.

39. Ibid.

40. Ibid.

41. Ibid.

42. McCarthy, interview.

43. Aguado, interview.

44. Takeda, interview.

"Have you ever been involved with a terrorist organization, or have you ever made a project for Creative Time?"

ARTISTS' RESIDENCIES AND COMMISSIONING OPPORTUNITIES

"And don't forget to feed the artist in residence."

Between the Lines

Residencies, Commissions, and Public Art

SARA REISMAN

SARA REISMAN: *Having worked for many years as an independent curator, I find the process of developing exhibitions to be creatively thrilling, and I hope my excitement and sense of possibility are equally shared by the artists with whom I'm working. Sometimes there are artworks and artists whose practices don't fit squarely into an exhibition, and at other times artists—like curators, critics, and other cultural producers—need time to regroup, research, develop ideas and money to make new work, or to just live with less of the noise that is both inspiring and distracting about living in New York City. Some of my earliest curatorial projects were focused on artists working across disciplines like architecture, public space, performance, installation, and the ephemeral realm. These interests have led me on a curatorial path that has included fundraising for artists' projects that didn't fit into existing institutional frameworks (or maybe the projects were just too new), curating independently and within institutions, managing an international residency program, and always trying to develop opportunities for artists doing public projects. Now I'm working within the very institutional framework of city government, commissioning artists to produce new works of art for permanent installation within city buildings and public spaces through the Department of Cultural Affairs' Percent for Art program. A guiding principle in my curatorial practice has always been: How can I facilitate valuable opportunities for artists and audiences?*

Here we are, in a virtual conversation with leaders of the New York arts community. The participants are Anne Barlow (Art in General), Maggie Boepple (Lower Manhattan Cultural Council), Anne Pasternak (Creative Time), Steven Rand (apexart), and Doreen Remen and Yvonne Force Villareal (Art Production Fund), each of whom has paved a very different but equally recognized path of support, engagement, criticality, visibility, and publics that exists between and among residencies, commissions, and public art.

Although your organizations are overlapping in their support for art and artists through residencies, commissions, and the presentation of public projects, each has a specific mission developed in response to the conditions of the moment when each was founded. Let's start with a brief overview of each organization's mission.

MAGGIE BOEPPLE, FORMER PRESIDENT, LOWER MANHATTAN CULTURAL COUNCIL (FOUNDED IN 1973): Lower Manhattan Cultural Council invigorates the arts downtown. LMCC brings art where it's least expected and engages the ideas of the moment by exploring the links between culture and capital. We curate and commission art installations, produce and present performances, and champion the arts as a vital component in creating and maintaining a vibrant community.

We turn banks into concert halls, offices into art studios, and storefronts into jewel box theaters. The Artist Residencies department, through the support of generous real estate partners, has turned more than 300,000 square feet of vacant real estate in lower Manhattan into studio, rehearsal, and presentation spaces for artists. We help artists achieve success with a robust schedule of training and professional development programs, networking events, and talks.

Our grant programs award more than $500,000 annually to enable more than 200 arts projects across all disciplines throughout Manhattan.

ANNE PASTERNAK, PRESIDENT AND ARTISTIC DIRECTOR, CREATIVE TIME (FOUNDED IN 1974): Creative Time commissions, produces, and presents groundbreaking art that infiltrates the public realm in New York City and across the United States and recently began experimenting with working globally. We are guided by a passionate belief in the power of art to create inspiring personal experiences as well as foster social progress. We are thrilled when art breaks into the public realm in surprising ways, reaching beyond the traditional limitations of class, age, race, and education. Above all, we privilege artists' ideas. We get excited about their dreams and encourage them to take bold new risks that value process, content, and possibilities. We like to push beyond our comfort levels, offering up new ideas about who an artist is and what art can be while pushing culture into fresh new directions. In the process, our artists' temporary interventions into public life promote the democratic use of public space as a place for free and creative expression.

ANNE BARLOW, EXECUTIVE DIRECTOR, ART IN GENERAL (FOUNDED IN 1981): Art in General's core goal is to assist artists with the production

and presentation of work that takes their practice to a new level in terms of scope, content, and ambition. Specifically, we support in-depth engagement with artists who, at an early stage in their practice, are often not sufficiently well known to garner museum or commercial gallery support but whose work stands out in its importance and vision. We also aim to provide in-depth public access to this work, so public programs, publications, and online texts are just some of the ways in which we do this.

STEVEN RAND, EXECUTIVE DIRECTOR, APEXART (FOUNDED IN 1994): The original idea behind apexart when it was founded in 1994, was to put artists, writers, philosophers, and otherwise interesting folks in the role of curator. In 1994 there weren't many independent curators, and Harald Szeemann was among the first , having found himself at odds with the institution. I think the Whitney Program was the only existing curatorial studies program, while 1994 seems to have marked the beginning of future excess of curatorial training programs. There was clearly a gap to be filled, and the "artrapreneur," a.k.a. independent curator, emerged. The focus of our programming is more about creativity and encouraging a discussion rather than the promotion of the individual.

DOREEN REMEN AND YVONNE FORCE VILLAREAL, ART PRODUCTION FUND (FOUNDED IN 2000): Art Production Fund (APF) is a nonprofit organization dedicated to producing ambitious public art projects, reaching new audiences and expanding awareness through contemporary art. Our mission is to bring the important messages found in contemporary art to a broader audience than that of a gallery or museum. Primarily, APF acts as a producer, offering guidance to the artist and bringing together the individuals, fabricators, sponsors, venues, and all other resources needed to realize and promote projects. APF also works to educate the public about contemporary art and share its expertise with individual artists and other emerging art-producing organizations.

REISMAN: *What kinds of opportunities are provided by LMCC, Creative Time, Art in General, apexart, and the Art Production Fund? What services, if any, do you offer artists and, in the case of apexart, curators?*

PASTERNAK: Creative Time primarily commissions artists to realize new works that encourage experimentation, to realize dream projects, to break new ground in their practice and in our field, and to challenge

traditional notions of what art is, and how an artist functions within society. In addition, other programs such as our annual summit bring artists together to share their ideas and projects with new audiences.

We also offer artists advice and experience for free through our Open Door program, which provides artists who apply online the opportunity to share their project ideas with us and get feedback from our experienced programming team. It is a unique chance to have questions answered about working in the public realm, brainstorm or troubleshoot ideas with our staff, and get informed about resources and opportunities. It is also a chance to discuss challenges, from the pragmatic to the conceptual.

BARLOW: Art in General's main programs are the New Commissions program, currently for New York–based artists only, and our international residency program. In addition to providing curatorial, logistical, and financial support, one of the most important things Art in General offers New Commissions artists is time, as the commissions can take from six months to two years to develop and realize. The international residency program—currently focused on eastern Europe—is geared to providing residency and presentation opportunities to both New York artists and eastern European artists.

One of AiG's more idiosyncratic programs is A/V Elevator, for which artists create audio/visual projects for the elevator's thirty-eight-second ride to the sixth-floor galleries. AiG also offers a range of artist services to support artists not presented within the organization's exhibitions through feedback sessions on artists' proposals and occasional forums on specific topics.

RAND: More and more we are concerned with the process rather than the result. Our Unsolicited Proposal and Franchise calls are organized to give people with good ideas opportunities to organize an exhibition. Using a process called crowd sourcing, we have written [a computer program] that allows for the anonymous submission of entries and subsequent jurying by hundreds of jurors. Instead of controlling the content, we continually try to put the control in the hands of jurors, many of whom are not part of the "inner rings" of the art world. Because we have so many jurors and hundreds of submissions, much of our process is conducted before the exhibition opens. Not only is the entire process automated, making it very easy for us to track and compile results, but we have more fun because we never know what will happen. Have we had bad shows? Sure. But we think bad shows

may have more effect in the quality of resulting discussion than shows that have almost no response.

We don't do one-person shows. We consider ourselves in service to our audience first. The gallery space continues to confound and perplex as we continue to shift from a promotion model to one of consideration and experience. We are idea-centric and place a great deal of emphasis on the short essay that accompanies each exhibition. We ask the curators to minimize jargon and write personally, and we hope it will be a good read.

In addition to our intimate exhibition space, we have local and international residencies, and a publishing arm. Residents are provided with a small apartment in Union Square and a schedule of up to four appointments and activities each day. These are mostly not directly related to art and include auditing classes and lectures outside of their discipline, touristic activities that explain the city, visiting some of the smaller idiosyncratic museums from the more than 200 that exist in New York, and spending the kind of time that is so hard to do at home, thinking about things that are not day-to-day issues. We give them the chance to spend time without the comfort of studio routine or art world social structure. We hope all the new experiences will lead to new ideas.

In addition to bringing residents to New York City, we send local artists, writers, and curators who have become too entrenched in the New York City art world to remote locations around the world, including the Australian Outback, Ethiopia, Korea, Thailand, and elsewhere.

Finally, we have published three editions of great essays on various topics we find pertinent to contemporary issues in the art world: *On Cultural Influence* (2006), a compilation of essays on our progression into globalization; *Cautionary Tales: Critical Curating* (2007), which considers the shifting role and the proliferation of the independent curator today; and *Playing by the Rules: Alternative Spaces/Alternative Thinking* (2010), addressing the creative process and spaces that don't want to grow in size.

REISMAN: *Through your leadership, each of you has innovated an existing mandate to better support artistic expression. Each of your organizations provides a combination of residencies, exhibitions, artist services, commissions, and public projects. Why do you think public art has gained importance in recent years? How does your process of commissioning public projects differ from other organizations'?*

PASTERNAK: Until recently, even most arts professionals thought of "public art" as heroes on horseback, decorative plop sculptures, or community murals. In other words, most public art seemed invisible, irrelevant, or, frankly, unattractive. There have been many reasons for this recent shift in awareness and enthusiasm for public art—from an increase in visually and culturally curious people in our urban centers, to huge media acclaim for big public projects like Christo's *Gates* or Olafur Elliason's *Waterfalls*. Plus, people are excited to have their public spaces used for truly interesting and engaging creative interventions—it gives them something to wonder about. In fact, all over the country, city governments are inviting artists to create temporary public projects to help enliven their downtown neighborhoods in the name of revitalization.

REMEN AND FORCE VILLAREAL: We fervently believe that art can raise the collective consciousness of any given community. As boundaries between art, fashion, technology, popular entertainment, and consumption have become increasingly blurred, art production and its public presentation have become more pronounced. Within this fluid area of art presentation, we've been free to invent ways of working and to support novel projects. In order to produce and present at a grand scale, we embrace the idea of mass market partnerships. Our ability to expand and contract as an office has been effective for us, allowing us to hire consultants when projects require but not maintain an unnecessary overhead when we're less busy. People are often surprised to hear APF has only a staff of four with a fantastic ongoing intern program. We appreciate the control, lack of bureaucracy, and hands-on nature that this system [provides] us, yet when we need to get the challenging projects produced, we reach out to the appropriate partners. We're fortunate to have fantastic high-profile partners who provide great visibility, which serves to expand the audience for the artist, the specific project, and art in general. It all becomes a bit contagious, and it is our aim that public art be considered a civic duty that keeps expanding.

REISMAN: *Are there new initiatives or programmatic changes you implemented in order to be more responsive to artists' needs as well as external dynamics?*

BARLOW: With the New Commissions program, we wanted to strengthen the publications component and find new ways of making the *process* of the commissions more public. Thanks to a major three-year grant

from the Institute of Museum and Library Services, since fall 2009 we have been able to enhance our New Commissions books and implement a new program of online videos, critical texts, and blogs written by the artists and guest writers. This initiative has significantly increased public access to these projects—many of which used to be in process for more than a year without being "seen" or experienced by audiences.

One of my goals early on was to expand the New Commissions program to include both local and international artists. We were able to produce some international projects before the financial crisis put plans on hold, but we are now launching these programmatic changes in the run-up to Art in General's thirtieth anniversary. In line with this, we also adopted the concept of commissioning as a "guiding principle" for what we do, so that our programs became more focused, and placed.

Our Eastern European Residency Exchange (EERE) program was founded in 2001 by AiG's former Executive Director, Holly Block, to cultivate longstanding and meaningful relationships between and among artists and organizations in the United States and central and eastern Europe. After working with various partners in eastern Europe for several years, I wanted to mark the program's tenth anniversary in 2011 with a more in-depth consideration of the program's impact on arts organizations and artists working in social, cultural, and political contexts that continue to change—and that in some cases are very different from when the program began. The research and discussions around this are helping us refine this program specifically, and how we approach our international programming overall.

BOEPPLE: Three of the projects that I started had one goal: that of expanding the visibility of LMCC and the funding base. LMCC was known for its residency programs and its grant making, with Sitelines, the summer outdoor dance series, being the big exception. These were and are great programs, but we were preaching to the converted and needed to expand our donor base. So in the first month, I sat down with my good friend Alice Quinn at the Poetry Society of America, and we dreamt up the wonderful series Poems and Pints at Fraunces Tavern. For six evenings, three in the fall and three in the winter, Alice would pick two poets to read in the historic tavern: We would publicize the events and pay the poets! The series was immensely popular and brought a different audience to LMCC.

Lent Space, a temporary art/architecture and performance space, was created on the edges of SoHo and Hudson Square, when Trinity

Real Estate asked if LMCC would like to use a vacant block for a few years prior to its development. Though expensive, it expanded the public awareness of the Council and generated a tremendous amount of publicity, not only in New York but worldwide. This made it easier to raise money from new individuals and foundations, while giving the community a lively temporary city square to use, and artists a platform for their work.

At the same time, LMCC responded to a Request for Proposals from the Governors Island Preservation and Economic Corporation to build and run a five-year artist residency program in one of the landmarked buildings on Governors Island. The program is in full swing two years later with twenty visual artist studios, two performing rehearsal spaces, a gallery, and views to die for with some very exciting art being made, and on the weekends it is open to the public.

REISMAN: *How has the role of the curator changed? Have you changed your approach to programming in response to this?*

RAND: There are curators who are gallerists without walls, and there are curators who see poignant connections between art and life and speak or write eloquently about the process and result.

When apexart started (1994), there was a small group of independent curators, and the chance to work with many of them was exciting. Now, however, it may be that the curatorial field has gained more influence than substance, and really creative people no longer see the art world as the free space it was.

In addition to the inside, we attempt to pursue art outside of the art world by working with film directors, writers, musicians, plastic surgeons, philosophers, and others who have little exposure to the international art world. This coming season [2010–2011] we will present the "Commercial" Art Video Call in which anyone can submit up to a sixty-second-long video that was dubbed, cut, added to, or otherwise manipulated from a TV or Internet commercial as its base. Consumerism + video + subversion = art. It might fail miserably, but it might generate a lot of discussion. Which will make it a success.

Curation and the art world really seem to be originally New York ideas. That creative knowledge congregates in one fabulous place seems a bit unlikely now. Our Outbound Residency and Franchise calls support the idea that New York is not the center of the creative world. The center of the world is wherever you are, and being really creative is really hard.

REISMAN: *Working for the city, it's not uncommon for me to be asked to review public art proposals submitted via 311 [New York City's phone number for government information and non-emergency services]. I'm sure you are all on the receiving end of many unsolicited proposals. What is your selection process?*

BOEPPLE: As President of LMCC I did get a lot of unsolicited proposals. I would direct them to one of our programs or to the curators. Basically curators do not often take on unsolicited work, but if you *must* send something, send it to a curator and not the President!

LMCC staff does not pick the artists for residencies. To be considered for residencies, artists must submit an application to LMCC, and the staff reviews all applications. Those that are complete (and a surprising number are not) are then reviewed by panels of visual and performing arts experts, writers, poets, and playwrights, who then pick the finalists. Swing Space is a shorter goal-oriented residency for artists of all disciplines who have a show, performance, or reading coming up and need space to work. A panel picks the group, but there is always a shift in attendees and staff then pick from the waiting list. [See also Melissa Rachleff, "Funding Artists: An Inside Perspective," this volume, for further information on Swing Space.—Ed.]

Artists who want to attend training and development programs come on a first-come, first-served basis, and panels of experts also pick artists who are applying for grants, which come from public funds and have their own sets of rules for LMCC to follow.

PASTERNAK: All Creative Time projects are selected by both the curator and me. We look for projects that are relevant to our times and that push the artist, our organization, our field, and culture forward. So, if we've done it before, we aren't likely to do it again. Though we do meet artists whose work we are interested in through Open Door, almost all of our projects emerge from conversations we pursue with artists whose works we enormously admire and with whom we actively pursue relations. In addition, we sometimes decide to curate a project because there is a public issue we believe deserves our attention, or there is an extraordinary site that we believe is ripe for artistic intervention. In those cases, we pursue artists we think will have something important to contribute. Artists are always free to share with us their work through e-mail or our Open Door program.

BARLOW: The most effective way to make a proposal to AiG is through the annual Open Call, which is primarily for the New Commissions

Program, but it also allows AiG to see work that might be suitable for other programs at the same time. As the Open Call is juried, submitted artwork is seen by a larger network of curators who often go on to consider artists for their own future projects.

As the core of AiG's programming revolves around supporting individual artists in depth through commissions and residencies, AiG presents only one or two group exhibitions or projects per year that are curated by AiG staff or guest curators. In terms of external curatorial proposals, AiG looks for projects that have a certain criticality and timeliness and, on occasion, projects that expand on ideas that are being explored by artists in the commissions and residency programs.

For AiG's Eastern European Residency Exchange program, AiG and its international partners each nominate artists (sometimes with input from a network of outside curators and colleagues) and select finalists through studio visits in New York and the participating countries.

RAND: We don't review artists' work, nor do we recommend artists to curators. We have set up specific opportunities for people that are designed to create level playing fields wherein anonymous submissions are juried by many people. Our open calls ask for individuals to send in ideas for exhibitions to take place in our New York space (Unsolicited Proposals) or elsewhere in the world (The Franchise), and, as previously noted, these submissions are then judged anonymously by a panel of several hundred jurors. In this case, we are looking to identify the most compelling idea, one that will translate well into a visual show, and we rely on others to help us make these decisions.

There are three "requirements" to be part of a residency. You must be over thirty years old, this must be your first visit to New York City or the outgoing city, and you have to be recommended by someone who knows you well. It is not unusual for the recommenders we contact to be people we don't know. We may contact an institution and ask an assistant curator or professor to be a recommender. To avoid diluting the process, we ask each recommender for one recommendation. Residents do not have to be artists to participate in this program. Any creative individual can qualify for this opportunity, from writers and teachers, to philosophers and poets, and beyond. We prefer to invite those individuals who may not have had such experiences because of schedule or economics or because their personalities do not create such situations. This process has been in effect for eleven years with a remarkable roster of past residents who have returned to their homes with new ideas, perspectives, energy, and opportunities.

On occasion we will generate an idea and then seek out an appropriate handler to bring it to fruition. In this case the curator/organizer would be someone who is both interested in the idea and has the writing ability and energy to realize the end result. Our staff handles all the logistics.

REMEN AND FORCE VILLAREAL: We have no formal review process. Approximately half of the artists we work with approach us with a project that has been brewing and sometimes we plant a seed with an artist we admire. Art Production Fund selects its projects with the aim of reaching a wide demographic and reducing the physical and psychic distance created by cultural, class, linguistic, racial, and income barriers that may hinder participation in contemporary art. Projects take place where people live and work, and an extensive Web site brings the projects to a worldwide audience. We have to be passionate about the project at hand because making the artwork happen is as much a labor of love as it is a major business and logistical endeavor.

While we have worked in classic public art venues like Rockefeller Center and Grand Central Terminal, we also place projects in unlikely places—McDonald's, for example, or on the set of "Gossip Girl." Most of our projects are temporary, but their impact lives on in their documentation. When appropriate, we strive to facilitate permanent pieces—such as the *Prada Marfa* installation by Elmgreen & Dragset in Marfa, Texas.

REISMAN: *What kind of advice would you give artists who are just starting out?*

BOEPPLE: Work hard, show you are serious, get in the studio, write the novel, compose the symphony, dance, paint, install, and shoot your video. If you need to have a "day job," get one that allows you to practice your art. Get into a routine with your artwork. And if you are so lucky to get into a residency program at LMCC or elsewhere, take advantage and produce. Dilettantes probably won't get in, but if they do, they won't last. Take the application process seriously. With everything online there is very little excuse to miss deadlines or requirements. Make the deadlines and take care to show what your art means. Act as if you really want the grant or the studio and show the panel why you should get it. Put in as much effort as you do in your work. While President of LMCC, I was astonished by the number of late or incomplete applications, and sloppy letters of intent.

PASTERNAK: Experiment and push yourself to do things that scare you— don't wait for others (gallerists, collectors, museum curators) to realize your dreams; get them done yourself. Be relevant, know your history, and don't repeat what's been done. Pursue your work with rigor and integrity. Question everything, and do your research well.

RAND: Our residency program would not be effective if we were not willing to think critically about what such residencies should accomplish and then quantify the result to determine if the program is actually doing what it should, and our books would not be useful if our ideas did not inspire comment. Even if the art world has become more business than art, my advice for artists and curators would be to be honest with themselves about what they are doing and what is important, and to try not to care what others think. Truly inspired ideas have a way of pushing through the red tape and finding support above and beyond the sheer tenacity of the artist, writer, or curator.

REISMAN: *The financial and legal side of what we do is complex. A new public art project, exhibition, or commission can be uncharted territory for the artists and curators involved. Do you have any advice for cultural producers about taking on larger-scale projects?*

BARLOW: Artists and curators coming from outside the United States are not always aware of the differences in the ways museums and nonprofits can support projects here. An artist may not realize, for example, when permits are needed to stage production in public spaces and can encounter difficult situations. So, it is easier to support them if AiG knows in advance what kind of technical assistance or guidance they might need. In general, it is important that artists take into account their own capacity as well as that of their host organization in terms of taking on a project of a larger scale or ambition, so that the project can be successful for everyone involved.

PASTERNAK: Don't ask for permission; you can ask for forgiveness later. I'm only half-joking about this. The truth is, artists should stick to a scale that they can responsibly manage on their own, or they should find safe and responsible ways around the numerous obstacles faced in realizing large-scale public projects like cost, insurance, permitting, etc. An artist should never put at risk of injury her audience or her team.

BOEPPLE: Try to be accurate as you present the proposal: Don't show one work as you start the process, make another, and then expect

something radically different to be approved. Listen to the curators. Understand the sites for which you're developing your proposal. Think even about the community, and design something safe. Work has to withstand blistering heat and blizzards. Work has to be installed correctly, satisfying governmental agencies and private entities whose space it is occupying. Hire a professional to install, and preferably someone who has a track record with the powers that be. Build those costs into the budget.

REISMAN: *Have you had any experiences with controversy or criticism that might help artists and curators understand what's at stake in presenting exhibitions to public audiences?*

PASTERNAK: Rather than give you specific case histories, here's my advice: (1) listen to criticisms and concerns, (2) be prepared, and (3) be informed! Before taking on a public project, consider all the ways it might possibly be interpreted. Then, if controversy begins to brew, listen to it, digest it, ask questions, and process the reactions you are hearing. Get advice from experts, not just your friends. The more you understand someone's position, the better you can open channels of communication and share your own views. Controversy brings opportunities to bridge information, share diverse perspectives, and even promote the artists' views. Think about your responses wisely and be prepared with responses that are well informed.

BOEPPLE: It has been my experience that the majority of artists understand issues around censorship and the public arena. In every case at LMCC, and there were not many, I would stop a project as early as possible only when I knew it would be vetoed by the city. In every case it involved safety issues, not content. When there is a censorship issue and the work will be in the public realm, the public entity will prevail.

REMEN AND FORCE VILLAREAL: In general, it makes sense to be sensitive to the obvious issues. Sex and profanity are objectionable; things get more complicated when dealing with copyright issues in the art, but something clearly appropriated will probably cause problems. In general, we like to respect these obvious issues because public art should be embraced enthusiastically by all. But it seems inevitable that in the end there is always somebody who remains offended. Art brings out strong emotions in people.

REISMAN: *How has the current economy affected your organization's work and the opportunities it has historically provided? Are there specific challenges and opportunities the economic climate has created for*

cultural producers? Are there steps you think artists can take to be more fiscally cautious during unstable economic times? Alternatively, do you think there are ways we as curators/directors/administrators can maximize opportunities for the artists we're working with?

BOEPPLE: LMCC is no different from any other arts organization and has seen financial support change. We've adjusted by tightening our budget, implementing a hiring freeze, cutting expenses, and reluctantly taking a week of unpaid leave. We also increased the board and made the decision to go ahead with the two big projects with the belief that one had to expand the base support in tough economic times. I understand that it is getting a little better now. Artists are no different than anyone else and had a hard time too, so we tried to expand our programs, benefiting as many artists as possible; and because many of the artists LMCC serves have jobs, we try to be as flexible as possible with studios open 24/7, and programs frequently repeated in the evening. And everything that LMCC does for artists is free.

BARLOW: In response to the current economy, some foundations changed their funding priorities—for example, from the arts to social services—so AiG needs to be even more proactive in terms of seeking new funding opportunities. As corporate support declined or disappeared altogether, other areas of fundraising such as new foundations, special events, and individual support have naturally taken on increased importance. In terms of the economic impact on our program, when needed, we cut some operating costs in order to maintain, as a priority, our current levels of support to artists for commissions and residencies. It also became increasingly important for artists and staff to work closely together to assess the most accurate project budget, and to have regular check-ins throughout the commissioning process to manage expectations on both sides.

In the immediate aftermath of the financial crisis [in 2008], commercial galleries—generally speaking—are less likely to "invest" in supporting the kinds of emerging artists AiG includes in its program. With fewer opportunities for emerging artists in this sector, applications to AiG's Open Call have increased in number, and our programs have become more competitive than before.

AiG expands artists' opportunities by introducing artists to outside curators, collaborating with other educational institutions on public programs, investigating touring opportunities for the New Commissions, and seeking production partnerships with other nonprofits. Our continued expansion into publications and online critique also builds

on AiG's commitment to producing in-depth content around artists' work.

PASTERNAK: From teaching to carpentry, there have always been lots of ways artists support themselves beyond the lucky who can live from the sales of their art. The recent economic downturn has given visibility to other ways in which artists are supporting themselves and one another. For example, artists in Chicago formed Incubate, getting together each week to make soup, share their latest work, and pool money from soup sales to create small project grants that any artist in the United States can apply for. Incubate's model has inspired more than a dozen similar efforts across the country, from Brooklyn to Baltimore to Detroit. Likewise, there are alternative art schools, like the Bruce High Quality Foundation University, which has artists teaching artists for *free*. The classes are super-interesting and surprising, and who needs the graduate art school debt? There are loads of alternative economy models in which artists barter or share spaces and technical skills.

Are there steps artists can take to be more fiscally cautious during "good economic times"? I used quotation marks around [those] words because these things are relative. Capitalism lures us into wanting more and more things. So, when there was more cash and more art selling than in the previous decade, I watched as many young artists threw their money away on expensive clothes, fancy trips, and eating at the hippest restaurants. I hate to sound judgmental, but I'd be surprised if many of these artists didn't agree that to one extent or another they pissed their income away because when the market plummeted and they stopped selling work, they had nothing to cushion the blow. Some I know moved home to live with their parents. Even when the market doesn't plummet, artists fall in and out of fashion. So when they make some money, they should do the following: (1) invest in their art, (2) buy real estate, and (3) save as much as they can to help prepare for the dry times that will inevitably follow. Young artists should start saving money every month—no matter how little—to build a pension. The earlier the better.

RAND: Bigger is not always better, and the number of people who know about an effort is not an indication of its value. We have all had to adjust to these economic times, and it is harder for us all to find funding for our projects. However, it is also an opportunity for people to think of new ways to approach their projects with creative solutions.

REMEN AND FORCE VILLAREAL: Art and artists are what matter, and in the recent strong economy, we increasingly found ourselves in an art world that was about other things that catered to an exclusive and privileged audience. While artists and nonprofit organizations definitely benefit from a strong economy, during leaner times there is a refreshing revival of the pure art experience that can get a little lost.

For example, the boom fostered an elevated expectation of production value. Art got very expensive to make, which was great in a way because artists' elaborate ideas and fantasy projects were actually being made. But an interest and appreciation for simpler work suffered. It also made life for artists in New York City almost unaffordable—unless they had rent stabilization or were selling their work regularly—which is still an issue. On a positive note, survival instincts kick in, and communal and collective practices become more prevalent among artists. Great creative movements have been generated by the condensed energy and editing that naturally occurs in talented enclaves, for example among artists like Aaron Young, Dan Colen, Nate Lowman, Agathe Snow, Hanna Liden, the late Dash Snow, and more recently, the Bruce High Quality Art Foundation. The recession actually brought things back into perspective.

REISMAN: *In your work, do you see specific themes and practices that you think have run their course, and others that are proving to be globally important now?*

PASTERNAK: Artists are now global citizens. Global travel is easily accessible and the art market has exploded with biennials, art fairs, contemporary art museums, residencies, and galleries popping up in just about every nook on the planet—from Abu Dhabi to Papua New Guinea. With that come exciting opportunities. But it also presents interesting, critical questions. For example, what is the nature of artists' engagement with the places and people where they create and show new work? In what ways might they engage people with different views, languages, and customs? It is clear that for many artists, studio practice has changed. The romanticized vision of the artist isolated in the studio becomes less and less relevant. Instead, more artists are on the road, conceiving site-specific projects, and making work on their computers and in meetings. It is time the institutions of art history, museums, critical publications, and the wider media begin to shape this conversation for the masses because, fundamentally, the nature of art making continues to evolve.

REMEN AND FORCE VILLAREAL: We are not interested in producing and presenting anything simply decorative—or, in other words, "plop art." We want to help artists create work with a soul, a message, a deep meaning, and bring that to the public. Humanitarian, environmental, and sociopolitical issues, changes due to technological advancements bringing a post-human lifestyle into play—these are all of great interest to artists and APF. When the art works are embedded with meaning through extraordinary execution, they give the public a sense of empowerment and point to alternative methods of receiving information and of communication that is more poetic and profound.

RAND: One of the aims of our residency program is to encourage artists to abandon their self-referential practice. It seems as though artists today easily gravitate toward biography as subject matter. I think art has to go beyond the individual to make an impact on others. Biography is not enough to accomplish this.

I'm not sure that the art world offers the same independence and opportunity for social criticism and self-expression it once did, or seemed to. It feels more conservative than other fields such as technology, or even commercial media where the valuation is done by the public in a more objective way than the in art world.

Art needs to return to that idea of serving the community, or at least offer a meaningful critique. What's globally important is to continually exercise one's creativity and to question the status quo. Art that makes you think will always be relevant.

"If I agree for you to represent my work, will the gallery
ensure to update my Wiki entry every week?"

THE WEB AND SOCIAL NETWORKING

"I just get a lot of shows because I am easy to Google."

Art World 2.0

KIANGA ELLIS

In less than twenty years, the Internet has become the main circulatory system of society and commerce globally. If data is not moving through it and into our devices, we can begin to feel cut off from life itself. In August 2010, the Nielsen Company reported[1] that Americans spend a quarter of their time online on social networking sites and blogs, up from 15.8 percent in the prior year (a 43 percent increase). Americans spend a third of their time online (36 percent) communicating and networking across social networks, blogs, personal e-mail, and instant messaging. In June 2010, Americans spent 906 million hours on social networks and blogs (the most heavily trafficked Internet sector), 329 million hours on personal e-mail, 160 million hours instant messaging, and 138 million hours on search.

As society and culture evolve under the influence of these forces, the fine art community is no less affected. Within the visual arts there are participants from all backgrounds who have embraced the Web with gusto and are exerting a unique influence on the field. I spoke with several prominent members of this inner circle of early adopters about the vital role of the Internet, social networking sites, blogs and online journals, and other electronic resources for artists and arts professionals.

Four themes clearly emerged in my conversations with Edward Winkleman[2] (Director, Winkleman Gallery), Hrag Vartanian[3] (Editor, online blogazine *Hyperallergic*), Man Bartlett[4] (artist), Barry Hoggard[5] (collector and Co-Editor of the online arts calendar ArtCat), James Wagner[6] (collector and Co-Editor of the online arts calendar ArtCat), and Manish Vora[7] (co-founder, online arts and culture community Artlog.com). There was complete consensus on the elements of interaction with the Internet that are nonnegotiable for artists. Each was emphatic that an artist needs a portfolio Web site as the bare minimum in professional tools. Perspectives on social media varied somewhat, as they tend to, based on the speaker's own usage and engagement with Web 2.0.[8] All

expressed great enthusiasm for the dynamic engagement taking place online today through social media and the opportunities it presents to artists. A leveling of the playing field is happening to a degree. There are new ways to engage in the ongoing public discourse about art, its institutions, and the people involved. We are seeing some barriers dissolve and windows of unprecedented possibility opening for an artist to achieve his or her professional goals. At the same time, the more things change, some things remain the same. While the proliferation of activity in virtual space receives a great deal of attention and "buzz," the necessity of a strong qualitative focus regarding artwork and relationship building is completely undiminished.

In honor of the mashup[9] culture that is prevalent on the Internet, I have cut, remixed, and integrated comments from five separate conversations that took place in December 2010. More than five hours of dialogue has been edited and rearranged as if Ed, Hrag, Man, Barry, James, and Manish had been in a room together having a conversation about these issues. All of the words are theirs, but the ordering is mine. This inevitably means that each person's remarks do not appear in their original context but rather in a context I have created to bring the most insightful parts of the discussions into clear focus. Imagine that we are dropping in on the middle of their conversation and they don't even know we are here.

The Basics

EDWARD WINKLEMAN: You are a visual artist. You have images. They should be online and there should be a way for curators, dealers, or collectors interested in the work to contact you. There should be feedback about your work available and readily accessible. It's worth it for you to organize all of that under a blog or on a Web site.

MANISH VORA: If I see an artist's Facebook profile and it does not clearly link to [his or her] portfolio Web site, immediately I think this artist doesn't actually care about putting in the work to properly show who [he or she is] and what [his or her] work is. You need to have an acceptable branding on the Web so that you can use that as a tool when you are meeting people. It's on your business card. [It's there if] you're Googled or for your friends to check in on Facebook and Twitter. [It's there] for you to use as a professional tool. Period.

JAMES WAGNER: You can run into somebody you know and somehow you are directed to what is described as worthy work. If there is no

evidence on the Web, you're very unlikely to see it. But if there is a site of some kind, presumably the artist's own, you can go home or even from your mobile device get an idea of what the work looks like. So, it could be a physical contact that initiates your exposure to the work online.

WINKLEMAN: It's deadly to have somebody Google your name as an artist and have to scroll through fifty pages of results before [finding] you. You are promoting a singular product. That product should be very high on those Google returns if you are serious about reaching a large audience. I hear a lot from artists, "Oh, yeah, I keep meaning to build a Web site. . . ." And I always say, "You have absolutely no excuse [for not doing it]. Blogger is free. Blogger will let you put up as many images as you want. Blogger is owned by Google and Blogger will shoot your name up through the search results on Google. So, go home tonight, start a blog, put up some of your images, and just don't make this excuse again." Because there is no excuse for it and I actually get a little upset. I don't know what the best parallel is, but it's like saying, "I really, really want something but I'm not going to do the single most helpful thing toward helping me achieve it." And if you don't have a gallery, the single most helpful thing is for you to have a presence online where people can learn more about you. The opportunities that come to artists from halfway around the globe because they have a strong Web presence speak for themselves.

WAGNER: A significant amount of the work in the collection[10] came from benefit art auctions. It matters a great deal for an artist to have some kind of Web presence because the kind of benefit that interests me is one where I probably haven't heard of most of the artists. One of the ways we research what we might want to get is we write down things that interest us but we don't know anything about, and then we come home and Google. That sometimes changes what works we want to go after at a benefit—what we find online from an artist.

HRAG VARTANIAN: Artists are getting smart in that they understand [that] the online world is not just about putting up images of their real-world stuff. Sometimes it's about knowing what to put up and how to put it up, and they are getting better and better at that. That really is as important as anything else.

MAN BARTLETT: I view different types of content differently based on what platform I'm pushing it to. For me, Facebook is slightly more personal in terms of the content because I still have old friends who

are on there who are not art world professionals. My Twitter feed is mostly, specifically art. And if it's personal updates, they almost always relate back to art. And then on my YouTube channel I publish videos that are usually a bit more whimsical in nature, either funny or self-reflective. I do a lot of mashups of videos that I get from other sources, and those get published to YouTube. My Vimeo channel, on the other hand, is much more professional and I consider it more serious content. My Tumblr is truly a mashup of all the different inspirations that I'm seeing, general thoughts that I have, other images, and my own work as well.

WINKLEMAN: [Creating profiles on social media sites] is worth trying. If you get on there and you are uncomfortable or if you hate it, don't waste too much time on it. But somewhere, somehow, online you should exist in a strong way associated with your art because that's become the new [way to separate] the wheat from the chaff. You kind of aren't seen as that important if you don't have this record online because if you were important, of course, you would. People would have either written about you or you would have started your own Web site.

BARTLETT: Increasingly Tumblr, which is a microblogging service, is another tool that a lot of artists use, and actually more people than that are curating other artists into their Tumblr accounts. *Art Fag City*'s Paddy Johnson[11] did a post listing the top Tumblr accounts that were essentially galleries. They were just galleries online, and individual artists as well, who have Tumblr accounts. There are tons of other services people are using, but Twitter, Tumblr, and Facebook are the three that I tend to use the most. I also have a Flickr account that is relatively active.

VORA: Artists are sometimes pushed away from what they should really be focusing on around technology, which is their personal branding on the Web. I have ten to fifteen artists a week who contact me on Facebook or "friend" me on Facebook. To me that shows a clear lack of understanding of how [they are] wasting their time building their brands via Facebook or Twitter. If you don't have your work well put together in a portfolio [online] and if you're not active in the community offline, having a social media presence is useless. It's a waste of your time. I'm not sure if this is the case, but it feels desperate at times, [as if the artist feels,] "Okay, I need a Facebook [account] or I need a Twitter [account]," but there's not an understanding of how this actually fits into a communications strategy for the work. [Social media

accounts] should be considered a small part of a broader way for you to connect to people who are already interested in your work [as well as] working with those people to build your audiences.

VARTANIAN: I engage with artists online all the time. I often use Facebook as a way to find new things and events. I will see an art work on Tumblr, for instance, and I will [think], "Who is this person? I've never seen this person's work." I think there's a lot of apprehension with artists and copyright online. This is more so with photographers than anyone else because the photograph reproduces so easily online. But I think that's going to go away when they become educated about the issues and how to do things. If you are an oil painter and someone reproduces your image on [a] Web site, [that person is] not stealing money from you [but] promoting you. Once these types of discussions happen more openly by people who know the issues, then artists will understand that. They will understand that every time their image is reproduced online, on someone's Web site or Twitter feed or Tumblr, it's not a bad thing. It's a good thing. Familiarity equals liking. It's like corporations. They put out advertising. Why? Because they want their stuff out there so people think about them.

I think artists need to be a little smarter about how they might watermark [their images]—though I'm personally not a fan of that tactic—or [. . .] put a little tag on the photos. Everyone eventually finds a solution that works for [that individual].

WINKLEMAN: Don't put up an image that isn't as good as it can possibly be of your work. This is critical. Make your Web site or blog clear and easy to navigate, because regardless of how strong the work is itself, if you have all these [animation or video] things or if it's too clever and people can't figure out how to navigate around, then you've lost a big chunk of your potential audience. So just follow the "clean easy to navigate a Web site" rules because it's not about how clever your Web site is. Your Web site should reflect a little of the aesthetic and/or philosophy of your work, very little. You should let the work do most of that.

BARTLETT: And then from there you can make decisions about how much you want to exist online because the other thing is it takes a certain personality to be able to maintain the amount of time and content required to keep [an online presence] active. The one thing I will say [is that] it's better to be online less than to be everywhere and not updating the content that you have. [The issue is] how people perceive

you. If you have a lot of content out there that hasn't been updated in six months, the perception is that you're not active. This doesn't always mean that activity is better, but when I look at something that hasn't been updated in six months or a year, I think about it differently.

VORA: People should be spending more time thinking about video than they should be thinking about sending Tweets. The ability for artists to tell their story via video . . . we are in the abso-first inning of how important it's going to be. [This opportunity exists for] any artist. If you are serious about creating a brand, again back to my opinion that I keep harping on, Twitter and Facebook are generally useless for your career unless you are creating an identity on the Web. You should be doing everything in your power to build an audience by telling your story. The best way to tell a story is by video, and that can be incorporated in a blog. [The video content] should be about showing your work, showing your methodologies, explaining the way you think and the kind of person you are. That to me is interesting. [It suggests,] "I'm an artist who is serious about my discipline and my work." And how easy is it? Everyone has a digital camera. The quality doesn't matter; you can show [quality images] through your Web site, but also give us a sense of what the story is, of what your process is, and spend that time with your work instead of sending a Tweet about your coffee in the morning.

The Conversation

VARTANIAN: The Internet is like any other social space, and I think that's what it's becoming. It's just a social space. It's an extension of the real. It is real. It's not any less real than a phone call. It's interesting how artists are using the Internet in so many ways, whether it's marketing their work or extending the audience for their work. It's also being used as a medium to actually create work or source work and crowd-source work.

WINKLEMAN: Collectors are definitely learning more about artists via the Internet. I think there's a confluence of chatter on Facebook and Twitter and *Huffington Post* pulling in some arts coverage along with some other people. I don't think there has ever been as much chatter about art as there is now because of what's happening online. It's just an overwhelming amount of discussion about art, and I think if you are

only tangentially related to somebody in the arts, that's going to spill over into your awareness through one of these channels. So, the Internet is playing a big role in increasing the sense that there is a vital dialogue going on.

BARTLETT: One of the things that I try and do online is not just personal updates, but networking and also being part of the dialogue. Sometimes that's responding to what other people are talking about. Sometimes it's adding my own two cents to a conversation that's been going on. I try and temper that with also letting people know about the various things that I have going on, whether its shows or performances or new drawings. And I do that [by thinking about] what I want to see from other people. I tend not to look at someone's [status updates] if they're only talking about themselves all the time. I might like their work, but if they're only talking about themselves. . . . I already know what they're doing and only need one link usually to see a new piece. What I'm really interested in is dynamic exchanges between people and people who are really invested in the community or invested in the bigger picture.

VARTANIAN: There's a real generational divide, particularly in regard to the art world, which comes down to an older generation that's very comfortable in what they do and how they do it and a younger generation that is more experimental. [The younger generation is] often more open to new things. There is an older, established generation that is still suspicious of the Internet and the openness and the transparency.

WINKLEMAN: What I'm realizing is that the immediacy and the quickness of [Twitter] is what [was] originally attractive about blogs, especially the immediacy. So the people who were addicted to this sort of rapid-fire back and forth on the blogs are getting an even bigger dose of that on Twitter and Facebook. A huge part of the dialogue has shifted to those mediums and it's in no small part due to the popularity of Jerry Saltz's[12] Facebook Wall. He almost single-handedly fostered this community for the art world, this watering hole so to speak. [It became a place] to jump in and work out issues.

BARTLETT: For a lot of artists the Jerry Saltz Facebook Wall is sort of a gateway into networking.

I'm seeing more and more artists actually get on Twitter as another way of getting their work out there and following what the conversation is and what the dialogues are.

VARTANIAN: Anybody who has been observing the art world in the last ten years has noticed how large it's become. The art world has grown tenfold. It's incredible. There is no way that you can keep abreast of art in New York. With my fellow critics, there are galleries that they mention that I've never even seen, and likewise. They don't know some of the galleries I am talking about or the artists. This is not what the art world used to be. Now it's huge. I can't keep abreast of what's going on in Queens, never mind Sweden. It's just so big. There is so much going on. The online world is the only way to really network it. There is no other way.

BARRY HOGGARD: I wouldn't necessarily say I discover a gigantic amount of artists on the Web these days because [seeing it] on the Web isn't really the way I want to look at art. I want to look at it in person. But it is one of my methods for getting recommendations from friends without actually seeing them in person or talking to them at an opening. Someone often recommends something to me via Twitter or email. Brett Burkett's[13] really good about that, sending me e-mails such as, "This artist's show closes in a week. I think you really would like to see it." I also notice what other art bloggers, whether I know them or not, are excited about.

VORA: Who in the industry uses Facebook to browse art works? Never heard of a single person. I would never go on Facebook [thinking], "Oh, I'm looking for art. I'm gonna search for art." It's impossible. Although if I saw a friend attending a show, [that may be an effective way for me to find out about an artist]. [But,] that's an event. You're not seeing a ton of engagement with users saying, "I 'like' this on Facebook," and [others] then saying, "I should look at [that] artist's work," because there is no context. There is no story. Facebook should only be thought about as a way to promote exhibitions. The building of your Web brand has to be completely associated with building your offline brand.

VARTANIAN: We often have a lot of interns in our office and all of them say they get all their information online. I have not had one person tell me that they get their information from *Artforum* or any other print magazine.

WAGNER: I often tell people that I don't read a great deal about art; that's just me. I never really did, although I've subscribed to art magazines and had them for . . . probably decades. I end up not really spending much of my time reading about art, but rather looking at it.

VARTANIAN: The other thing about the online world is it really is a daily conversation. I don't mean that you need to write a blog post every day. You may want to put a status update on Facebook or just even "like"[14] someone's post. Be engaged. And trust me, people notice when you like things and when you comment on things or even ask questions if you don't understand. You should make conversations.

The Art World Is Flat(tening)

WINKLEMAN: I think one of the most interesting things the Internet is doing, and Facebook in particular, is providing shortcuts to intimacy, professional intimacy even more so than interpersonal intimacy. When I meet an artist and they say, "Hey, I'm your Facebook friend," that's all they need to say and I immediately have a sense of what we can talk about. Whereas if they had never met me before in any other context, they can say, well, "I've been following your Web site for your gallery or I've been reading reviews of your gallery." There were so fewer opportunities to find a way to engage with others, for an artist with a dealer and vice versa.

VARTANIAN: I think performance artists are more in tune with the Internet [and online interaction with strangers] because they recognize that it's close to what they already do [as artists]. Net artists probably are [also in tune]. Street artists are. Street artists function in this sort of realm where the Internet becomes an important part of their community. I've seen, though, everything from oil painters developing their community online to sculptors doing it, so this is important because it's the way to keep in contact with people who have similar interests. There is no other way in this day and age to do that because we don't live geographically in the same place. [In any case,] you often find an affinity with people in different locations. One of my Twitter friends is in Saudi Arabia. I've never met him, but we've been Tweeting back and forth for a year and he writes about fashion and art. I find his insights interesting and we disagree sometimes, but that's all right. And I would have never found him any other way in my life. He informs my decisions and we share artists' names. We say, "You should follow this person. You should look at this person's work. Did you know this about that?" I mean, the discussion is there.

HOGGARD: There are an enormous number of people I've met that I'm friends with now that without social media and without the Internet I

never would have met, like An Xiao.[15] I doubt I would have run across her without this stuff.

WINKLEMAN: I've seen a lot of artists get invited to participate in events or simply find other artists of like mind they can start an offline correspondence with. Imagine before. You would walk into a crowded opening and if you were lucky, if you were really super-lucky, you would be introduced to one other artist who had something in common with you. You might go to a hundred openings before you met five people like that, whereas online you can just start dismissing everything that's not of interest of you and weeding out. Again, you have this great shortcut when you finally do meet [these people]. You know so much about what their thoughts are and vice versa, and so in real life you can pick up with this huge head start.

BARTLETT: With very few exceptions, almost all the people I know in New York I met online. And if I didn't meet them online, they have very strong presences online such that I'm communicating with them on a regular basis. One of my first sales in New York came from someone who saw a post that I made, I think even on Jerry's Facebook Wall, and that person heard about a project that I was doing and then started following what I was doing and then later bought a drawing from me. That's a relationship that's still being nurtured, so those possibilities are there, and, again, the important thing is that I didn't set out saying, "How can I use Facebook as a way to increase my sales?" That's not the thought that I have about it. Relationships and friendships have definitely been nurtured online that have [naturally] led to some pretty amazing things.

HOGGARD: The Internet has made it easier for artists to be somewhere other than New York and have a community there and stay in touch with what's going on elsewhere. I suspect Philadelphia would not be as interesting as it is now and have as vibrant a small art scene as it does without the Internet. It's one of the reasons why a lot of us know who those people are.

VORA: What is interesting about the digital world is that we can now [build relationships] globally. [Consider the scenario] where you as an artist were in the world of Basquiat, you were in the world of Warhol or currently you are in Marilyn Minter's[16] circle—that provides you with a sort of credibility because you are connected with those influencers. There are ways with the Web that you can associate yourself from afar with these folks who are tastemakers by doing interesting

things around social media and around working with organizations.
[For example,] if you have an opportunity to speak on a panel with
Marilyn Minter, [this] immediately gives you credibility. How do you
figure out ways, if your work is related, to be associated with folks
who have that right audience? How do you do stuff through technol-
ogy and through the Web that engages you in the dialogue and that
immediately puts you in the conversation?

HOGGARD: It used to be that the only way you heard of an artist was
either an art gallery showed them or through artist friends of yours or
through art world friends of yours . . . well, and criticism: magazines
and newspapers. But now artists don't have to only rely on those gate-
keepers to be found. I think one of the best examples is Man Bartlett.
None of us had heard of—almost none of us had heard of him a year
ago and now he's quite visible and a lot of people know who he is.
And that was because of Twitter and social media and getting his proj-
ects out there that way.

WINKLEMAN: You've seen this huge uptick in the number of museums and
galleries using Facebook and Twitter in the last year. Huge. And
whereas they were really resistant a few years ago to being as kind of
chatty as I am on the blog, they're speaking in that online chatty tone
now in their Facebook and Twitter [communications]. Gagosian[17] is
very active and very friendly in almost complete opposition to the way
you feel when you go into that gallery. But online I think they under-
stand—this is the language, this is the tone. So, it's curious to me that
a bunch of geeks with altruistic values who set the tone like, a decade
ago, are shifting the way these very professional blue chip genteel
places are putting their information out there. I think that's
fascinating.

BARTLETT: There's an interesting social clique, and I don't mean that nec-
essarily with any judgment, but it is like being in a certain type of
room. So, I feel like when I'm reading some of the people who regu-
larly comment (and there's a handful. . . . Jen Dalton's brilliant piece[18]
looked at that, that there are a certain number of people commenting
[on Jerry Saltz's Facebook Wall] a certain large percentage of time), in
terms of paradigms, Jerry's being on there offers a certain type of
access that might not have been possible before. It's also not quite
as dynamic as the direction we might be moving in, which is more
decentralized. I think about the blog *Hyperallergic* where Hrag is the
Editor-in-Chief, but when I think about the image of *Hyperallergic*,

that image is very decentralized. There are lots of different types of posts from lots of different authors about a wide variety of subjects. To me that represents the next generation. I view *Hyperallergic* as a blog that has many different kinds of voices and it's not one sort of authoritarian voice that's speaking for what art is and what is good and what is bad.

HOGGARD: There is much more [significance in my view] if Heart as Arena[19] or Hrag or someone like that wrote about an artist. That has a bigger impact for me than if one of the art magazines or *The New York Times* wrote about it. I trust their taste and their agenda more. I don't think the agenda is getting ads from the galleries. What the agenda is of a blogger is more upfront than the art world media.

The Business Is Still the Business

WINKLEMAN: We are seeing the dawn of the age when you don't need anything other than a Web site to sell your art work. Seriously. Anybody who wants to invest the energy in that can do it, but it is an investment of energy. We are entering into an age where if your practice allows you to do this, you might want to give it a try. What you are going to miss, and it may not be that important to your particular practice, is the context. So, the reason artists want to be in Gallery X or Y or Z is [that] they want to be associated with the prestige or the context that [a particular] gallery has and [operates in], which in and of itself helps facilitate opportunities and sales. I don't think an artist should work with a gallery [just] because there is something inherently better about a gallery as opposed to selling your own work. I think [artists want] sales so they can keep making their work and they want an audience. If you can manage both on your own, go for it. The gallery [exists] to do both as well. [Keep in mind, however, that] it's much harder to get critical attention outside of the gallery [system] at the moment, but that could change.

VORA: I think the fundamental aspect of building a core following has been replaced by a sense that you need more quantity. And this is something outsiders in the art industry don't really understand. It's not a numbers game. It's a quality game. It's the same thing that galleries will tell you. It's not about selling your work to a hundred people. It is about finding the right people who are going to support you and that's not necessarily the strength of Twitter and Facebook, nor is it

really the strength of the Web [in general]. But what the Web does and what social media does is maybe help you find those right people. And that's how people should be using technology. The more important thing is for people to be using technology to connect with the right connectors or the right supporters of your work. It's not about gaining more audience to your Web site. It's not about gaining more followers on Twitter. Or "friend"-ing people on Facebook with the hopes that people are going to look at your work, because it's just not the case.

VARTANIAN: Loren Munk,[20] who does the *Kalm Report*, had a really good point when he spoke at the retrospective I organized of his online video in November 2010: The online world is as much about giving back as it is [about] getting. And if you think you're just going to put something out there because you want it back immediately, then you're not going to get it back. But if you help other people online— it's just like the real world—if you're helping other people, you're going to get it back tenfold.

Sharon Butler[21] doesn't write about her own work. James Kalm doesn't video his own work. He has a rule that he doesn't do that. Guess what? They've been able to create a community of people who are interested in their work because of that. [People] recognize that they are helping others and they are legitimately interested in other people's work. They are painters who look at other people's work and are like, "Hey, I'm going to promote those people I love." And those people have turned out to support them. They'll show up to [Sharon's and James's] shows, they'll write about them, they'll mention their work to other people.

HOGGARD: Well, this attitude of assuming that now that we're on the Internet—if I can get my hands on your e-mail address, I can send you stuff—for me, that's not the way these relationships are supposed to work. Because people have decided it's easy to do that in the same way Facebook is easy, they end up decreasing the value of communication and missing the importance of personal connections. If I get 500 e-mails from people I barely know, I basically start deleting. These days I delete half of the e-mails that come in based on the subject [line] without looking at them.

VORA: I universally decline [Facebook "friend" requests from artists I do not know]. It immediately gives me a sense that they are not real, that they are not artists who are serious because [this behavior] means they are wasting their time instead of doing their work. It means that [they]

have a spam mentality that shows either a lack of understanding or lack of confidence that [they] are [good artists]. That's sort of my sense. Artists who are using social media in effective ways are doing overall things to build their brand. They are active in the community. They are commenting on other people's work. Using social media just to broadcast your work is only interesting if you [already] have people interested in your work. It doesn't work the other way. It doesn't *create* interest in your work. So, if you're going to use social media and there is not [already] interest in your work, create interest in your personality. Become interested [in others] and engaged with other institutions.

WINKLEMAN: The number-one currency on these platforms is generosity. You can convince people that you are likeable by being generous more easily than anything other than the classic [way], which is laughing at their jokes. If you laugh at people's jokes they assume you have a good sense of humor and that you're likeable. Generosity, it's the simplest thing in the world. [Clicking] "like" on something that somebody writes makes [that person] like you more in return.

BARTLETT: I was thinking about this recently. Knowing yourself is important and where you operate best and the best avenues and channels to get your work out there. Finding that out is a trial and error [process]. So, I encourage anyone to get [his or her] work online and start conversations with people. Then really pay attention to what seems to be sticking and what seems to not be working, both by other people's responses and by your own internal intuition.

Notes

The title of the section "The Business Is Still the Business" is taken from a remark that Manish Vora made during our interview.

1. http://blog.nielsen.com/nielsenwire/online_mobile/what-americans-do-online-social-media-and-games-dominate-activity/
2. http://edwardwinkleman.com/
3. http://hragvartanian.com/
4. http://manbartlett.com
5. http://bloggy.com/
6. http://jameswagner.com/
7. http://manishvora.com/, http://artlog.com/
8. http://en.wikipedia.org/wiki/Web_2.0
9. http://en.wikipedia.org/wiki/Mashup
10. http://hoggardwagner.com/

11. http://www.artfagcity.com/

12. http://en.wikipedia.org/wiki/Jerry_Saltz

13. http://heartasarena.blogspot.com/

14. http://en.wikipedia.org/wiki/Facebook_features

15. http://anxiaostudio.com/

16. http://www.salon94.com/artists/20/

17. http://www.gagosian.com/

18. "What Are We Not Shutting Up About? (Five Months of Status Updates and Responses from Jerry Saltz's Facebook Page)" (2010) http://www.jennifer dalton.com/makingsense/

19. a.k.a. Brent Burket

20. http://www.lorenmunk.com/

21. http://www.twocoatsofpaint.com/

"*It appears you were born on the wrong side of art history.*"

Selected Chronology of World and Art Events, 1979–2010

COMPILED BY MÓNICA ESPINEL

1979

Margaret Thatcher becomes prime minister of the United Kingdom, the first woman to hold that office. She will serve until 1990, making her the longest continuously serving prime minister in 150 years.

The taking of sixty-six U.S. hostages by Iranian militants on November 4 triggers a diplomatic crisis between Iran and the United States. Fifty-two hostages are ultimately held for 444 days, until January 20, 1981.

The Soviet Union, under the leadership of Leonid Brezhnev, invades Afghanistan. The conflict lasts until 1989.

A Joseph Beuys retrospective opens at the Guggenheim Museum.

Ars Electronica, a festival of art, technology, and society, is founded. Within a few years it becomes one of the world's foremost media art festivals.

Artist Sherrie Levine re-photographs images by Walker Evans as a means of making art that questions notions of originality. Over the next decade, Levine, Dara Birnbaum, Barbara Kruger, and others become prominent in the Appropriation Art movement.

Larry Gagosian opens his first gallery in Los Angeles. By 2010 he runs nine galleries worldwide, including three in New York, two in London, and one each in Beverly Hills, Rome, Paris, and Athens.

Judy Chicago's *The Dinner Party* premieres at the San Francisco Museum of Modern Art, where it is seen by 100,000 people. In 2002 it is acquired by the Brooklyn Museum of Art, where it remains on view in the Elizabeth A. Sackler Center for Feminist Art.

Fashion Moda opens in the South Bronx, founded by the artist Stefan Eins. The space celebrates the confluence of street life, urban and vernacular culture, and contemporary art through the work of such artists as John Ahearn, Jenny Holzer, David Wojnarowicz, Keith Haring, and Kenny Scharf, as well as graffiti artists like Richard Hambleton, Crash, and Spank.

1980

Former actor and California governor Ronald Reagan is elected the forti-
eth president of the United States.

Former Beatle John Lennon is shot and killed outside his New York City
apartment building by Mark David Chapman.

Media mogul Ted Turner launches Cable News Network (CNN), the first tele-
vision channel to provide twenty-four-hour news coverage.

A war between Iran and Iraq commences and rages inconclusively for eight
years, with many casualties on both sides. Peace is brokered in 1988 after
several other countries, including the United States and the Soviet Union,
become involved in the conflict.

IBM launches the personal computer (PC), bringing computing into the home
and leading to computers' widespread use in education, business, art making,
and leisure activities.

**Anthony d'Offay Gallery opens in London. D'Offay represents Joseph
Beuys, Christian Boltanski, Gerhard Richter, Gilbert and George, Richard
Long, and Jeff Koons, and in the 1990s it begins representing the Young
British Artists including Rachel Whiteread and Richard Patterson. The gal-
lery operates until 2002.**

**Michigan print dealer John Wilson founds Art Chicago. During the 1990s it
is considered the nation's leading fair of twentieth-century art, second in
the world only to Art Basel in Switzerland.**

Czechoslovakia, Hungary, Poland, and the Soviet Union boycott the Venice
Biennale when its director refuses to cancel an exhibit of eastern European
and Soviet dissident art.

**In the 1980s the term "postmodernism" becomes commonplace. Works
that employ new media, stress the importance of communication from
artist to audience, and often incorporate performance become prevalent.**

**Metro Pictures Gallery opens in SoHo with a group show including Cindy
Sherman, Robert Longo, Troy Brauntuch, Jack Goldstein, Sherrie Levine,
James Welling, and Richard Prince.**

**The first exhibitions of neoexpressionist art are held in New York. The
term "neoexpressionism" describes a group of international artists who
reject conceptual art and minimalism. Julian Schnabel, David Salle, Eric
Fischl, Francesco Clemente, Sandro Chia, Anselm Kiefer, and Georg
Baselitz are associated with the movement.**

**"The Times Square Show," organized by Collaborative Projects, is held in
a former bus depot at 41st Street and Seventh Avenue in New York. Artists
included are John Ahearn, Basquiat, Stefan Eins, Joe Fyfe, Jenny Holzer,**

Tom Otterness, and Kiki Smith. It sets the model for the do-it-yourself approach that has shaped many New York City art happenings since.

"Vito Acconci, A Retrospective: 1969–1980" is held at the Chicago Museum of Contemporary Art.

1981

MTV, the first music television channel, is launched with the Buggles' "Video Killed the Radio Star."

Sandra Day O'Connor becomes the first female associate justice of the U.S. Supreme Court, appointed by President Reagan.

In Los Angeles, the first cases of AIDS are reported by the U.S. Centers for Disease Control.

Laurie Anderson becomes widely known outside the art world in 1981 with the single "O Superman," which airs on MTV.

The first annual ARCO art fair is held in Madrid.

"A New Spirit in Painting" presents neoexpressionist work at the Royal Academy, London.

1982

Vincent Chin is beaten to death in Detroit by two white auto workers who are later acquitted. The murder becomes a rallying point for the Asian American community and the subject of the 1989 documentary "Who Killed Vincent Chin?"

The Vietnam Veterans Memorial, designed by architecture student Maya Lin, is dedicated in Washington, D.C.

John Cage's scores and prints are exhibited for the first time at the Whitney Museum.

The landmark "Zeitgeist" exhibition opens at the Martin-Gropius-Bau in Berlin, adjacent to the Berlin Wall, and is much lauded for its overwhelming sense of history juxtaposed with new works by artists such as Warhol, Baselitz, Penck, and Kiefer.

Rudi H. Fuchs curates Documenta VII in the German town of Kassel. Joseph Beuys presents *7000 Oak Trees*, which lives on in Kassel today.

"Nam June Paik" opens at the Whitney Museum.

"Louise Bourgeois" opens at the Museum of Modern Art.

"Transavanguardia Italia / America" opens at the Civic Gallery of Modena, Italy. It includes Jean Michel Basquiat, David Salle, Julian Schnabel, Sandro

Chia, Francesco Clemente, and Mimmo Paladino, among others. The term *transavantgarde* is officially born in the Aperto '80 section devised by Achille Bonito Oliva and Harald Szeemann for the 39th Venice Biennial.

1983

The Institut Pasteur identifies the human immunodeficiency virus (HIV), an important step toward the eradication of AIDS, which reaches epidemic proportions by the mid-1980s.

In April the U.S. Embassy in Beirut is bombed, killing 63 people and injuring 120. In October a truck bomb explodes at the U.S. Marine barracks, killing 241 military personnel. In February 1984 President Reagan orders the Marines to withdraw from Lebanon.

Art collector Dakis Joannou founds the Deste Foundation in Athens.

The Museum of Contemporary Art in Los Angeles opens an interim space, "The Temporary Contemporary," in a former hardware store renovated by Frank Gehry.

Jean Baudrillard publishes *Simulations* and Hal Foster publishes *The Anti-Aesthetic: Essays on Postmodern Culture*, two seminal treatises on postmodern theory.

Mary Kelly publishes *Post Partum Document*, a process-based work that uses objects of both personal and theoretical significance to document the mother–child relationship.

1984

Apple releases the first Macintosh computer.

Bulgaria begins a campaign to erase the national identity of the Turkish minority by forcing the Turks to take Slavic names. By 1989, there is a mass exodus of Bulgarian Turks from the country.

Rising demands for a Sikh nation separate from India induce a wave of terrorism. When militants seize the Golden Temple in Amritsar, Prime Minister Indira Gandhi responds by sending in troops, and thousands are killed in a four-day battle. Within months she is assassinated by two of her own Sikh bodyguards, and riots and massacres of Sikhs follow. Her son Rajiv Gandhi is elected her successor.

The Bhopal gas disaster in India kills approximately 4,000 people and causes long-term health problems for more than 500,000. It is considered the world's worst industrial catastrophe.

Sidney Janis Gallery in New York mounts exhibitions of graffiti art by Crash and Daze.

Inspired by the New York Triangle Workshop, South African artists Bill Ainslie and David Koloane organize the Thupelo Workshop in Johannesburg. The success spawns a series of workshops held throughout Africa, including Botswana (1989), Mozambique (1991), Zambia (1993), Namibia (1994), and Senegal (1994).

Postmasters Gallery opens in the East Village. In 1989 it moves to SoHo and in 1998 to Chelsea.

The first edition of the Cairo International Biennial opens at the Arts Palace.

The Havana Biennial is founded. It becomes an important forum for underrepresented voices, a kind of "Third World biennial."

"Primitivism in 20th Century Art: Affinity of the Tribal and the Modern" opens at The Museum of Modern Art, exploring the connections between Western artists and tribal works.

"Difference: On Representation and Sexuality" opens at the New Museum.

1985

Mikhail Gorbachev becomes general secretary of the Communist Party in the Soviet Union and pursues policies of openness and restructuring.

Noguchi Museum opens in Long Island City, New York.

The '85 New Wave Art Movement flourishes in China. It advocates for artistic freedom and independence from official ideology, encompassing social activities such as performances, meetings, conferences, and village-factory visits as well as many self-organized, unofficial exhibitions.

The first Biennial of Contemporary Bantu Art is organized in Libreville, Gabon.

The Guerrilla Girls stage anonymous actions protesting racism and sexism in the art world.

The Saatchi Gallery, founded by Charles Saatchi, an art collector and global advertising mogul, opens in London. In 2010 he announces that the gallery will be given to the British public as the Museum of Contemporary Art.

1986

The *Challenger* space shuttle explodes shortly after takeoff, killing all seven crew members on board.

The Iran-contra affair, involving senior members of the Reagan administration, begins to unfold.

The U.S. crack epidemic that lasted roughly from 1984 to 1990 reaches a high point when the federal Anti–Drug Abuse Act of 1986 is passed during the media frenzy following the death of University of Maryland basketball star Len Bias. The Act reinstates mandatory minimum prison sentences for drug possession.

Keith Haring's mural *Crack Is Wack* is executed without city permission at 128th Street and Second Avenue in New York. The mural, immediately put under the protection and jurisdiction of the City Department of Parks, still exists.

An accident at the Soviet nuclear power plant at Chernobyl releases radioactive materials throughout the surrounding area.

Sonnabend Gallery in New York exhibits the work of Neo-Geo artists.

Jan Hoet curates "Chambres d'Amis" (Guest Rooms) in fifty-eight houses belonging to everyday townspeople in Ghent, liberating artworks from the sanctity of the museum setting and revolutionizing curatorial strategies.

Joseph Beuys dies in Düsseldorf.

Donald Judd founds the Chinati Foundation in Marfa, Texas.

The Museum of Contemporary Art in Los Angeles opens its main venue, designed by Arata Isozaki, with "Individuals: A Selected History of Contemporary Art, 1945–1986."

1987

The stock market crashes on "Black Monday" (October 19), signaling the beginning of a recession.

ACT UP (the AIDS Coalition To Unleash Power) is founded in New York, and gay activists form the Silence = Death Project and begin plastering posters stating "SILENCE = DEATH." They later join ACT UP and offer the logo to the group.

The NAMES Project AIDS Memorial Quilt, with 1,920 panels, is displayed on the National Mall in Washington, D.C., during the National March on Washington for Lesbian and Gay Rights. The Quilt goes on a twenty-city national tour that raises $500,000 for AIDS service organizations. By 2009 the Quilt has more than 44,000 panels and is the largest ongoing community arts project in the world.

Documenta VIII opens in Kassel.

The second edition of "The Skulptur Projekt," a site-specific exhibition of sculptures in public places held every ten years, takes place in Munster, Germany.

"Berlinart 1961–1987" opens at The Museum of Modern Art.

Andy Warhol dies. The Andy Warhol Foundation is established.

Dia:Chelsea opens in a former warehouse designed by Richard Gluckman, kickstarting the art scene's move from SoHo to Chelsea.

Portikus, founded by Kasper König, one of the most influential curators of contemporary art, opens in Frankfurt am Main.

The Istanbul Biennial is founded.

The Menil Collection, designed by Renzo Piano, opens in Houston.

1988

President Reagan's vice president, George H.W. Bush, is elected the forty-first president of the United States.

Benazir Bhutto becomes the first woman to be elected head of a Muslim state as prime minister of Pakistan.

Under Gorbachev, the Soviet Union withdraws from Afghanistan after a ten-year war. Civil war ensues.

Generali Foundation opens in Vienna as a nonprofit association to support contemporary visual art oriented toward conceptual art.

Jasper Johns exhibits in the U.S. pavilion at the Venice Biennial.

The "Freeze" exhibition takes place in an empty London Port Authority building at Surrey Docks. Organized by Damien Hirst and Angus Fairhurst, as well as other students from Goldsmiths College of Art, it is significant for the development of the Young British Artists.

"The Latin American Spirit: Art and Artists in the United States, 1920–1970" opens at The Bronx Museum of the Arts.

"Robert Mapplethorpe: The Perfect Moment," curated by ICA Director Janet Kardon, presents works dating from 1969 to 1988. The show falls victim to public outcry against government sponsorship of "obscene" art. Washington's Corcoran Gallery cancels its stop on the tour for fear of negative repercussions, especially a possible impact on funding from the National Endowment for the Arts. The Corcoran's decision sparks a controversial national debate and the show is eventually held at Washington Project for the Arts.

1989

Denmark becomes the first country to legalize same-sex marriage.

Pro-democracy protests in Tiananmen Square in Beijing led by 300,000 people are halted by Chinese troops who confront the protesters, resulting in hundreds of casualties and arrests.

The *Exxon Valdez* oil tanker spills approximately 11 million gallons of crude oil off the coast of Alaska.

The fall of the Berlin Wall symbolizes the collapse of the Communist regimes in eastern Europe. The reunification of East and West Germany follows. Unified Germany becomes a member of NATO. The dismantling of the Soviet Union is completed by 1991.

Newly elected South African President F. W. de Klerk announces his program to reform apartheid. In 1991 the African National Congress announces the victory of its thirty-year struggle against apartheid.

"Image World: Art and Media Culture" opens at the Whitney Museum, organized by Marvin Heiferman, Lisa Phillips, and John Hanhardt.

"Magiciens de la terre" opens at Centre Pompidou, curated by Jean-Hubert Martin. It marks the internationalization of contemporary art. Fifty percent of the works are from Europe and North America and fifty percent are from Asia, Africa, and Latin America.

Robert Mapplethorpe dies of complications resulting from AIDS.

The inaugural Lyon Biennial, "The Love of Art," explores the strength of art in France going against the trend of being "international." Invited artists include Arman, Cesar, Robert Filliou, Pierre Soulages, Erik Dietman, Dominique Gonzalez-Forester, Philippe Parreno, Pierre & Gilles, and Sophie Calle.

The "China Avant-Garde Exhibition" takes place at the National Arts Gallery in Beijing and is shut down twice by the authorities.

"A Forest of Signs" is held at the Museum of Contemporary Art in Los Angeles, documenting a shift toward critical art from 1970 onward.

France celebrates the bicentennial of the French Revolution. Several projects are completed, including the new Louvre pyramids, designed by I. M. Pei; and the Musée d'Orsay, designed by Gae Aulenti.

"Contemporary Art from the Islamic World" is co-organized by the Jordanian Royal Society of Fine Arts and the Islamic Arts Foundation of the United Kingdom; it travels from London to Amman in hopes of highlighting new dimensions in the collaboration between East and West.

1990

Serbian President Slobodan Milošević abolishes the autonomy of Kosovo and institutes a purge of ethnic Albanians in the province.

Tim Berners-Lee "invents" the World Wide Web. The combination of the HyperText Transfer Protocol (http) and a platform-independent markup language (HTML) allows people to share and access information globally with relative ease.

Nelson Mandela is released after twenty-seven years in prison. In 1994 he is elected president in the first multiracial elections held in South Africa.

The seeds of the Persian Gulf War are sown in response to Iraq's invasion of Kuwait in August. Economic sanctions by members of the UN Security Council are immediate, and the military response Operation Desert Storm is launched in January 1991 by a UN coalition of thirty-four countries led by the United States. Operation Desert Storm ends February 28 with the liberation of Kuwait.

The U.S. Congress requires the National Endowment for the Arts (NEA) to consider "general standards of decency and respect" in awarding grants.

The National Campaign for Freedom of Expression (NCFE) is created to address continuing acts of censorship and the addition of amendments like the "decency clause" to National Endowment for the Arts contracts.

"The Decade Show: Frameworks of Identity in the 1980s" is co-organized and co-presented by the Museum of Contemporary Hispanic Art, the New Museum of Contemporary Art, and the Studio Museum in Harlem.

The Museum of Contemporary Art opens in Tangier, Morocco.

African artists are represented for the first time at the Venice Biennial. The works of El Anatsui, Tapfuma Gusta, Bruce Oboprakpeya, Nicholas Mukumberanwa, and Henry Munyaradzi are featured in "Five Contemporary African Artists."

ArtFutura, a yearly festival of digital culture, opens in Barcelona, with each succeeding edition dedicated to a central theme. The first one, "Virtual Reality," presents innovations of digital art and design and computer animation and reflects on the social implications of the new technologies.

"The Finitude of Freedom," a citywide project in Berlin initiated by Rebecca Horn, Jannis Kounellis, and Heiner Müller, celebrates the unification of East and West. Artists are invited to give an artistic answer to the changes through site-specific projects in both East and West.

Keith Haring dies of complications resulting from AIDS.

1991

Boris Yeltsin becomes the first popularly elected president of Russia.

The fifteen member nations of the European Union meet in Maastricht to sign the Maastricht Treaty, thereby agreeing to adopt a single currency.

The Japanese asset price bubble collapses, triggering what becomes known as "The Lost Decade."

The Yugoslav wars erupt when military forces controlled by Milošević attempt to prevent the secession from Yugoslavia of, first, Slovenia, then

Croatia, Macedonia, and Bosnia-Herzegovina. NATO enters the conflict in 1994 with the first air strikes in its history, targeting Bosnian Serbs. The war continues until 1995, with casualties in the hundreds of thousands, widespread use of genocide, and incalculable destruction of archaeological and cultural sites.

"Pop Art" opens at the Royal Academy of Arts, and "Objects for the Ideal Home: The Legacy of Pop Art" opens at the Serpentine, both in London.

"Dislocations" opens at the Museum of Modern Art. Curated by Robert Storr, it mixes aesthetic pleasure and political context. It is MoMA's first show of installation work since the 1970s.

"Metropolis" opens at the Martin-Gropius-Bau in Berlin. Curated by Christos M. Joachimides and Norman Rosenthal, it presents works linked to media aesthetics, history, memory, artificiality, consumption, and art's status as a commodity.

Felix Gonzales-Torres's *Untitled*, a photograph of an unoccupied bed taken after the AIDS-related death of his lover, Ross, is installed on twenty-four New York billboards.

The 51st Carnegie International in Pittsburgh is characterized by artworks conveying a sincerity that breaks away from the irony of the '80s.

1992

Following the acquittal of Los Angeles police officers accused of beating a black man, Rodney King, rioting by thousands erupts in L.A.

"Helter Skelter: L.A. Art in the 1990s," organized by Paul Schimmel, opens at the Museum of Contemporary Art in Los Angeles.

The Dakar Biennial, or DAK'ART, is founded.

"Post Human," curated by Jeffrey Deitch, opens at the FAE Musée d'Art Contemporain in Lausanne.

"Trans-Voices" is presented in Paris and New York, organized by the American Center in Paris, the Whitney Museum, and the Public Art Fund.

Joan Mitchell dies in Vétheuil, France. The Joan Mitchell Foundation is established in 1993.

The Museo Nacional Centro de Arte Reina Sofía opens its permanent space in Madrid. Pablo Picasso's *Guernica* (1937) is among the works on exhibit.

"Mining the Museum: An Installation" opens, a groundbreaking intervention by artist Fred Wilson that transforms the Maryland Historical Society's collection to highlight the history of slavery in America.

1993

Democrat Bill Clinton of Arkansas begins a two-term presidency that will be buoyed by renewed economic prosperity and plagued by scandal.

A truck bomb detonates below the North Tower of the World Trade Center in New York, killing seven people and injuring 1,042. Six Islamic militants are convicted and sentenced to life in prison. The attack is meant to pressure the United States to stay out of the Middle East and curb its support of Israel.

A fifty-one-day siege by FBI agents of the compound held by David Koresh, the leader of the Branch Davidians in Waco, Texas, ends with an assault, explosion, and fire that kill Koresh and seventy-six followers.

The Gramercy International Art Fair is held at the Gramercy Hotel in New York, founded by art dealers Colin De Land, Pat Hearn, Matthew Marks, and Paul Morris. The fair outgrows its location and is renamed The Armory Show in 1999 when it is first held at the 69th Regiment Armory, the site of the legendary Armory Show of 1913.

Fashion designers Miuccia Prada and Patrizio Bertelli establish the Fondazione Prada in Milan.

The first Sharjah Biennial takes place in the United Arab Emirates, sponsored by the Sharjah Art Museum.

The 1993 Whitney Biennial, assembled by a team of curators under Elisabeth Sussman, is the first to have a minority of white heterosexual male artists, only 36 percent; the rest of the works are made by women, African Americans, Asian Americans, Latinos, and gays.

Yerba Buena Center for the Arts opens in San Francisco, designed by Fumihiko Maki and James Stewart Polshek.

Hans Ulrich Obrist curates "Do It," an exhibition with an online and museum version that explores human interpretation of instructions. The show travels to nineteen cities until 2002.

An Eva Hesse retrospective opens at the Hirshhorn Museum in Washington, D.C.

The First Asia-Pacific Triennial of Contemporary Art is held at the Queensland Art Gallery in South Brisbane, Australia.

White Cube, founded by Jay Jopling, opens in London as a project room for contemporary art.

1994

The North American Free Trade Agreement (NAFTA) is implemented. The treaty is credited with stimulating economic exchanges between Canada, the United States, and Mexico but is also said to cause the exportation of manufacturing jobs from the United States to its southern neighbor.

Civil war and genocide break out in Rwanda. Hutu militias backed by sectors of the military begin the systematic massacre of Tutsis, killing 800,000 in three months.

The Taliban movement gains momentum in Afghanistan when it takes Kandahar and two years later enters Kabul. By 1998, the group controls almost 90 percent of the country. Women's rights are sharply curtailed under the enforcement of an extreme form of Islamic law.

With the release of the Netscape browser, Internet "surfing" becomes readily available.

"The Winter of Love" opens at the Musée d'Art Moderne in Paris.

"Japanese Art after 1945: Scream Against the Sky" opens at the Guggenheim Museum.

The Dutch Electronic Art Festival (DEAF) is established as a biennial in Rotterdam.

Santiago Sierra has his first solo exhibitions at the Galería Ángel Romero and Espacio "P" in Madrid. Sierra specializes in orchestrating performances by non-artists that call into question economic, social, and class relations.

Manifesta is founded in the Netherlands as a pan-European Biennial of Contemporary Art in response to the dramatic political changes in central and eastern Europe. It is conceived as a nomadic event, its base moving from one city to another within Europe, every two years.

The first "Rencontres Africaines de la Photographie," a photography biennial, is held in Bamako, Mali.

1995

eBay, an online auction and shopping Web site, is founded. It is one of the notable successes of the dot-com bubble. In 2006 a fake Richard Diebenkorn work fetches $135,805 on eBay, and Kenneth Walton is accused of forgery. In 2007 employees of the company "Pictures on Walls," which publishes Banksy prints, is accused of selling unauthorized Banksy prints on eBay.

O. J. Simpson is acquitted of two counts of murder in connection with the June 1994 deaths of his ex-wife Nicole Brown Simpson and her friend Ronald Goldman. The controversial verdict fuels racial tensions. In a subsequent civil trial in 1997, Simpson is found liable for damages, and the victims' families are awarded $33.5 million.

The Dayton Agreement divides Bosnia and Herzegovina between the Federation of Bosnia and Herzegovina and the Bosnian Serb Republika Srpska.

On April 19, the Murrah Federal Building in Oklahoma City is bombed and 168 people are killed. Timothy McVeigh and Terry Nichols are convicted of the crime, and McVeigh is later executed.

"Reconsidering the Object of Art, 1965–1975" opens at the Museum of Contemporary Art, LA.

"Rites of Passage: Art for the End of the Century" opens at Tate Gallery London, curated by Stuart Morgan and Frances Morris.

The first Johannesburg Biennial is held.

The San Francisco Museum of Modern Art inaugurates its new building, designed by Mario Botta.

Africa 95 is held at venues in Africa and the United Kingdom, including exhibitions like "Seven Stories About Modern Art in Africa" at Whitechapel Art Gallery, London, and "Self Evident" at the Ikon Gallery, Birmingham.

Christo and Jeanne-Claude wrap the Reichstag in Berlin.

Dia initiates a series of artists' projects for the Web by commissioning projects from artists interested in exploring the aesthetic and conceptual potentials of this medium.

Emmanuel Perrotin opens a gallery in Paris that is soon at the epicenter of Nicolas Bourriaud's "relational aesthetics," a term referring to 1990s artists like Maurizio Cattelan, Liam Gillick, Douglas Gordon, Pierre Huyghe, Henrik Plenge Jakobsen, Philippe Parreno, Gabriel Orozco, and Rirkrit Tiravanija.

Site Santa Fe is inaugurated with "Longing and Belonging: From the Faraway Nearby," organized by Bruce Ferguson.

The Gwangju Biennial opens in South Korea, becoming Asia's first and most prestigious contemporary art biennial.

The contemporary art foundation Fondazione Sandretto Re Rebaudengo opens in Turin.

A Felix Gonzalez-Torres retrospective opens at the Guggenheim Museum, organized by Nancy Spector.

1996

The Kosovo Liberation Army (KLA) fights to restore the autonomy of Kosovo from the country of Serbia and Montenegro. Kosovar Albanian refugees accuse Milošević of atrocities. NATO intervenes once again in 1999 with air strikes in Belgrade. Shortly after, the Serbs withdraw from Kosovo and the KLA agrees to disarm.

The Mercosul Biennial is founded in Porto Alegre, Brazil. Based on the Mercosur economic treaty, it promotes Latin American art and includes a strong educational element.

"NowHere" is held at the Louisiana Museum of Modern Art in Humlebæk, Denmark.

Art Forum Berlin is founded by Volker Diehl and is held at the Ring unter dem Funkturm.

The First Shanghai Biennial opens, devoted to Chinese artists employing traditional techniques.

Felix Gonzalez-Torres dies of complications resulting from AIDS.

Juan Muñoz has his first U.S. museum exhibition, "A Place Called Abroad," at the Dia Center in New York.

"Manifesta 1" is held in sixteen different institutions in Rotterdam.

Museum für Gegenwart opens at the former railway station Hamburger Bahnhof in Berlin, refurbished by Josef Paul Kleihues.

The nonprofit Rhizome is founded to support the creation, presentation, preservation, and interpretation of art engaged with the Internet and networked technologies.

The Bronx Museum of the Arts commemorates its twenty-fifth anniversary with "Bronx Spaces," a show focusing on the lifespan of four younger institutions: the Bronx River Art Center, Longwood Arts Gallery, En Foco, and Lehman College Art Gallery.

The Niterói Contemporary Art Museum opens in Niterói near Rio de Janeiro. Designed by Oscar Niemeyer, it houses the João Sattamini collection.

Matthew Barney is awarded the first Hugo Boss Prize, which carries an award of $100,000 and is administered by the Guggenheim Foundation.

Yve-Alain Bois and Rosalind Krauss curate "L'informe—mode d'emploi" at the Centre Pompidou.

1997

All major industrialized nations except the United States sign the Kyoto Protocol, aimed at battling global warming.

Speculative attacks on Thailand's currency precipitate an Asian financial crisis that spreads to Indonesia, South Korea, the Philippines, Malaysia, and Hong Kong.

Scottish geneticists successfully clone a sheep named Dolly from an adult cell.

"Gothic: Transmutations of Horror in Late-Twentieth-Century Art," opens at the ICA Boston, organized by Christoph Grunenberg and Marcella Beccaria.

The Guggenheim Museum, designed by Frank Gehry, opens in Bilbao.

The annual Japan Media Arts Festival is founded by Japan's Agency for Cultural Affairs and the National Art Center in Tokyo, focusing on digital art, interactive art, animation, and manga.

ZKM Center for Art and Media opens in the German city of Karlsruhe in a former munitions factory renovated by Schweger & Partner.

"Minimalia: An Italian Vision in 20th Century Art" is held in Venice alongside the Biennial, curated by Achille Bonito Oliva.

Hans Haacke exhibits *Shapolsky et al. Manhattan Real Estate Holdings, a Real-Time System, as of May 1, 1971* at Documenta X in Kassel.

Marina Abramović is selected to show in the Yugoslavian pavilion at the Venice Biennial. The Montenegrin Minister of Culture objects to her selection. Eventually her video *Balkan Baroque* is shown in the exhibition curated by Germano Celant and she wins the International Venice Biennial Award.

"Sensation" opens at the Royal Academy of Arts and travels to New York, where Chris Ofili's *The Holy Virgin Mary* generates controversy that leads to a lawsuit by Mayor Rudolph W. Giuliani against the Brooklyn Museum. The media frenzy generates crowds totaling more than 190,000 visitors.

The Getty Center opens in Brentwood, Los Angeles, as the second location of the J. Paul Getty Museum. Designed by Richard Meier, it includes a central garden by artist Robert Irwin.

1998

President Clinton is impeached by the U.S. House of Representatives on charges of perjury and obstruction of justice on December 19. His subsequent Senate trial ends in acquittal on all counts on February 12, 1999. The charges arise from the Monica Lewinsky scandal and the Paula Jones lawsuit.

The Irish and British governments sign the Belfast Agreement, effectively ending violence in North Ireland.

Google, an Internet search engine, is launched.

The war in the Democratic Republic of Congo breaks out, eventually claiming 2.5 million lives.

"David Goldblatt: Photographs from South Africa" opens at the Museum of Modern Art, curated by Susan Kismaric.

The exhibition "Experiencias '68" opens at the Fundación Proa, Buenos Aires, as a re-creation of the one held at Instituto Di Tella in 1968.

"The Art of the Motorcycle" opens at the Guggenheim Museum, organized by Thomas Krens. It is the best-attended show in the museum's history.

The Liverpool Biennial, San Francisco Biennial, and Berlin Biennial are founded, continuing the trend of "biennialization" of the contemporary art world.

The KIASMA Museum of Contemporary Art opens in Helsinki, designed by Steven Holl.

1999

Two seniors, Eric Harris and Dylan Klebold, kill twelve students and a teacher at Columbine High School in Colorado.

The Euro currency is adopted by member states of the European Union for electronic transactions. Great Britain retains use of the pound sterling.

Adrian Piper's traveling retrospective, organized by Maurice Berger, opens at the Fine Arts Gallery of the University of Maryland, challenging audiences' racial assumptions.

Leo Castelli dies.

AIM alumnus Anton Vidokle launches e-flux, an online forum for art.

The Museum of Contemporary African Diasporan Arts (MoCADA) opens a new building in Brooklyn.

"Robert Gober: Sculpture + Drawing" opens at the Walker Art Center, Minneapolis.

"The American Century" opens at the Whitney Museum, including a sound art exhibition curated by Stephen Vitiello, "I Am Sitting in a Room: Sound Works by American Artists 1950–2000."

2000

The popularity of "reality" television explodes with the success of "Big Brother" and "Survivor."

The "dot-com" bubble bursts as the NASDAQ exchange tumbles and hundreds of start-ups fold.

Serbia and Montenegro replace Yugoslavia. Milošević is forced out by mass protests after refusing to accept defeat in the elections. In 2003, he is handed over to the UN War Crimes Tribunal at The Hague. Kosovo becomes a UN protectorate.

The U.S. presidential election culminates in a legal challenge. Republican Governor George W. Bush of Texas is eventually declared the winner when the U.S. Supreme Court disallows the recounting of Florida votes, which might have resulted in the victory of Vice President Al Gore.

The "Third Shanghai Biennial" includes international artists and curators for the first time. "Fuck Off" opens simultaneoulsy at the Eastlink Gallery with work by forty-six avant-garde artists such as Ai Weiwei, Cao Fei, Li Zhiwang, Liang Yue, Song Dong, and Zhu Yu. Shanghai police close down the exhibition.

P.S.1 and the Museum of Modern Art present their first curatorial collaboration with "Greater New York," presenting more than 140 emerging artists from the metropolitan area.

The Tate Modern opens in London at the former Bankside Power Station, converted by Herzog & de Meuron.

The International Center of Photography inaugurates its new space in midtown Manhattan, designed by Gwathmey Siegel & Associates.

The "Coastline 2000" exhibit near Reykjavik includes fifteen site-specific sculptures that affirm the continuing importance of the landscape to Icelandic and Scandinavian art.

The Kunstmuseum Liechtenstein opens in Vaduz, designed by Morger, Degelo & Kerez.

The traveling exhibition "After the Wall: Art from the 1990s: From Berlin to Baku, from Tallinn to Tirana" opens at the Max Liebermann Haus and the Hamburger Bahnhof Museum, Berlin.

2001

The New Partnership for African Development (NEPAD) is launched with the goal of ending wars and government corruption in exchange for foreign investment and the lifting of barriers on African exports.

On September 11, Al Qaeda terrorists hijack four commercial airplanes to attack the World Trade Center in New York and the Pentagon near Washington, D.C. The fourth airliner crashes in a rural area of Pennsylvania. Within a month President Bush declares war in Afghanistan, targeting the Taliban regime and Osama bin Laden. The Taliban government falls and is replaced by an Afghan Interim Authority whose chairman, Hamid Karzai, is elected president in 2002.

iPod, a digital music player, is launched by Apple along with the companion iTunes software.

Jimmy Wales and Larry Sanger found Wikipedia, a free and collaborative Internet encyclopedia that anyone can contribute to or edit.

"Brazil: Body and Soul" opens at the Guggenheim Museum.

A traveling retrospective of William Kentridge is held at the South African National Gallery, Cape Town.

Okwui Enwezor curates "The Short Century: Independence and Liberation Movements in Africa, 1945–1994" at the Museum Villa Stuck, Munich.

Lia Gangitano founds Participant, a nonprofit alternative space in New York with an emphasis on artistic experimentation.

"Iranian Contemporary Art" opens at the Barbican Centre in London and "A Breeze from the Gardens of Persia: New Art from Iran" opens at the Meridian International Center in Washington, D.C.

The Neue Galerie, a museum of German and Austrian art and design, opens in New York. In 2006, its founder, Ronald Lauder, purchases Klimt's *Portrait of Adele Bloch-Bauer I* on behalf of the museum for $135 million, reportedly the most expensive painting ever sold.

The Yokohama Triennial is founded with "MEGA WAVE—Towards a New Synthesis," the first event of such scope in Japan's history.

2002

Rwanda and the Democratic Republic of Congo (DRC) sign a peace agreement stipulating that Rwanda will pull troops out of the DRC and the DRC will help disarm Rwandan Hutu mercenaries involved in the 1994 genocide of the Tutsi minority.

A rediscovered Rubens, *The Massacre of the Innocents* (1609–11), is sold at Sotheby's London for $76.7 million, the third-highest price ever paid for a painting at auction and the highest for an Old Master work.

Art Basel Miami Beach is founded as a sister event to Art Basel Switzerland, which began in 1970.

SCOPE is founded. It quickly makes the leap from an alternative hotel art fair to a major booth fair happening in London, New York, Miami, and the Hamptons.

The Sculpture Center opens its new home in a former trolley repair shop in Long Island City, New York, redesigned by Maya Lin.

"Gerhard Richter: Forty Years of Painting" opens at the Museum of Modern Art, organized by Robert Storr.

"Drawing Now: Eight Propositions" opens at the Museum of Modern Art, organized by Laura Hoptman, highlighting drawing's recent resurgence in contemporary art.

"Documenta 11" takes place in Kassel, curated by Okwui Enwezor and a team of fellow curators. Conceived as five platforms, it was extended temporally, geographically, and conceptually to discussions in Vienna, New Delhi, Saint Lucia, and Lagos, with the aim of discussing the role of art in a postcolonial, globally interconnected world.

New Art Dealers Alliance (NADA) is founded as a nonprofit collective of contemporary art professionals. Its mission is to create an open flow of information and collaboration and a free annual art fair in Miami.

2003

Conflict in the Darfur region of Sudan escalates into war. In 2004 pro-government militias massacre thousands of villagers; the international community calls it genocide. The UN installs a peacekeeping force to disarm the militias.

Scientists complete the Human Genome Project.

The United States and the United Kingdom launch an invasion of Iraq that marks the beginning of the Iraq War, which topples the regime of Saddam Hussein. In 2005 the CIA releases a report saying no weapons of mass destruction, the supposed existence of which was used as a *casus belli*, were found. The occupation lasts until August 2010, with casualties of 4,000 U.S. military personnel and approximately 1 million Iraqis.

"Conditions of Humanity," a traveling show of Kim Sooja's work, opens at the Museum Kunst Palast, Düsseldorf.

Dia:Beacon opens in a former Nabisco factory in upstate New York, converted by the architecture firm OpenOffice and artist Robert Irwin.

Frieze Art Fair opens in London.

The Schaulager, designed by Herzog & de Meuron, opens near Basel, Switzerland, with a retrospective of Dieter Roth.

Julie Mehretu has her museum solo debut, "Drawing into Painting," at the Walker Art Center in Minneapolis.

2004

George W. Bush is reelected president of the United States.

Massachusetts becomes the first state to legalize same-sex marriage.

Prisoner abuse at the U.S.-run prison Abu Ghraib in Iraq is revealed.

An Indian Ocean earthquake triggers tsunamis that kill more than 230,000 people in 14 countries.

Facebook is founded; it becomes the most popular social networking site.

The groundbreaking "Inverted Utopias: Avant-Garde Art in Latin America" opens at the Museum of Fine Arts, Houston, curated by Mari Carmen Ramírez and Héctor Olea.

La Maison Rouge is founded in Paris by art collector Antoine de Galbert.

Andrea Giunta curates "León Ferrari: Obras 1954–2004" at Centro Cultural Recoleta in Buenos Aires. The Catholic clergy demands that the show be canceled because of what it views as its antireligious content, and the exhibition closes on a judge's orders. Eighteen days later Recoleta wins on appeal, and the exhibit reopens on claims that no one is obliged to see it.

Mexico Arte Contemporáneo (MACO) art fair starts yearly in Mexico City.

The Museum of Modern Art unveils its new building, designed by Yoshio Taniguchi, to commemorate its seventy-fifth anniversary.

"Africa Remix: Contemporary Art of a Continent," under the curatorial direction of Simon Njami, opens at the Museum Kunst Palast, Düsseldorf.

2005

After the levee system fails in New Orleans, Hurricane Katrina becomes one of the most damaging natural disasters in U.S. history.

In Liberia, Ellen Johnson-Sirleaf becomes the first woman to be elected head of state in an African country.

YouTube, a video-sharing Web site, is founded.

Banksy places artworks in the Museum of Modern Art, the Metropolitan Museum of Art, the Brooklyn Museum, and the American Museum of Natural History.

Marlene Dumas's painting *The Teacher* (1987) fetches $3.34 million at Christie's London, commanding the highest price for a living female artist at auction.

The First Moscow Biennial of Contemporary Art, "Dialectics of Hope," opens at the former Lenin Museum.

The Walker Art Center in Minneapolis opens its expanded facility, designed by Herzog & de Meuron.

"Performa 05," founded in New York by RoseLee Goldberg, is the first biennial of visual art performance.

"Beautiful Losers: Contemporary Art and Street Culture" opens at the Orange County Museum of Art. It celebrates the influence on contemporary art of youth cultures such as skateboarding, graffiti, punk, and street culture.

"Sue de Beer, Black Sun" opens at the Whitney Museum at Altria. Her work is part of what is sometimes termed "new gothic." Other artists associated with the show are Olaf Breuning, David Altmejd, Banks Violette, and Matt Greene.

"Visual Music," an alternative history of abstraction in twentieth-century art exploring ideas related to synesthesia, opens at the Hirshhorn Museum in Washington, D.C.

Art Fair Tokyo is founded.

Richard Prince's *Untitled (Cowboy)* (1989) is the first photograph to sell for more than $1 million at auction when it sells at Christie's New York for $1,248,000.

The Bucharest International Biennial for Contemporary Art is founded.

Art collector Jean-Pierre Lehmann sues art dealer Christian Haye, owner of The Project, for denying him access to Julie Mehretu's works, breaking their agreement of right of first refusal. The New York State Supreme Court directs Haye to pay $1.73 million in damages. The landmark trial exposes the inner workings of the primary art market and the strategies a dealer has to control the distribution of art.

2006

Saddam Hussein is executed.

Twitter is launched; museums quickly adopt it as a marketing tool.

The Israel–Hezbollah War breaks out in July between Lebanon and Israel. The conflict formally ends in September when Israel lifts its naval blockade of Lebanon.

Bernardo Paz founds Inhotim, a contemporary art center emphasizing the relationship between art and landscape, in Brumadinho, Brazil.

The Bronx Museum of the Arts nearly doubles in size with an expansion designed by Arquitectonica.

The ICA Boston unveils its new building, designed by Diller Scofidio + Renfro.

"Subcontingent: The Indian Subcontinent in Contemporary Art" opens at the Fondazione Sandretto Re Rebaudengo in Turin.

Cabinet presents "Iron Artist" at P.S.1, a live artist-versus-artist competition modeled after "Iron Chef America."

The Singapore Biennial and the Turin Triennial are founded.

The Guggenheim announces plans to build a museum designed by Frank Gehry in the Cultural District of Saadiyat Island in Abu Dhabi.

2007

A controversy known as "Lawyergate" arises following the dismissal of seven U.S. Attorneys in 2006. The congressional investigation unleashes the Bush White House e-mail controversy and culminates in the resignation of nine high-level ranking officers of the Department of Justice, most prominently Attorney General Alberto Gonzáles.

Apple launches the iPhone with new touch screen technology.

Benazir Bhutto, former prime minister and current leader of the Pakistan Peoples Party, is assassinated in conjunction with a suicide attack at a political rally. The Pakistani government points to Al Qaeda as the perpetrator.

A financial crisis starts in the United States. Triggered by a liquidity shortfall in the banking system, it results in the collapse of large financial institutions, the bank bailout, the end of the housing bubble, and downturns in global stock markets.

Damien Hirst's *The Physical Impossibility of Death in the Mind of Someone Living* (1991) goes on view at the Metropolitan Museum of Art.

Dubai hosts the first Gulf Art Fair of Contemporary Art (named Art Dubai in later editions) at the Madinat Jumeirah.

Mexico makes its official debut at the Venice Biennial with an exhibition of Rafael Lozano-Hemmer's interactive installations at the Van Axel palace.

Jean Blaise, director of Nantes' Lieu Unique, founds the Estuaire Biennial. The event sprawls from Nantes to Saint-Nazaire, two cities connected by the Loire River.

Thomas P. Campbell, a curator with a specialty in European tapestry, becomes Director of the Metropolitan Museum of Art, succeeding Philippe de Montebello's three-decade tenure.

"Helio Oiticica: The Body of Color" opens at the Museum of Fine Arts, Houston.

"Alfredo Jaar: La politique des images" opens at Musée cantonal des Beaux-Arts de Lausanne.

Antony Gormley's "Blind Light" retrospective opens at the Hayward Gallery, London.

Doris Salcedo's *Shibboleth* cracks the Tate Modern's Turbine Hall floor.

John Szarkowski, who served as Chief Curator of Photography at the Museum of Modern Art from 1962 to 1991, dies.

Marian Goodman Gallery celebrates its thirtieth anniversary with "A Selection of Forty Artists from Thirty Years."

Robert Storr curates the 52nd Venice Biennial, "Think with the Senses—Feel with the Mind: Art in the Present Tense." He is the first American Director ever appointed. Golden Lion prizewinners are León Ferrari, Emily Jacir, and Malick Sidibe.

The CAFKA Biennial in the Waterloo Region of Canada and the Herzliya Biennial of Contemporary Art in Israel are founded.

The Musée du Louvre announces that a new Louvre museum designed by Jean Nouvel will be built on the Saadiyat Island complex in Abu Dhabi.

The New Museum opens its permanent location on the Bowery in lower Manhattan with "Unmonumental: The Object in the 21st Century."

2008

Senator Barack Obama of Illinois is elected the forty-fourth president of the United States, becoming the country's first African American chief executive.

"Face to Face," curated by Hans-Michael Herzog, opens at Daros in Zurich. The show juxtaposes works from the United States and Europe with Latin American works, providing a unique perspective on the postwar period.

FACE, the Foundation of Arts for a Contemporary Europe, is formed as a European interest group for the promotion of contemporary art, including the DESTE Foundation, Athens; Ellipse Foundation, Cascais; Fondazione Sandretto Re Rebaudengo, Turin; La Maison Rouge, Paris; and Magasin 3 Stockholm Konsthall.

"Susan Meiselas: In History" opens at ICP, organized by Kristen Lubben.

The Broad Contemporary Art Museum (BCAM) opens as part of the Los Angeles County Museum of Art's expansion, designed by Renzo Piano.

The International Roaming Biennial of Tehran opens in Istanbul and then travels to Berlin and Belgrade.

"BEUYS: We Are the Revolution" opens at Hamburger Bahnhof, Berlin.

"Indian Highway" opens at the Serpentine Gallery, London.

"Objectivités—La Photographie à Düsseldorf" opens at the Musée d'Art Moderne de Paris. The show traces the history of the Düsseldorf school from the late 1960s to the present day, highlighting the influence of the Bechers.

Triptych (1976) by Francis Bacon sells at Sotheby's New York for $86.3 million, becoming the most expensive postwar work sold at auction. Damien Hirst sells works worth £111 million at Sotheby's London.

"Machines & Souls: Digital Art and New Media," curated by Montxo Algora and José Luis de Vicente, opens at the Reina Sofía in Madrid.

Bronx Blue Bedroom Project is founded by AIM artist Blanka Amezkua as an artist-run project located in her bedroom in Mott Haven, South Bronx.

Garage Center for Contemporary Culture opens in Moscow on the site of the former Bakhmetevsky Bus Garage with a retrospective of Ilya and Emilia Kabakov.

The first editions of the Johannesburg Art Fair and the New Delhi India Art Summit take place.

Brian O'Doherty buries his alter ego, Patrick Ireland, on the grounds of the Irish Museum of Modern Art in Dublin, reversing an act he began in 1972 as a form of protest to Bloody Sunday.

The Devi Art Foundation, India's first contemporary art museum, opens in Gurgaon, a suburb of New Delhi, founded by Anupam Poddar and his mother, Lekha Poddar.

2009

"King of Pop" Michael Jackson dies.

Avatar, an epic science fiction film by James Cameron, is released for 2-D viewing, 3-D viewing, and "4-D" viewing. It becomes the highest-grossing film ever, and the stereoscopic filmmaking and special effects are touted as a breakthrough in cinematic technology.

Sonia Sotomayor, a native of the Bronx, becomes an associate justice of the U.S. Supreme Court, appointed by President Obama.

"The Pictures Generation" opens at the Metropolitan Museum of Art.

"Elles" opens at the Centre Pompidou, marking the first time a museum devotes its permanent collection display entirely to women artists. Key figures like Sonia Delaunay, Frida Kahlo, Dorothea Tanning, Joan Mitchell, Sophie Calle, Annette Messager, and Louise Bourgeois are featured.

Beirut Art Center opens in Lebanon.

2010

Louise Bourgeois dies at age ninety-eight.

Key members of the Polish government, including President Lech Kaczynski, die in a plane crash in Smolensk, Russia.

BP's *Deepwater Horizon* spill becomes one of history's largest environmental disasters.

MAXXI, the National Museum of XXI Century Art, opens in Rome, designed by Zaha Hadid.

In September on the occasion of the twentieth anniversary of the congressional decision to require the National Endowment for the Arts to consider "general standards of decency and respect," the National Coalition Against Censorship and the Vera List Center for Art and Politics collaborate on two panel discussions evaluating censorship and the present state of arts funding. The debate is reignited in December when David Wojnarowicz's *A Fire in My Belly* (1987) is censored from an exhibition on gay portraiture at the Smithsonian's National Portrait Gallery on World AIDS Day.

The Guggenheim Museum presents "Tino Sehgal" as part of its fiftieth-anniversary celebrations. Sehgal's *mise-en-scène* conversations and choreography occupy the entire Frank Lloyd Wright rotunda, which is cleared of art for the first time in its history.

The reality series "Work of Art: The Next Great Artist" presents up-and-coming artists competing for a solo exhibition at the Brooklyn Museum and a cash prize of $100,000. The winner is Abdi Farah.

A branch of the Centre Pompidou opens in Metz, France, designed by Shigeru Ban and Jean de Gastines.

The Guggenheim Museum presents "YouTube Play: A Biennial of Creative Video" at museums in New York, Bilbao, Berlin, and Venice.

THE ARTIST PHARMACY

PROPO SEX — THE ENERGY DRINK YOU NEED TO WRITE GRANT PROPOSALS!

DERIVATIX TABLETS — GET RID OF THAT ANNOYING INFLUENCE OF BETTER ARTISTS!

TUYMANS

FAMOSOL — ERASE YOUR URGE FOR BEING FAMOUS ONCE AND FOR ALL!

ART APPLICATIONS

VIAGRART

LOSING YOUR CREATIVE FERTILITY?

SELECTED BIBLIOGRAPHY AND RESOURCES

COMPILED BY MÓNICA ESPINEL

BOOKS

Basa, Lynn. *The Artist's Guide to Public Art: How to Find and Win Commissions*. New York: Allworth Press, 2008.

Battenfield, Jackie. *The Artist's Guide: How to Make a Living Doing What You Love*. Cambridge, Mass.: Da Capo Press, 2009.

Becker, Howard. *Art Worlds*. Berkeley: University of California Press, 1984.

Bhandari, Heather Darcy, and Jonathan Melber. *ART/WORK: Everything You Need to Know (and Do) as You Pursue Your Career*. New York: Free Press, 2009.

Bickers, Patricia, and Andrew Wilson, eds. *Talking Art: Interviews with Artists Since 1976*. London: Art Monthly, Ridinghouse, 2007.

Cabanne, Pierre. *Dialogues with Marcel Duchamp*. New York: Viking Press, 1971.

Cage, John. *Silence: Lectures and Writings*. Middletown, Conn.: Wesleyan University Press, 1961.

Crawford, Tad, and Susan Mellon. *The Artist-Gallery Partnership: A Practical Guide to Consigning Art*. New York: Allworth Press, 2008.

De Coppet, Laura, and Alan Jones. *The Art Dealers: The Powers Behind the Scene Tell How the Art World Really Works, Revised and Expanded Edition*. New York: Cooper Square Press, 2002.

Helguera, Pablo. *The Pablo Helguera Manual of Style*. New York: Jorge Pinto Books, 2007.

Hickey, Dave. *Air Guitar: Essays on Art & Democracy*. Los Angeles: Art Issues Press; New York: Distributed by D.A.P., 1997.

Kaprow, Allan. *Essays on the Blurring of Art and Life*. Berkeley: University of California Press, 1993.

Lindemann, Adam. *Collecting Contemporary Art*. Los Angeles: Taschen, 2006.

Motherwell, Robert. *The Collected Writings*. New York: Oxford University Press, 1992.

Nesbett, Peter, et al., eds. *Letters to a Young Artist*. New York: Darte Publishing, L.L.C., 2006.

Pissarro, Joachim. *Cézanne/Pissarro, Johns/Rauschenberg: Comparative Studies on Intersubjectivity in Modern Art*. New York: Cambridge University Press, 2006.

Rainer, Yvonne. *Feelings Are Facts: A Life*. Cambridge, Mass.: MIT Press, 2006.

Rubinstein, Raphael. *Critical Mess: Art Critics on the State of Their Practice*. Lenox, Mass.: Hard Press Editions, 2006.

Thompson, Don. *The $12 Million Stuffed Shark: The Curious Economics of Contemporary Art*. New York: Palgrave Macmillan, 2008.

Thornton, Sarah. *Seven Days in the Art World*. New York: W. W. Norton, 2009.

Weschler, Lawrence. *Seeing Is Forgetting the Name of the Thing One Sees: Over Thirty Years of Conversations with Robert Irwin*. Berkeley: University of California Press, 2008.

Winkleman, Edward. *How to Start and Run a Commercial Art Gallery*. New York: Allworth Press, 2009.

MAGAZINES AND OTHER PERIODICALS

8 Magazine
Published biannually, it shines a spotlight on the issues that shape our world through the lens of photojournalism and documentary photography.

A PRIOR
A magazine about contemporary art that seeks to present close collaborations between artists and authors, to create unique moments and documents, to bring forward the depth and breadth of artistic practice.

Aesthetica
U.K. culture and arts magazine that covers literature, visual arts, music, film, and theater.

Aperture
Fine-art photography magazine featuring the work of the most important photographers as well as articles by art scholars, critics, and writers.

Archistorm
A bimonthly journal in French devoted to architecture, design, and contemporary art with content consisting of surveys, reports, interviews, reviews, and columns.

Art & Auction
A magazine focused on the international art markets, from antiques to contemporary art, including analyses of market trends, auction reviews, and art fair coverage.

Art Absolument
A bimonthly magazine in French that addresses both the "aesthetic shock" felt for the artistic heritage of civilizations, the links between past and contemporary art, and the plurality of French artists or artists living in France.

Art Asia Pacific

A bimonthly magazine that reports on the powerful creative forces shaping the surge in artistic energy in Asia, the Pacific, and the Middle East, offering the latest in contemporary visual culture.

ART DAS KUNSTMAGAZIN

A German magazine specializing in art, architecture, design, and the art market.

Art in America

An illustrated monthly magazine concentrating on the contemporary art world, including extensive coverage and criticism of sculpture, painting, and photography, profiles of artists and genres, updates about art movements, show reviews, and event schedules.

Art News

A monthly magazine that reports on the art, personalities, issues, trends, and events shaping the international art world, including coverage of Old Masters, modern art, and contemporary art.

Art Newspaper

Publishes news affecting the visual arts and culture worldwide. Part of a network with correspondents in more than thirty countries.

Art Nexus

A bimonthly magazine about Latin American art that offers reviews, interviews, articles, and events listings.

Art Papers

Selected articles from magazines focusing on contemporary art as a socially engaged discourse.

Arte al Dia

A bilingual (English/Spanish) bimonthly magazine that focuses on contemporary Latin American art through in-depth profiles of artists, collectors, and dealers and reviews of museum and gallery exhibitions worldwide.

Artforum

Offers news and critiques of exhibitions in the visual arts, as well as critics' picks, interviews, archives, and an events calendar.

Blind Spot

A semi-annual art journal that publishes unseen work by living photographers, unaccompanied by introductory, biographical, or explanatory text.

Bomb

A quarterly magazine that features interviews among artists, writers, musicians, directors, and actors.

British Journal of Photography
Established in 1854, the world's longest-running photography magazine.
 Published monthly, it includes in-depth articles, profiles of emerging and
 established talent, a portfolio section, business analysis, and detailed tech-
 nology reviews.

Cabinet
A quarterly magazine about art and culture divided into three sections: recurring
 columns such as "Colors," "Leftovers," and "Inventory"; miscellaneous
 essays, interviews, and artist projects; and a third section featuring essays,
 interviews, and artist projects related to a specific theme.

Celeste Magazine
A magazine about contemporary art and culture in Mexico and abroad.

Eyemazing
A high-quality, large-format portfolio-style magazine published quarterly, dedi-
 cated to international contemporary photography featuring cutting-edge,
 autonomous conceptual and artistic work.

Flash Art
A bimonthly magazine about international contemporary art, focusing on artists
 and up-to-date trends.

Foam Magazine
An international photography magazine published quarterly that embraces every
 aspect of photography, featuring documentary, fashion, contemporary,
 historical, world-famous, and emerging photographers.

Frieze
European contemporary art and culture magazine that includes essays, reviews,
 and columns and presents an art fair in London that features more than 150
 contemporary art galleries.

Frog
An international contemporary art and architecture magazine published twice a
 year.

Juxtapoz
A monthly magazine focusing on contemporary and underground art.

L Magazine
Offers up-to-the minute reviews, commentary, and listings for local events and
 arts and culture in New York City.

Modern Painters
A magazine with an international scope focusing on the analysis of contemporary
 art and culture, including painting, sculpture, photography, film, architecture,
 design, and performance.

The New York Times
Daily newspaper with extended coverage on Fridays of news and reviews on art
and design, paintings, photography, and antiques.

The New Yorker
Magazine featuring in-depth reporting on politics and culture, fiction and poetry,
art, book and film reviews, cartoons, and more.

New York
Magazine featuring coverage of New York's politics, culture, restaurants,
shopping, and fashion.

Nueva Luz
A unique tri-annual photographic journal, featuring work by contemporary fine-
art and documentary photographers of African, Asian, Latino, and Native
American heritage.

October
A quarterly journal that focuses on the contemporary arts and their various
contexts of interpretation, presenting critical texts by and about today's
artistic, intellectual, and critical vanguard.

Parkett
Published twice per year in English and German, a direct collaboration with
important international artists whose oeuvres are explored in essays by
leading writers and critics.

Pin-Up
A magazine that is a nimble mix of genres and themes that focuses on architecture
and that fascinating area where architecture and design connect with contem-
porary art.

Purple
A doggedly provocative biannual chronicle of the avant-garde in fashion, art,
and culture, published in France.

Snapped
A quarterly magazine showcasing thoughtfully selected photography from the
African continent by leading and emerging photographers, featuring a themed
portfolio, current photo essays by outstanding photojournalists, and in-depth
interviews with photographers.

Spike
A bilingual (German/English) quarterly magazine about contemporary art and
culture.

Third Text
An international bimonthly scholarly journal dedicated to providing critical
perspectives on art and visual culture.

Wallpaper
A monthly magazine focusing on art, travel, design, fashion, and media.

Yareah
A bilingual (English/Spanish) cultural magazine that focuses on art, literature, poetry, and Madrid's cultural output.

Zing
A magazine that commingles and cross-references arenas, born out of the curatorial collaborative spirit and comprising rotating projects that create a context for each issue, combining architecture, design, fiction, poetry, drawing, photography, music, and fashion.

WEB SITES AND BLOGS
Art Fag City
A blog by Paddy Johnson about New York art news, reviews, and commentary on culture.

Artdaily
The first (established in 1996) art newspaper on the Web, providing information on artists, galleries, museums, and more.

ARTINFO
Online access to the world of art and culture, including breaking news, profiles of top and emerging artists, stories about collectors and collecting, gallery round-ups, market trends and analysis, and detailed coverage of art fairs.

Artlog
Real-time access to art events, fine-art data, and artworks for sale from around the world.

Artnet
Insider's guide to the art market with daily news, reviews and features, and the Price Database, an archive of fine-art auction results worldwide.

Artworld Salon
A moderated discussion focused on the fast-paced transformations currently taking place in the global art world.

Arts Journal
Daily arts news from more than 200 newspapers, magazines, and e-publications.

Circa
An online journal dedicated to contemporary art and its practices, criticism, and criticality in Ireland and beyond.

Culture Pundits
A carefully curated network of today's leading cultural Web sites and blogs that incorporates a group of the most reputable, top-trafficked sites covering visual art, literature, architecture, film, and design.

Culturekiosque
European arts and culture magazine and travel guide, with news, reviews, interviews, and travel event calendar.

Culturevulture
Reviews and commentary on art, architecture, books, dance, movies, opera, and theater.

DKS
The latest bits and insider tips on the New York art world, including gallery openings, events, lectures, and parties.

Edward Winkleman
A blog about art, politics, gossip, and tough love providing insider tips from a dealer about the business of having and running a gallery in Chelsea.

Exquisite Corpse
Art and culture journal featuring poetry, short stories, essays, gallery, and more.

Foto8
E-zine of photojournalism featuring stories by freelancers and agency photographers covering topical issues worldwide.

Huffington Post Arts
A blog that covers all things arts- and culture-related, including up-to-the minute news and commentary from artists and opinion makers.

Hyperallergic
A forum for serious, playful, and radical thinking about art in the world today.

Identity Theory
Online magazine of literature, music, film, social justice, and art.

Lens Culture
An online magazine celebrating international contemporary photography, art, media, and world cultures.

Naked Punch Review
Engaged review of contemporary art and thought, a collaboration of thinkers and artists residing in different cities of the world.

Nat Creole
Online magazine offering an entertaining perspective on the literature, politics, art, and music of contemporary global culture.

The New York Times Arts Beat
A blog that explores the world of culture and the arts, including art, television, books, movies, music, and more.

Other Voices
E-journal of cultural criticism that publishes essays, interviews, translations, and reviews on the arts and humanities.

Scene 360

Online film and arts magazine that profiles and interviews artists, Web designers, filmmakers, and poets with a focus on their careers and analysis of the driving forces behind their work.

Zone Zero

Online photography magazine with articles, portfolios, and a forum that offers a platform for a community interested in viewing, thinking about, creating, sharing, and discussing images.

FUNDING OPPORTUNITIES

NEW YORK AND TRISTATE AREA

Art in General

Assists emerging artists in the production and presentation of new work, through the Open Call for New Commissions.

Cintas Foundation

Awards fellowships annually to creative artists of Cuban lineage who live outside of Cuba.

Creative Capital Foundation

A catalyst and funder for the development of adventurous, interdisciplinary, and imaginative ideas by supporting artists who pursue innovation in the performing and visual arts, in film and video, and in emerging fields.

Elizabeth Foundation for the Arts

Provides international grantmaking and operating programs to help visual artists develop their careers and achieve financial self-sufficiency.

Franklin Furnace Fund

Awards grants of between $2,000 and $5,000 to performance artists, allowing them to produce major works anywhere in the state of New York. International artists are also invited to apply.

Jerome Foundation

Supports the creation and production of new artistic works by emerging artists and contributes to the professional advancement of those artists. Open to residents of Minnesota and New York City. Individual grants are available in media arts and for travel or study.

The Manhattan Community Arts Fund (MCAF)

Operated by the Lower Manhattan Cultural Council (LMCC), supports local arts organizations and artists that have little access to government funding sources. MCAF provides small grants for arts projects serving Manhattan communities.

New York Foundation for the Arts

Awards Artists' Fellowships that are $7,000 cash awards made to individual artists living and working in the state of New York for unrestricted use. NYFA

also launched Strategic Opportunity Stipends (SOS), a project in collaboration with arts councils and cultural organizations across New York state, designed to help individual artists. SOS is available to New York state artists only.

NATIONAL

Aaron Siskind Foundation
Offers a limited number of fellowship grants of up to $7,000 each for individual artists working in still photography and photo-based art.

Art Matters
A foundation created to assist artists who make work that breaks new ground aesthetically and socially. In 2011, Art Matters is considering applications by invitation only and will award grants of $3,000 to $10,000 to artists focusing on communication and collaboration across borders.

Artadia
Encourages innovative artistic practice and meaningful dialogue by providing artists in specific communities with unrestricted awards and a national network of support, as well as unrestricted awards from $1,500 to $15,000. Open to artists who live in San Francisco, Chicago, Houston, Boston, and Atlanta.

Artists' Assets
A resource guide for artists in Washington state, including information about funding opportunities.

Arts Council Silicon Valley
Offers six $4,000 grants per year to professional working artists living in Silicon Valley to enable them to continue to pursue their creative work.

Astraea Foundation
Offers three annual Visual Arts Fund awards to promote the work of contemporary lesbian visual artists who show artistic merit and share Astraea's commitment to LGBTI visibility and social justice.

Boris Lurie Art Foundation
Provides grants of up to $25,000 to unrecognized, innovative artists in all media whose work broadly embraces the spirit of the NO! ART movement represented by the life and work of Founder Boris Lurie.

Center for Cultural Innovation
Provides grants and loan information and promotes knowledge, sharing, networking, and financial independence for individual artists and creative entrepreneurs in California.

College Art Association
The CAA's Professional Development Fellowship Program offers five Fellowships in the Visual Arts of $5,000 each to outstanding students who will receive their MFA degrees in the following calendar year.

Cultural Arts Council of Houston and Harris County
Offers fellowships of $2,500 and $5,000 for artists who have resided in Houston
 for two full years prior to the application deadline.

Fulbright Program
The U.S. Fulbright Student Program is designed to give recent B.S./B.A. grad-
 uates, masters and doctoral candidates, and young professionals and artists
 international opportunities for personal development.

Gottlieb Foundation
Established by Adolph Gottlieb to award financial assistance to painters,
 sculptors, and printmakers who have shown a lifetime commitment to their
 art.

Hispanic Scholarship Fund
The Hispanic Scholarship Fund/McNamara Family Creative Arts Project Grant
 provides financial resources of up to $15,000 to outstanding Latino under-
 graduate and graduate students enrolled in a creative arts–related field: media,
 film, performing arts, communications, writing.

LEF
A private foundation in New England that supports the creation and presentation
 of contemporary work in the fields of visual art, performing art, new media,
 literary art, architecture, and design.

Pollock-Krasner Foundation
Offers financial assistance through grants to individual working artists of estab-
 lished ability through the generosity of the late Lee Krasner.

Puffin Foundation
Offers grants from $1,000 to $2,500 for emerging artists whose works might
 have difficulty being aired because of their genre and/or social philosophy.
 Open to permanent residents and citizens of the United States.

Turbulence Commissions
Awards twelve grants from $2500 to $5000 annually to emerging and established
 artists whose work creatively explores the Internet as a site of production and
 transmission.

INTERNATIONAL
Alliance Française
Supports French culture and the French language. The fellowship programs are
 for French artists only.

American-Scandinavian Foundation
Promotes international understanding through educational and cultural
 exchange between the United States and Scandinavian countries. The ASF
 awards more than $500,000 in fellowships and grants annually for projects
 abroad.

Art Moves Africa (AMA)

An international nonprofit organization that facilitates travel for cultural and
artistic exchanges within the African continent. AMA offers travel funds to
artists, arts professionals, curators, and critics living and working in Africa.

Arts Collaboratory

Supports visual artist–run initiatives in Africa, Asia, and Latin America, as well
as exchanges between artists from these regions and visual arts organizations
in the Netherlands. Any artist-run initiative can apply for funding and artistic
exchange.

Arts Council England

Offers grants for individuals, arts organizations, national touring exhibitions,
and others who use the arts in their work. The Council supports activities that
benefit Britons or that help artists and arts organizations from England.

Asian Cultural Council

Supports cultural exchange between Asia and the United States in the performing
and visual arts by providing individual fellowship grants to artists, scholars,
and students. Some grants are for Americans wishing to study in the People's
Republic of China, Japan, or Taiwan.

Canada Council for the Arts

Fosters and promotes the study, enjoyment, and production of works in the arts.
It provides grants and application information to professional Canadian
artists.

Center for Icelandic Art (CIA)

Supports Icelandic visual artists in working or presenting their art abroad. CIA
provides awards that support travel and/or residencies abroad, the devel-
opment of single projects or publications, and exhibitions presented abroad.

ECF/Step Beyond

The European Cultural Foundation offers Step Beyond, a mobility grant for
artists to intensify the exchange between western and central/eastern Europe.
STEP beyond can be applied for throughout the year.

Elizabeth Greenshields Foundation

The Elizabeth Greenshields Foundation promotes an appreciation of the repre-
sentational style in painting, drawing, sculpture, and the graphic arts by aiding
worthy emerging artists or sculptors who need assistance during their
formative years.

Frame—Finland

The Finnish Art Academy Foundation/FRAME Finnish Fund for Art Exchange
awards grants for the exhibition of contemporary fine art abroad.

Harriet Hale Woolley Scholarships at the Fondation des Etats-Unis
The Fondation des Etats-Unis annually awards up to four Harriet Hale Woolley
 Scholarships to American visual artists and musicians for study at the
 graduate level for one academic year in Paris.

Henry Moore Foundation
Supports a wide range of projects in the visual arts through its grants program to
 artists, supported by host institutions, for fellowships or residencies of
 between two and six months. Also provides support for exhibitions, exhi-
 bition catalogues, and commissions.

International Visegrad Fund
The International Visegrad Fund accepts applications for support from artists in
 Hungary, Poland, the Czech Republic, and Slovakia to apply for several
 grants.

Japan Foundation
Provides artists the opportunity to pursue creative projects in Japan for two to
 six months.

Roberto Cimetta Fund
Focuses on cultural operators and artists in the Mediterranean. The fund offers
 individual travel grants to attend workshops, artist's residences, symposiums,
 and the like.

Scottish Arts Council
Offers grants, awards, and bursaries to support individual artists in the research,
 development, training, production, and presentation of work.

Sovereign Art Foundation
Encourages understanding and appreciation of the diversity of Asian arts and
 gives financial support to emerging Asian artists.

Stiftungsindex—Germany
This organization's Web site contains more than 260 links and offers an extensive
 navigational aid to home pages of German foundations.
 www.stiftungsindex.de

GENERAL SOURCES AND GUIDES TO FUNDING
Art Opportunities Monthly
A monthly electronic newsletter listing opportunities for artists, including grants,
 shows, public art commissions, residencies, and more.

ArtDeadline
A listing of opportunities for artists, including grants, artist-in-residence
 programs, juried exhibits, and more. Available by subscription.

Cultural Funding: Federal Opportunities
Sponsored by the National Endowment for the Arts. Includes government-
 sponsored funding programs for artists and arts organizations.

Foundation Center
Offers an extensive searchable database with a directory of private philanthropic
 and grantmaking foundations on the Internet. With headquarters in New
 York, it is one of five library/learning centers operated by the Foundation
 Center.

Fundtracer
Provides information on public funds, foundations, corporate giving programs,
 and other European Union programs. The Web site covers Austria, Germany,
 Greece, and Italy. www.fundtracer.org

Kickstarter
A funding platform for artists, scientists, and entrepreneurs. Artists can post a
 description of projects they want funded, how much money they need, and a
 deadline. If enough people pledge the needed money, everyone is billed. For
 funding goals that aren't reached, no one is charged.

Mira's List
A free blog for visual artists, performing artists, and writers, with up-to-date
 information, resources, and deadlines for grants, fellowships, and interna-
 tional residencies.

NYFA Source
An extensive database for visual and performing artists, writers, and arts service
 organizations. Includes a wide range of information on grant opportunities,
 open calls, auditions, and residencies.

Resource Handbook for Minnesota Artists
An online listing of resources for Minnesota artists, including grants and other
 funding.

Rhizome
Frequently updated list of art opportunities for artistic practices that engage
 technology.

BOOKS
Edelson, Phyllis. *Foundation Grants to Individuals*. New York: The Foundation
 Center, 2007. Contains hundreds of entries; lists fellowships, residencies,
 scholarships, and other awards to individuals from private foundations.
Geever, Jane. *The Foundation Center's Guide to Proposal Writing*. New York:
 The Foundation Center, 1993. A guide to writing and submitting grant
 proposals, designed to help both novice and experienced grant seekers under-
 stand the world of foundations and corporate grant makers and identify
 appropriate funding sources.

Grant, Daniel. *The Business of Being an Artist*. New York: Allworth Press, 2000. Chapter 12 details the entire grant process from the artist's perspective.

Lazzari, Margaret R. *The Practical Handbook for the Emerging Artist*. Belmont, Calif.: Wadsworth, 2002. Chapter 13 describes the grant application process and other funding opportunities.

Liberatori, Ellen. *Guide to Getting Arts Grants*. New York: Allworth Press, 2006. Provides artists with information on facts and skills needed for grants applications in the arts, including formulating budgets, online resources and application opportunities, insights into understanding the selection and review process, and more.

Michels, Caroll. *How to Survive and Prosper as an Artist*. New York: Henry Holt & Company, 2009. See the chapter "The Mysterious World of Grants: Fact and Fiction."

Rosenberg, Gigi. *The Artist's Guide to Grant Writing: How to Find Funds and Write Foolproof Proposals for the Visual, Literary, and Performing Artist*. New York: Watson-Guptill Publications, 2010. Targeted at both professional and aspiring artists and writers who are looking for concrete information about how to write artist statements and grant applications that persuade grant funders to provide them with the money they need to realize their projects.

Vitali, Julius. *The Fine Artist's Guide to Marketing and Self-Promotion*. New York: Allworth Press, 2003. Includes information on how to find corporate support, grants, and other funding. Chapter 8 introduces the world of individual and special project grants for artists.

RESIDENCY PROGRAMS

NEW YORK AND TRISTATE AREA

Art Omi

Art Omi's Annual International Visual Artists Residency is a three-week residency program in July located in upstate New York. Artists are provided with a studio, living quarters, and meals; they are responsible for their travel and art materials. Participants benefit from the advice and criticism of noted art critics, gallery owners, and prominent artists invited to visit.

Center for Book Arts

The Center's Artist-in-Residence program supports the production of new work and provides artists with individual studio space, a materials budget, a cash stipend, an exhibition, and twenty-four-hour access to equipment and facilities.

LMCC

The Lower Manhattan Cultural Council offers artists two programs: The Workspace Residency is a studio residency program for emerging visual artists and writers in two lower Manhattan locations. The Paris residency is a six-month live/work residency in Paris for New York City–based visual artists.

Lower East Side Printshop

The Printshop's workspace residency program offer artists studio space and time to work, stipends, technical assistance, career development, and public exposure.

The Marie Walsh Sharpe Art Foundation

The Space Program, offered by the Marie Walsh Sharpe Art Foundation, located in Brooklyn, provides studios that are nonliving spaces for the making of new works of art.

Millay Colony for the Arts

The Millay Colony offers one-month residencies to visual artists, composers, and writers between the months of April and November. Resident artists get private rooms, studios, and all meals during their stay at the pastoral campus in upstate New York. The property is the former residence of the poet Edna St. Vincent Millay.

Third Ward

The Open Call series by Third Ward offers the chance at a three-month New York City residency, a $5,000 cash grant, and access to the resources to help artists create a body of work that is larger than the city itself.

Yaddo

Yaddo offers residencies to professional painters, composers, and writers. It is an artists' community located on a 400-acre estate in Saratoga Springs, New York. Residencies vary in length: The average stay is five weeks, and there is a minimum stay of two weeks and a maximum of eight weeks.

NATIONAL

Art and Community Landscapes Program

The Art and Community Landscapes Program, operated by the New England Foundation for the Arts, awards grants to artists and hosts artists residencies.

Artists in Residence in Everglades (AIRIE)

AIRIE offers artists the opportunity to live and work in a unique environment for up to one month. The works completed under the program contribute to the public understanding and appreciation of Everglades National Park. The program is open to writers and visual artists who wish to work alone and unfettered.

Espy Foundation Residency Program

The Espy Foundation Residency Program offers month-long residencies, including food stipends, for emerging and established writers and visual artists. The goal is to provide international writers and artists with an environment in which they can pursue their work without interruption. Residents live in bayview cottages in the village of Oysterville, a National Historic District located on the southwest coast of Washington state.

J. B. Blunk Residency

The J. B. Blunk Residency supports emerging and established artists committed
to living in harmony with nature. Set in the midst of the Bishop Pine Nature
Preserve in Inverness, California, the residency offers a home, studio, and
outdoor clearings for work in the home and studio built by J. B. Blunk in
1959.

National Park Service

The NPS offers artist-in-residence opportunities to visual and performing artists
and writers in twenty-nine parks throughout the United States.

Santa Fe Art Institute Residency Program

The Santa Fe Art Institute Residency Program has a bi-annual competitive
selection process for artist and writer residencies that focuses on the profes-
sional experience of the artist and their potential to have a productive resi-
dency at SFAI.

Skowhegan

Skowhegan offers an intensive nine-week summer residency program in Maine
for emerging visual artists that seeks to bring together a diverse group of indi-
viduals who have demonstrated a commitment to art-making to create the
most stimulating environment possible for a period of artistic creation, inter-
action, and growth.

INTERNATIONAL

Arab Fund for Arts & Culture—Jordan

The Arab Fund is a private Arab initiative dedicated to empowering the Arab
contemporary narrative through strategic cultural philanthropy. It seeks to
deliver a sustainable funding mechanism for individuals in the arts while facili-
tating cultural exchanges across the Arab region.

Asialink—Australia

Each year the Asialink Residency program sends forty Australian writers,
performers, and artists to live and work throughout Asia. Grants of up to
$12,000 go toward travel, living, and project expenses and afford recipients
the opportunity for in-depth research and international collaboration.

Balkankult—Serbia

Balkankult's creative center, located in the National Park of Fruska Gora in
Serbia, supports the mobility of artists and ideas to build bridges between
cultures.

Banff Centre—Canada

Creative residencies in the Visual Arts department provide the luxury of time and
space for the artist to create new works, research innovative ideas, and exper-
iment with different techniques and modes of production. Located in Banff
National Park, the facilities accommodate printmakers, painters, ceramists,
photographers, and sculptors.

Caravansarai—Turkey
An independent art production space and meeting point for creators in Istanbul, Turkey, Caravansarai offers a seasonal live/work program open to artists, creators, and researchers.

CEC ArtsLink—International
An international arts service organization, the CEC ArtsLink programs encourage and support exchange of artists and cultural managers between the United States and eastern and central Europe, Russia, central Asia, and the Caucasus. A variety of grants and residence opportunities are available.

Fondation des Etats-Unis—France
The Harriet Hale Woolley Scholarship is a grant awarded annually to up to four graduate and postgraduate American students in the visual fine arts and music. Successful candidates propose a unique and detailed project related to their study that requires a one-year residency in Paris.

Lugar a Dudas—Colombia
Lugar a Dudas (Room for doubts) is an independent nonprofit space located in Cali. Its purpose is to promote and disseminate contemporary artistic practices, research, reflection, and criticism through programs, events, exhibitions, work-shops, and an artist residency.

Nordic Artists' Centre—Norway
Nordic Artists' Centre provides artists an opportunity to live and work in a community of artists with full accommodation included. The residency award also includes a monthly stipend and travel allowance.

Polish Cultural Institute—Poland
The PCI is a recently established diplomatic mission of the Ministry of Foreign Affairs of the Republic of Poland to the United States. It offers an American/Polish residency exchange program, an initiative that seeks to secure a variety of forms of mutual cooperation in the arts between both countries.

Pro Helvetia—South Africa/Switzerland
Pro Helvetia Cape Town fosters cultural interaction between the whole of southern Africa and Switzerland and supports local capacity building. Pro Helvetia invites practitioners in the visual arts to apply for residency exchanges in Switzerland and the southern African region. Studio and research residencies are available.

Sharjah Art Foundation Residencies—United Arab Emirates
This program offers visiting artists and art practitioners a dedicated outpost in Sharjah, not only as a place of rest, reflection, and exploration but also as a unique point of departure for those who are reassessing their relationship with the Emirates and the region at large.

Triangle Arts—International
Triangle Arts is an international network of arts organizations that promotes
 dialogue, exchange of ideas, and innovation within contemporary art.
 Through listings of residencies and outreach events, it generates peer-to-peer
 learning, professional development for artists, and the dissemination of inter-
 national art practices. It has more than thirty active partners, particularly in
 countries with limited arts infrastructure, including Bangladesh, Colombia,
 India, Jordan, Kenya, Pakistan, the People's Republic of China, South Africa,
 and the United Kingdom.

U.S/Japan Creative Artists' Program—Japan
This program provides support for up to five outstanding artists from the United
 States to spend a three-month residency in Japan to pursue their individual
 artistic goals. Artists must present compelling reasons for wanting to work in
 Japan.

GENERAL SOURCES ABOUT RESIDENCY PROGRAMS
Alliance of Artists' Communities
The Alliance of Artists' Communities supports the field of artists' communities
 and residency programs. Its Web site provides a searchable directory of North
 American residency opportunities and links to numerous art colonies.

Res Artis
Res Artis is a searchable directory of worldwide artist residency opportunities,
 dedicated to offering artists a time and place away from their everyday life,
 an experience framed within a unique geographic and cultural context.

Residency Unlimited
Residency Unlimited is a nonprofit organization whose mission is to support
 artists and curators in residence and facilitate international mobility opportu-
 nities by drawing from a broad network of local, national, and international
 resources. It delivers up-to-date information including open calls and
 fellowship opportunities.

Trans Artists
Trans Artists is a foundation based in the Netherlands that provides artists with
 information about international artist-in-residence programs and other
 opportunities. Its online database offers information on more than 1,000
 international residency programs, searchable by region, dates, or medium.

BOOKS
MacNeil, Robert. *Artists Communities*. New York: Allworth Press, 2005. A
 complete guide to residency opportunities in the United States for visual and
 performing artists and writers.
Middleton, Robyn, et al. *Artists and Writers Colonies: Retreats, Residencies and
 Respites for the Creative Mind*. Hillsboro, Ore.: Blue Heron Publishing, 2000.
 Describes 260 residencies, retreats, and fellowships in the United States and
 overseas.

*"Remember how we used to ignore you
before you became a successful artist?"*

ARTIST IN THE MARKETPLACE ALUMNI LIST

1983
Victor Amador
Tom Brennan
Virginia Buchan
Lie-Sanne Doo
Eva Goetz
George Hatjygeorge
Praxitelis Hatjygeorge
Makabit Kahana
Douglas Kay
Frank Lombardi
Leslie Lowinger
William Morgan
Ray Nunez
Wanda Quinones
Linda Shedlock
Rose Tevernia
Nina Talbot
Rosalind Simi Thompson

1984
Dareen Agard
Imna Arroyo
Conrad Barclay
Stephanie Chanel
Ruffin A. Cheyney
Nadine Delawrence-Maine
Michele Godwin
Ellen Hoffman
Judith Huf
Iona Kleinhaut
Lanie Lee
Glenn Ligon
Whitfield Lovell
Jonathan Rosen
Eva Stettner

Christine Wade
Hanna Zawa

1985
Kathleen Anderson
Tomie Arai
Emily Berger
Paul Cappelli
Elizabeth Connor
James Cuebas
Stephanie Douglas
Michael Filan
Ellen Gamble
Irene Kelly
Ira Merritt
Diego Quintero
Roaslyn Hawthorne Rego
Cari Rosmarin
Vincent Salas
Eve Sandler
Mei Tei Sing Smith

1986
Luis Alonso
Polly Apfelbaum
Agnes L. Carbrey
Alberto de Braud
Skowmon Hastanan
Carmen Lazo
Chris Lin
Susanne Mueller
Laurie Ourlicht
Euripedes Rodriguez
Gail Rothschild
Emilia Sunyer
Fumio Takasugi
Rafael Urbinas
Mary Jo Vath

A. J. Wagenhals
Ricardo Estanislao
Zulueta

1987
Mo Bahc
Millie Burns
Larry Carroll
Mary Colby
Susan Ebersole
Heidi Feiwell
Lorraine Fiddle
John K. Flynn
Erik Furuboth
Kenneth Garrett
Anne Gilman
Janet Goldner
Tony Gray
Paula Hacker
Joel Holub
Elissa Tatigikis Iberti
Candy Jernigan
Art Jones
Brian Killigrew
Jovalin Lekay
Jody Leopold
Amy Lowry
Cedric Lucas
Philomena Marano
Efrain Martinez
Julio Mateo
Claudia Matzko
Kathleen McCarthy
Robert Montoya
Orlando Rodriguez
Justo Roman
Jewel P. Ross
Heidi Schlatter

Daniel B. Tisdale
Louise Weinberg
Gloria E. Williams

1988
James Reuben Acevedo
Susan Amoy
Leslie Brenner
Chiong Yiao Chen
Thomas Colbath
George Crespo
Georgia Meriwether Diehl
Nancy Diessner
Anne Finkelstein
Cynthia Fusillo
Selwyn Garraway
T. Ghirata
Paul Greco
Sarah Haviland
Rolando Herrera
Stephanie Hightower
Jareth Holub
Prudencio Irazabel
David Kezur
Mikyung Kim
Kyung-Lim Lee
Pamela Lins
Jeanette Louie
Manuel Macarrulla
Nanette Macias
Fabian Marcaccio
Mark Mastroianni
Lori Riela
Charles Riley
Margarite Rose
Radian Sumler
Mary Ting
Peter Tobey
Josette Urso
Francisco Vidal
Philemona Williamson

1989
Lynda Bailey
Diogenes Ballester
Luis A. Barato
James M. Barry
Lizzie Berdann
Robin Christian
Vinod Dave
Catherine T. Diab
Lamerol A. Gatewood

John A. Gills
Sandy Goldberg
Debra Goldman
Paula Hardin
Eileen Hoffman
Gale Kaseguma
Jung Hyang Kim
Kwang-sung Lee
Ronit Leora
Kamin Lertchaiprasert
Carol Lipton
Zdeno Majercak
Donna E. Marshall
James Maszle
Maria Mingalone
Ricardo F. Morin
Kazuko Nagao
Mario Naves
Mari Oshima
Ethan Pettit
Chris Randolph
Edward L. Rollins
Peter Rosenfeld
Eva Schicker
Micky Schon
Lara Smith
Carol A. Totten

1990
Grimanesa Amoros
Andras Borocz
Jean Chiang
Gregory W. Coates
Ada Pilar Cruz
Jim Dahl
Stephane Dumas
Carlos Durazo
Jame Fay
Donna Francis
Charo Garaigorta
Daniel Georges
Ana Golici
Eric Guttelewitz
Andrea Guttman
Maggie Wei Hsu
Ying S. Hung
Jean Patrick Icart-Pierre
Andre Juste
Noga Kalinsky
Byron Kim
Akiko Matsuo
Patrick Moynihan

Rodolfo Nunez
Chigyoun Oh
Beata Pies
Jennifer C. Protas
Don Reid
Mario Rentas
Dorothy Shamonsky
Hong-Juin Shieh
Frances Miller Smith
Yon Verwer
Lynn Wilder
Alexandra Zalce
Karen Zuegner

1991
Manuel Acevedo
Donald Boyle
Lisa Bradley
Deborah Jones Buck
James Buxton Jr.
Tamara Carlisle
Tze-Yan Chiu
Esperanza Cortes
Susana Dent
Margarita Figueredo
Gary Fredriksen
Janet Gillespie
Mizuho Ichioka
Claire Jervert
Katalin Kotvics
Boris Kuo
Adam Licht
Ana Linnemann
Anthony A. Manglicmot
Vicente Martinez
Elahe Massumi
Regina de Paula
Hector Perez Lozano
Joseph Petrovics
Lily Prince
Zuzana Rudavska
Roger Sayre
Tova Snyder
Sara Sosnowy
Elisa de Souza
Tamas Szalczer
Raul Tamariz
Kim Tran
Rumiko Tsuda
Ernesto de la Vega-Pujol
Mie Yim

1992
Jeremy Adams
Douglas Anderson
Christa Blackwood
J. Michael Bramwell
Nicole Carstens
Robert Chi
Antoinette Coniglio
Regina Araujo Corritore
Tatiana Garmendia
David Jing Chu Yu
Jenny Krasner
Estella Lackey
Wendy Letven
Luis Manuel Soto Lopez
Terrance McHugh
Wendy L. Moore
Wendy Morris
Stuart W. Nicholson
Shane Patrick
German Perez
David Rodgers
Eufemio Tadeo Rogriguez
Wayne Roland
Moses Ros
Ondrej Rudavsky
Jinnie Seo
Lisa Titus
Celeste Torrello
Hermes Torres Jr.
Miguel Trelles
Christopher Wynter
Lynne M. Yamamoto
Jane E. Zweibel

1993
Michel Alexis
Rod Appleton
Ihor Barabakh
Bartus
Susan Breitsch
Rodrigo Cardoso
Andrea Davis
Lisa Corinne Davis
Stephen Dean
Allan deSouza
Ann deVere
Nora Fisch
Pio Galbis
Peter Gillespie

Nakyung Han
Marcia Hillis
Hee Sook Kim
Lisa Krivacka
Jennifer Lavin
Kwi Hoon Lee
Natalie Moore
Sheila Marie Packert
Ray Eduardo Robbennolt
Ellen Ross
Mark Rubin
Miguelange Ruiz
Richard Rule
Aleya Saad
Jack Siman
Valeska Soares
Sartoru Takahashi
Elke Ulmer
Tenesh Webber
Joanne Gover Yoshida
Sui Kang Zhao

1994
Jesus Aguilar
Barbara Andrus
Soledad Arias
Masumi A saoka
Mindy Belloff
Alan Buckley
Jeri Coppola
Linda Cummings
Linda Jean Fisher
Alexus Guzman
Toru Hayashi
Stephen James
Duncan Johnson
Mijeong Kim
Jung Hyang Kim
Cathleen Lewis
Hayato Matsushita/
Planetoi
Stephen Moore
Aron Namenwirth
Nurit Newman
Selime Okuyan
Michael Richards
Suzanne Kaoru Saylor
Jennifer Sloan
Antonio Tamayo-Arango
Lynn Tondrick

Julie Trager
Julio Valdez-Gonzalez
Linda Weinraub
Audrey Weinraub
Susumu Yonaguni
Mimi Young
Julie Zemel
Melissa Zexter
Dolores Zorreguieta

1995
Diyan Achjadi
Susan Black
Marco Breuer
Laurie Halsey Brown
Mary DelMonico
Eduardo DiFarnecio
Angie Eng
Mary-Louise Geering
Susan Graham
Monica Guitierrez
Hernandez
Baju Hadi-Wijono
Olga Hubard
Luis De Jesus
Su-Kyung Lee
Rejin Leys
Birgitta Lund
Charles Mahorney
Max-Carlos Martinez
Alison Moritsugu
Jeffrey Norgen
Nana Olivas
Megan Pugh
Steven Rotter
Margot Schmitt
Koji Shimizu
Greg Singer
Lance Singletary
Susannah Strong
Sara Chin-Yu Sun
Thiago Szmrecsanyi
Michael Tamashiro
Steed Taylor
Anton Vidokle
Gong-Xin Wang
Maureen Wong
Hyun-Mi Yoo

1996
Thierry Alet
Cristian Alexa

Rina Banerjee
Heike Bartels
Isabel Bigelow
Peter Bregoli
Binda Colebrook
Vladimir Cybil
Pamela Dewey
Anthony Fodero
Anna B. Jones
Raffy Kazakov
Juri Kim
Cary Kung
Laura Larson
Sarah L. Leahy
Niki Lederer
Catarina Leitao
Linda Liang
Claudia Linares
Robyn Love
Soroya Marcano
Omar Medrano
Reina Nakagawa
Jaime Permuth
Erika Ranee
Nancy Romines
Stephanie Snider
Audrey Stone
Ilene Sunshine
Kristin Tripp
Adrienne E. Urbanski
Ling Wang
Molly White
Roxanne Wolanczyk
Fred Yee

1997
David R. Burke
Robert Caldwell
Laura Carton
Cassia Castro Silva
Seong Chun
Erin Courtney
Gary Cruz
Stephen Earthman
Celeste Fichter
Jeph Gurecka
Peter Hendrick
Marietta Hoferer
Yun-Fei Ji
Roanne Kulakoff

Lisa Levy
Cynthia Lovett
S. Douglas Matlaga
Felicia Megginson
Ingrid Menendez
Shirin Mohtashami
Katherine Mojzsis
Regi Muller
Brian Mukerjee
Satoko Onishi
Karen Ostrom
Catya Plate
Jesus Polanco
Paul Henry Ramirez
Andrea Sanders
Donna Sharrett
Meagan Shein
Sandra Annette Toro
Lane Twitchell
Mark Dean Veca
Deborah Wasserman
Edie Winograde

1998
Elia Alba
Nicole Awai
Amy M. Bay
Hildur Bjarnadottir
Terry E. Boddie
Katharina Bosse
Maggy Buck
Bushra Chaudry
Matthew Deleget
Xiomara De Oliver
Amy Eckert
Daniel Feingold
Nancy Friedemann
Alysha Galvez
Anthony Goicolea
Caroline Hastie
Khiang Han Hei
Colleen Ho
Ana Kariotakis
Eiko Kijima
Susy Kim
Jennifer Krauss
Beth Cora Lipman
Daniel Mirer
Heidi I. Nash-Siedlecki
Stephanie Patton

Melissa Potter
Joan Reidy
Nadine Robinson
Brad Rothrock
Francesco Simeti
Sonita M. Singwi
Stephen Sollins
Joseph Songco
Derek Weiler
Leigh Winter

1999
Valerie Atkisson
Jacqueline Baum
Caroline Birks
Chris Burns
Wendy Chisholm
Amanda Crandall
Geoffrey Detrani
Brian Guidry
Jayne Holsinger
Wennie Huang
Myong Hwa Jeong
Elke Lehmann
Alyson Levy
Joan Linder
Scott Lizama
Kim Mayhorn
Richard McCabe
Tamara Mewis
Thomas E. Moran
Keiko Narahashi
Marcia Neblett
Domingo Nuno
Erik Parker
Abby Pervil
Anthony T. Salazar
Lizzie Scott
Karina Skvirsky
Sookjin Suh
Julianne Swartz
Takashi Usui
Vargas-Suarez Universal
Sara H. Wasilausky
Frank Webster
Cynthia Wiggins
Amy Wilson
Wei-Li Yeh

2000
Taleen Berberian
Tanyth Berkeley

Marcus Bjernerup
Bruce Brosnan
Beth Campbell
Alejandro Cesarco
Kirsten Cole
Lisa Conrad
Pam Cooper
William Crow
Amy Cutler
Reet Das
Stephanie Dinkins
Sara Eichner
Tana Hargest
Patrick Jacobs
Jennifer Klor
Lihua Lei
Pia Lindman
Kristine Marx
Hajoe Moderegger
Angel F. Nevarez
Lori Nix
Alejandro Ortiz Mejia
Mick O'Shea
Jason Paradis
Richard Pasquarelli
Jon D. Rappleye
Carl Scholz
Daniel Seiple
Edwine Seymour
Anton Sinkewich
Tim Thyzel
Judi Werthein
Sara Chi Hang Wong
Mia Wood

2001
Maria Alos
Elka Amorim
Paolo Arao
Sandra Bermudez
Kelley A. Bush
Karlos Carcamo
Byung-Wang Cho
Sung-Hee Choi
Erika deVries
Michael Dickas
Nicolas Dumit Estevez
Rosemarie Fiore
Monika Goetz
Glenn Grafelman

Pablo Helguera
Rebecca Herman
Stephen Hightower
Nancy Hwang
Yoko Inoue
Claudia Joskowicz
Hiroshi Kimura
Noah S. Klersfeld
Franziska Lamprecht
Eva Lee
Laura Lobdell
Tricia McLaughlin
Alejandra Munizaga
Sarah Oppenheimer
Troy Richards
Kent Rogowski
Carol Shadford
Dannielle Tegeder
Scott Teplin
David C. Terry
Bradley Wood
Jennifer Zackin

2002
Gema Alava-Crisostomo
Jonathan Allen
Caroline C. Allison
Kim Baranowski
Erik Benson
Janice Caswell
Saul Chernick
Fritz Chesnut
David Coggins
Fei Cui
James Cullinane
Carl Eckhoff
June T. Gomez
Melissa Gould
Deborah Grant
Adam Henry
Ulrike Heydenreich
Rajkamal Kaur Kahlon
Swati Khurana
Jen Kim
Jeff Konigsberg
Jose Enrique Krapp
Geraldine Lau
Miguel Luciano
Fernando Martin
David Pardoe

Sharon Paz
Nelson Santos
Analia Segal
Houben Tcherkelov
Khanh Vo
Peter Walsh
Micki K. Watanabe
Katarina Wong

2003
Lynda Abraham
Kenseth Armstead
Bibi Calderaro
Jeong Tae Chae
Rutherford Chang
Colleen Coleman
Alison Crocetta
Megan Cump
Issac Diggs
Joe Fig
Chitra Ganesh
Mariam Ghani
Eduardo Gil
Kate Gilmore
Rachel Stein Hulin
Lisa Kereszi
McKendree Ely Key
Johee Kim
Clarence Lin
Rossana Martinez
Jillian McDonald
Diane Meyer
Ricardo Miranda Zuniga
Terry Nauheim
Kristen Nelson
Trong Nguyen
Laura Nova
Anibal Jorge Pella
Hidemi (Sato) Takagi
Claudia Sohrens
Traci Talasco
Mayumi Terada
Christian Tomaszewski
Ginna Triplett
Ofer Wolberger
Antonio Vigil

2004
Eric Azcuy
Gretchen Bennett
A. J. Bocchino

Phillip Buehler
Alfonso Cantu
Amy Chan
Jen DeNike
Steven Fishman
Gina Fuentes Walker
Valerie Hegarty
Heidrun Holzfeind
Carol Irving
Derek Jackson
Vandana Jain
Haegeen Kim
Shin Il Kim
Songyi Kim
Noah Loesberg
Jason Lujan
Miguel Martinez
Liza McConnell
David McQueen
Joel Murphy
Laura Sue Phillips
Nathaniel Quinn
Karla Roberts
Marco Roso
Kris Sabatelli
Naz Shahrokh
Mike Peter Smith
MiYoung Sohn
Trevor Stafford
Pierre St. Jacques
Eduardo Villanes
Phoebe Washburn
Letha Wilson
Michael Yoder

2005
Mai Braun
Brian Caverly
Ofri Cnaani
Ben Colebrook
Ernest Concepcion
Priyanka Dasgupta
Tom Downs
Elaine Gan
J. J. Garfinkel
Beth Gilfilen
David Hardy
Leslie Hewitt
Vlatka Horvat
Olen Hsu

Wade Kavanaugh
Fawad Khan
Shinichiro Kitaura
Tom Kotik
Beth Krebs
Steven Lam
Rena Leinberger
Thessia Machado
Esperanza Mayobre
Yucef Merhi
Ivan Monforte
Stephen Nguyen
Ian Pedigo
Kurt Perschke
Meridith Pingree
Wanda Raimundi-Ortiz
Jaye Rhee
Rachel Schuder
Jennifer Schwarting
Kwabena Slaughter
Heesop Yoon

2006
Danielle Abrams
Tazeen Ahmed
Diana Al-Hadid
Scott Andresen
Theresa Bloise
Mathieu Borysevicz
Michael Paul Britto
Matthew Callinan
Kabir Carter
Michael Cataldi
Eduardo Cervantes
David Antonio Cruz
Pedro Cruz-Castro
Lisa Dahl
Yolanda del Amo
Adam Eckstrom
Mike Estabrook
Peter Gerakaris
Eric Graham
Wayne Hodge
Vibeke Jensen
Katarina Jerinic
Bettina Johae
Gautam Kansara
Jessica Lagunas
Gwenessa Lam
J. C. Lenochan

Steve McClure
Heidi Neilson
Graham Parker
Christopher Patch
Virginia Poundstone
Kristen Schiele
Christina Seely
Sarah Trigg
Alison Ward

2007
Bami Adedoyin
Becca Albee
Fanny Allié
Jesse Alpern
Dorthe Alstrup
Gabriela Alva Cal y
Mayor
Jill Auckenthaler
Gail Biederman
Hector Canonge
Christine Catsifas
Jillian Conrad
Vince Contarino
Jon Cuyson
Caroline Falby
Tracey Goodman
Patrick Grenier
Emily Hall
Joseph Hart
Ketta Ioannidou
Elaine Kaufmann
Jayson Keeling
Taeseong Kim
Joseph Maida
Amanda C. Mathis
Amanda Matles
Megan Michalak
Hiroyuki Nakamura
Alison Owen
Chihcheng Peng
David Politzer
Emily Puthoff
Jenna Ransom
Rashanna Rashied-Walker
Jason Reppert
Joseph Tekippe
Will Walker

2008
Negar Ahkami
Blanka Amezkua

Keliy Anderson-Staley
Daniel Bejar
Charles Beronio
Matthew Burcaw
Si Jae Byun
Brendan Carroll
Vidal Centeno
Margarida Correia
Rä di Martino
Jason Falchook
Michelle Frick
David Gilbert
Kyung Woo Han
Cosme Herrera
Catherine Kunkemueller
Luke Lamborn
Sujin Lee
Bill Lohre
Rebecca Loyche
Giuseppe Luciani
Brian Lund
Colin (Emcee C.M.,
Master of None)
McMullan
Kelli Miller
Laura Napier
Dulce Pinzon
Christy Powers
Risa Puno
Ronny Quevedo
Sa'dia Rehman
John Richey
Irys Schenker
Mark Stafford
Jeanne Verdoux
Angie Waller

2009
Rahul Alexander
Robert Andrew Amesbury
Nathan Bennett
Wesley M. Berg
Jonathan Brand
Adam Brent
Maria Buyondo
Melissa A. Calderón
Asha Canalos
Heejung Cho
Lauren Clay
Stephanie Costello

Eva Davidova
Meredith Drum
Brendan Fernandes
LaToya Ruby Frazier
Clare Grill
Jeffrey Hargrave
Jessie Henson
Joshua Abram Howard
Christine Lebeck
Simone Leigh
Kenneth Madore
Mio Olsson
Wilfredo Ortega
Chloe Paganini
Amy Pryor
Ryan Roa
Lisa Ross
Rosa Ruey
Jahi L. Sabater
Abigail Simon
Travis LeRoy Southworth
Christy Speakman
Emma Wilcox
Saya Woolfalk

2010
Tomer Aluf
Thomas Bangsted
Nina Barnett
John Bent
Lea Bertucci
Laura Braciale
Calvin Burton
John Bent
Priscila De Carvalho
Andrew Chan
Noa Charuvi
Matthew Conradt
Corey D'Augustine
Katherine Daniels
Nicky Enright
Carl James Ferrero
Christine Gedeon
Sarah Granett
Michael Clyde Johnson
Nick Lamia
Jongil Ma
Luis R. Maldonado Jr.
Glendalys Medina
Kenneth Millington

Monica Moran
Julia Oldham
Maia Palileo
Shani Peters
Gabriel J. Shuldiner
Christopher Smith
Benjamin Tiven
Meghan Wilbar
Scott Wolfson
Natalie Collette Wood
Marina Zamalin
Jenny Zhang

2011
Hannah Smith Allen
Joell Baxter
Gabriela Bertiller
James Bills
Chris Bors
Anton Cabaleiro
Brian Scott Campbell
Cecile Chong
Dennis Darkeem
Dennis Delgado
Stella Ebner
Xavier Figueroa
Veronica Frenning
Kira Greene
Debbie Grossman
Nathan Gwynne
Meg Hitchcock
Erik Hougen
Bokyung Jun
Laura Kaufman
Hein Koh
Heidi Lau
Michelle Cheikin
Ed Purver
Gregory Reynolds
Jacob Rhodes
Jennifer Maria Sanchez
Romy Scheroder
Tina Schneider
Viviane Rombaldi Seppey
Hrvoje Slovenc
Jessica Stoller
Jerry Torréns
Randal Wilcox
Karla Wozniak
Sean Wrenn

artfacebook

Status updates

Barry is casually rubbing in your face that he got a famous collector to buy his work.

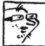

Randy won't talk to you in person at openings but he will be your **FB** friend.

Lina says she is insanely busy at the studio but has enough time to change her status updates every hour.

Britanny put a 15 year-old profile picture of herself and thinks no one will notice.

Matthew forwards you teddy bears and still thinks you will take him seriously as an artist.

Barry says he is in Leipzig installing in some weird-sounding art space no one has heard of.

Shahana is in Venice, but you have no idea why she is in your **FB** list.

Mary Ann is an important curator trying to be cool by joining **FB**.

HELGUERA

CONTRIBUTORS

Rocío Aranda-Alvarado is Associate Curator at El Museo del Barrio, where she is currently working on the 2011 S-Files exhibition "The Street Files." She received her Ph.D. from the CUNY Graduate Center in 2001 and teaches at the City College of New York. Prior to El Museo, she was Curator at Jersey City Museum for nearly ten years. Her writings have appeared in numerous catalogues and periodicals. Her essay on the connections between the works of Romare Bearden and Carlos Enríquez is forthcoming in a volume on Bearden published by the Center for Advanced Studies in the Visual Arts.

Regine Basha is an independent curator and has developed projects for many institutions, such as Arthouse, SculptureCenter, Ballroom Marfa, Platform, Townhouse Cairo, the Aldrich Contemporary Art Museum, and more recently for *Cabinet* magazine, Mass MoCa, and Bloomberg, New York. She explores various formats within exhibitions such as radio and web + live presentations, temporal public interventions, sound work, and collaborative commissions. Basha is co-founder of Fluent~Collaborative and Grackleworld.com. She currently sits on the board of Art Matters.

Antonio Sergio Bessa is Director of Curatorial and Education Programs at the Bronx Museum of the Arts. Bessa worked previously as a lecturer at the Metropolitan Museum of Art and taught contemporary art at the School of Visual Arts. He currently teaches on museum education issues at Teachers College. A graduate (Ph.D.)

of the Steinhardt School of Education, NYU, Bessa is a scholar of concrete poetry and has also organized several exhibitions including "Double Space" (Apex Art, 2000), "Re: La Chinoise" (Baumgartner Gallery, 2001), and "Intersections: The Grand Concourse at 100" (Bronx Museum, 2009).

Holly Block was appointed Executive Director of the Bronx Museum of the Arts in 2006. Prior to that she served as Executive Director of Art in General, a leading nonprofit arts organization dedicated to commissioning and presenting contemporary art. She also served as a co-commissioner for the Department of State for the 2003 Cairo Biennial with the selection of the artist Paul Pfeiffer; and, most recently, organized "todo clandestino, todo popular," the first solo exhibition of the Cuban-based artist Alberto Casado. Block is the author of *Art Cuba: The New Generation*, a comprehensive survey of contemporary art from Cuba.

Ian Cofré is a Brooklyn-based independent curator, working primarily with emerging artists. Recent exhibitions include "The Doubtful Guest" at Kill Devil Hill in Brooklyn (2010); "Southern Exposure" at Dumbo Arts Center (2009); and "The LouvreFRITOS" at Cuchifritos Gallery (2008). With the founders of Kill Devil Hill, he co-organized "The Menus of Chanterelle" (2010), a retrospective of the unique menu collection that designer Bill Katz exclusively compiled for the pioneering downtown restaurant Chanterelle.

Kianga Ellis is President of Avail Art, an incubator for innovative projects that use technology to develop new audiences for art. Ellis is also a Managing Director at Phoenix Partners, LLC, where she advises the firm's sister galleries in New York and Hong Kong. Her work focuses on the role of the Internet in business development, and she is an enthusiastic adopter of social media. Prior to founding Avail Art in 2005, Ellis was a Wall Street derivatives lawyer. She is a graduate of Spelman College and Yale Law School.

Mónica Espinel is an independent curator based in New York. She holds a B.S. in Psychology from Florida International University in Miami and is pursuing an M.A. in art history at Hunter College. Previously she worked at Marvelli Gallery, Wildenstein & Co., and Latincollector. Curatorial projects include "Black Milk" (Marvelli, 2004), "Emerging Artist Series" (Gramercy Post, 2005–6), "Ceremonies of Summer" (Latincollector, 2008), "Then & Now: Abstraction in Latin American Art" (Deutsche Bank, 2010), and "Memory Leaks" (Creon, 2010). In 2009 she was awarded ArtTable's Mentorship Grant to be a curatorial fellow at Wave Hill.

Pablo Helguera is a visual and performance artist (AIM 2001). His works include *The Pablo Helguera Manual of Contemporary Art Style*, the novel *The Boy Inside the Letter*, *Artoons* (Vols. 1, 2, and 3), the play *The Juvenal Players*, and the performances *Theatrum Anatomicum (and other Performance Lectures)*, *What in the World: A Museums Subjective Biography*, and *Urÿonstelaii*. In 2008 he received a Guggenheim Fellowship. His Artoons appear regularly in *Artworld Salon* and in *The Art Newspaper*.

Cary Leibowitz likes art. He makes it (artist). He collects it (collector). He sells it (Director of Contemporary Editions at Phillips de Pury, New York). When approached to participate in this project he procrastinated; as an artist, he understands the mixed emotional baggage that comes with such a desire to express oneself via the powerful art world. In the end he said "Yes" because "It's important we all keep it moving."

Omar Lopez-Chahoud is an independent curator whose recent exhibitions include: "NY/Prague6," at Futura Contemporary Art Center, Prague, Czech Republic; "Lush Life," at nine galleries on the Lower East Side of New York City (co-curator); and "The Pipe and the Flow," at Espacio Minimo in Madrid. He has written essays for several publications, including *Dynasty* (2006) and *Rewind/Re-Cast/ Review* (2005). Lopez-Chahoud has participated in curatorial panel

discussions at Artists' Space, Art in General, MoMA PS1, and the Whitney Museum of American Art in New York City. He was the 2007 Critic-in-Residence at Art Omi.

Marysol Nieves is an independent curator with more than twenty years of museum and corporate art experience specializing in contemporary international and Latin American art. She has held positions at Sotheby's New York; Museo de Arte de Puerto Rico, San Juan; and the Americas Society, New York. Nieves served as senior curator at the Bronx Museum of the Arts (1995–2002), where she organized several exhibitions and catalogues including the annual Artist in the Marketplace series. Currently she is developing curatorial projects for Colección FEMSA, Monterrey, Mexico; and Espacio 1414, San Juan, PR.

Melissa Rachleff is a Clinical Associate Professor of Visual Art Administration, Steinhardt School of Culture, Education, and Human Development, at New York University. Previously she was a Program Officer at the New York State Council on the Arts. Rachleff was also Manager of Public Programs at the Brooklyn Museum and at the Museum of the City of New York, as well as Associate Curator at Exit Art. She is a contributing writer for *Exposure*, a journal published by the Society for Photographic Education.

Rodney Reid is co-founder and Director of The Contemporaries, the largest independent organization for young collectors in the United States. Since his early twenties, Reid has been a passionate collector of contemporary art and photography and has amassed a diverse collection of more than 150 works by such artists as Chuck Close, Ann Hamilton, Alec Soth, and René Cox. He resides in New York City and is an investment banker.

Sara Reisman is Director of New York City's Percent for Art program, which commissions permanent artworks for city-owned public spaces. Reisman has organized exhibitions and written about public engagement and public art, social practice, the aesthetics of globalization, and site-specificity for the Philadelphia Institute of Contemporary Art, the Queens Museum of Art, the Cooper Union School of Art, Smack Mellon, Socrates Sculpture Park, Momenta Art, and Aljira, among others. Reisman is the 2011 Critic-in-Residence at Art Omi.

Raphael Rubinstein is a poet and art critic whose books include *Polychrome Profusion: Selected Art Criticism 1990–2002* (Hard Press Editions); *The Afterglow of Minor Pop Masterpieces* (Make Now); and *Critical Mess: Art Critics on the State of Their Practice* (Hard Press Editions). Previously he was a Senior Editor at *Art in America*, where he continues to be a Contributing Editor. Currently he is a professor of Critical Studies at the University of Houston and is also on the faculty of the Art Criticism and Writing MFA Program at the School of Visual Arts, New York.

Brian Sholis was Artforum.com Editor at *Artforum* from 2004 to 2009. He has written exhibition reviews and essays for *Artforum*, *Frieze*, *Aperture*, and other art periodicals, as well as book reviews for *Bookforum*, the *Virginia Quarterly Review*, and the *Village Voice*. His essays have appeared in exhibition catalogues published by the Museum of Modern Art, the Whitney Museum of American Art, and the New Museum. He is currently a doctoral candidate in the Department of History at CUNY's Graduate Center.

Axel Stein has served as a curator at Museo de Bellas Artes (1978–81) and as Director of Sala Mendoza (1982–90), both in Caracas. Stein joined Sotheby's in 1991 and since 1999 has served as Sotheby's Regional Director in Miami, where he has worked closely with many of the most important contemporary and Latin American private collectors in South Florida.

 Carla Stellweg, a New York–based independent curator, is considered a pioneer in the field of Latin American art. From 1989 to 1997 she ran the Carla Stellweg Gallery in New York. She was also Executive Director of Blue Star Contemporary Art Center, San Antonio, Texas; Director of Curatorial Funding at the Jewish Museum, New York; and Director of White Box, a New York alternative art space where she currently serves on its Board of Advisors. Stellweg teaches in the Art History Department of the School of Visual Arts, New York.

 Barbara Toll owned and operated Barbara Toll Fine Arts, a gallery in SoHo, from 1981 to 1994. Since then, she has been a freelance curator and art advisor who has also served on the boards of several nonprofit art institutions, the Drawing Center and Independent Curators International among them. Previously, she worked at the Museum of Modern Art and the David Rockefeller Collection, and in the 1970s she ran Hundred Acres Gallery, one of the first galleries in SoHo.

 Anton Vidokle is a visual artist (AIM 1995) who has exhibited at the Venice Biennale; Lyon Biennial; Dakar Biennale; Liverpool Biennale; Tate Modern, London; Moderna Galerija, Ljubljana; Musée d'art Modern de la Ville de Paris; Museo Carrillo Gil, Mexico City; UCLA Hammer, Los Angeles; ICA, Boston; Haus Der Kunst, Munich; and P.S.1, New York, among others. As founder of e-flux (1999), he has conceived and presented projects such as An Image Bank for Everyday Revolutionary Life, the Martha Rosler Library, e-flux video rental, and (with Julieta Aranda) Time/Bank. Vidokle is also Co-Editor of e-flux journal.